# Living in Data

# Living in Data

A Citizen's Guide to a Better Information Future

Jer Thorp

**MCD**
Farrar, Straus and Giroux | New York

MCD
Farrar, Straus and Giroux
120 Broadway, New York 10271

Printed in the United States of America
First edition, 2021

Grateful acknowledgment is made for permission to reprint the
photograph of *Infinite Weft* by Eric Wolfe, © snapwolf.com.

Library of Congress Cataloging-in-Publication Data
Names: Thorp, Jer, author.
Title: Living in data : a citizen's guide to a better information / Jer Thorp.
Description: First edition. | New York : MCD, Farrar, Straus and Giroux, 2021. |
    Includes bibliographical references.
Identifiers: LCCN 2020055322 | ISBN 9780374189907 (hardcover)
Subjects: LCSH: Information visualization. | Information behavior. | Statistics. |
    Quantitative research. | Big data—Social aspects.
Classification: LCC QA76.9.I52 T55 2021 | DDC 001.4/226—dc23
LC record available at https://lccn.loc.gov/2020055322

*Designed by Gretchen Achilles*

Our books may be purchased in bulk for promotional, educational,
or business use. Please contact your local bookseller or the Macmillan
Corporate and Premium Sales Department at 1-800-221-7945,
extension 5442, or by email at MacmillanSpecialMarkets@macmillan.com.

www.mcdbooks.com • www.fsgbooks.com
Follow us on Twitter, Facebook, and Instagram at @mcdbooks

10  9  8  7  6  5  4  3  2  1

For Nora.

There are a hundred thousand species of love,
separately invented, each more ingenious than the last,
and every one of them keeps making things.

<div align="right">—Richard Powers, <em>The Overstory</em></div>

# Contents

# Preface

I am writing this under curfew. The police are, right now, roaming this city in great packs, batons in hand. They are herding protesters, kettling them, beating them, zip-tying their wrists, detaining them for hours without food or water or medical care. It is our fourth night of this. It is our seventy-seventh day of shutdown, of shelter in place; we are at some unclear point in a pandemic that may last many more weeks or months or years.

It has been a spring of data. Numbers of cases, numbers of tests, numbers of deaths. Numbers about social distancing and herd immunity. Numbers of protesters, of Black people killed by police. Numbers, numbers, numbers. On March 27, *The New York Times* published a chart that showed the unprecedented numbers of people seeking unemployment insurance that week in the country; the right-most bar (3.3 million) stretched from the very bottom of the page to the top. The *Times* did it again on May 9, when the monthly figure had passed twenty million. On May 24, the newspaper printed a thousand names of people who had died so far from the coronavirus: a thousand names that spilled off the front page and into the next. Angel Escamilla, sixty-seven, Naperville,

Illinois. *Assistant pastor.* April Dunn, thirty-three, Baton Rouge, Louisiana. *Advocate for disability rights.* Joseph Yaggi, sixty-five, Indiana. *Mentor and friend to many.* Alby Kass, eighty-nine, California. *Lead singer of a Yiddish folk group.*

In my neighborhood, on the edge of the East River, someone has been leaving little painted rocks on the trails in the park. "Everything is going to be OK," one says, painted in tidy black letters on white. "We are all in this together," reads another.

We are not all in this together. Read those names in *The New York Times* more closely, dig into the numbers, and you'll find out that the virus has affected Black people and Black communities more severely than white ones. In Minneapolis, where George Floyd was killed on May 25, 2020, the police are seven times more likely to use violence against Black people than they are against white people. It is the "we" in the stone's platitude that is problematic.

That same collective "we" has too often been data's "all lives matter," a way to soft-pedal concerns about privacy while refusing to speak directly to dangerous inequalities. If I want to talk about the human experience of data, I need to talk about risk, and risk is something that does not affect people equally or at the same time. Living in data may seem like a shared reality, but it is an experience that critically differs from person to person and from group to group. One two-letter word cannot possibly hold all of the varied experiences of data, specifically those of the people who are at the most immediate risk: visible minorities, LGBTQ+ people, indigenous communities, the elderly, the disabled, displaced migrants, the incarcerated.

Much of the book you're about to read *is* written in the first-person plural. That is to say that I'm going to use the word "we" a lot, wrapping you and me together. It makes me uncomfortable, and it should make you uncomfortable too. But I believe it's

necessary. To borrow from Julietta Singh, my "we" is "a hopeful summons." It exists not in the present but in some better future that I have to believe we will arrive at.

This is only the second time in New York's history that the city has been placed under curfew. The first time was August 1, 1943. It was the night of the Harlem riots, which had erupted after a white police officer, James Collins, shot a Black soldier, Robert Bandy. Mayor LaGuardia sent a force of six thousand police and fifteen hundred civilians into Harlem to quell "outbreaks of hoodlumism." Six hundred people were arrested, and several were killed. That night was also the funeral for James Baldwin's stepfather, and he wrote of driving to the graveyard "through a wilderness of smashed plate glass." The riots and his stepfather's death would inspire one of his most famous essays, "Notes of a Native Son," which ends with these words:

> It began to seem that one would have to hold in the mind forever two ideas which seemed to be in opposition. The first idea was acceptance, the acceptance, totally without rancor, of life as it is, and men as they are: in the light of this idea, it goes without saying that injustice is a commonplace. But this did not mean that one could be complacent, for the second idea was of equal power: that one must never, in one's own life, accept these injustices as commonplace but must fight them with all one's strength. This fight begins, however, in the heart and it now had been laid to my charge to keep my own heart free of hatred and despair. This intimation made my heart heavy and, now that my father was irrecoverable, I wished that he had been beside me so that I could have searched his face for the answers which only the future would give me now.

How does one speak about something that is both fish and water, means as well as end?

—URSULA FRANKLIN,
*THE REAL WORLD OF TECHNOLOGY*

# Living in Data

# Prologue

Hal Fisk stood in the Louisiana sun, wiping the sweat from his brow with a clean white handkerchief. It was one of a few dozen that Emma always packed for him on these trips, for the sweat and for the mud. There was mud still in the deep furrows of his geologist's hands, even after he'd wiped them clean and then wiped them clean again. There was mud, too, caked and dried up both of Hal's arms to where he'd rolled up his shirtsleeves neatly in the morning. To do any sort of work out here was to be very intimate with mud, no way around it.

They'd been trying to get the bore rig started all morning, but the big bit kept on getting caught on something before it could build up enough torque. An old tree root, it turned out, so Bill Hendy was neck-deep in the muck with a hacksaw trying to get the thing out. Hal hoped they could get the machine started soon; around noontime the heat would be downright unbearable. This was the second last drill between Harrisonburg and Natchez, and he was eager to get back to Vicksburg, to Emma and the lab and to the data.

Where Hal was standing was a good ten miles from the Mississippi. There was another river that ran much closer by, the Tensas. It was a stream really, choked with turtle grass, half decent for fishing according to the locals but barely wide enough for a boat even after a rain. What the mud would tell them, Hal knew, was that the Tensas was the meandering ghost of a Mississippi past, a last trickle of a course abandoned some three thousand years before.

It had been clear from the beginning, to the first humans who had navigated the river, that the Mississippi was restless. Over time its curves would widen, the water becoming more shallow. Eventually the elbows of the river would double back on themselves, and the water, taking what it deemed the most rational path, would decide to avoid the old part altogether, would flow across the ground to the next loop of the river, cutting off a piece of itself. And repeat.

Evidence of this bending and re-bending lives in the mud and in the life that sprang from it. A cutoff elbow of the river might spend a century or two as a stranded lake. During this time it discards its riverine identity and becomes a closed system, something more still. Largemouth bass and quick silvery dace are replaced by languid longnose gar and deep-burrowing catfish. At the water's edges, new plants arrive, more suited to the idle water of the lake. Year to year, decade to decade, they send their roots into the water to drink, and the soil builds around them. It is a drawn-out argument between land and water, won before it began. The water is consumed, and what is left is a lake-shaped mark of greenery, growing on top of a lake-shaped layer of mud.

From the sample they'd draw today, and some sixteen thousand others, Hal and his team would reconstruct the river as it was. Some of the boreholes the team drilled reached down more than thirteen thousand feet into the earth, and the rock there held ev-

idence of the river's beginnings after the last great ice age, some two and a half million years ago. From mud and rock and aerial photographs, they would draft maps of each of the river's abandoned curves, stacked on top of each other, a record of a huge, timeless, writhing thing. The result was a report, delivered in 1944, titled *Geological Investigation of the Alluvial Valley of the Lower Mississippi River*. From all those columns of earth and images from airplanes they built an epic geological story, one more complete than had ever been told. In the report, you can read of roaring glacial runoffs, of boulders carried across continents. Of the Sunflower system, the Thebes Gap, the Walnut Bayou Segment, the Gulf Coast geosyncline. Of bed materials and bank recession and salt domes and uplifts.

Fisk's work was a gargantuan feat of data collection, of synthesis and mapmaking. From mud and patchwork photographs, he gave the river, with its school-rhyme name, a 170-page origin story, of a place, of a landscape, of a way of life.

There were two hundred copies of Fisk's report printed, and for $2.50 plus postage it'd be delivered to you, a compact book printed on white paper, and twenty-six map plates neatly folded into quarters and tucked into a brown paper envelope. One of the copies ended up at the New York Public Library, and a few months back I went to the main branch in Bryant Park to visit it. Even though I'd seen images of the maps many times, when I unfolded the first plate onto one of the reading room's broad wooden tables, my heart skipped a beat. The maps are gorgeous, visceral things, rendered in a brilliant color palette of green and yellow and orange and red. And they are big: I could fit only four plates at a time on the 20-foot-long table; to see the whole set of maps in one place, you'd need a hallway 108 feet long.

Seeing that I was trying to get a photograph of the maps from above, one of the librarians brought out a stepladder, and I climbed to the top. It might have been vertigo (I'm not good with heights), but a kind of dizziness overtook me as I looked down onto the four plates, onto a stretch of the river that spanned twenty-four hundred miles and ten thousand years. For a moment I saw a map of this book you have in front of you, and I realized that the story I have to tell is, too, one of meanderings, of swift currents and slow corners, of silt and history. It's a story that has come to be in part by looking down from above, watching and listening and reading, spending hours in archives. Mostly, though, it has come from time spent waist-deep in data: in research labs at *The New York Times* and the Library of Congress (LOC), on expedition with *National Geographic* field teams, in the galleries at the Museum of Modern Art, at the bottom of the ocean, in cities like Calgary and St. Louis and Manchester and in the middle of Times Square. There is mud on my hands.

There are 164 rivers that join the Mississippi along its two-thousand-mile course from Lake Itasca to the Gulf of Mexico. The L'Anguille, the Skokie, the Edwards, the Grant, the Iowa, the Missouri. West Branch Sugar River and Hay Creek and Bayou Pierre. The biggest of these have their own tributaries, so to consider the river is to stretch from Montana to Pennsylvania; from Saskatchewan to New Orleans. Read about data in the newspaper, read about it online, and it might fool you. It might fool you into believing that the path we're on is a predetermined one, that the way in which we are being carried along its course is the only way we can go. That its history could be drawn with one clean line. To tell the real story of data, though, is to speak not only of the big topics, of Facebook and machine learning and targeted advertising and visualization and facial recognition. To get the whole picture, we need to visit the smallest creeks and brooks and streams, the

places where the story bubbled up a century ago, and the places where we can find new stories just beginning to flow.

Helen Hall Jennings sits in a classroom in Brooklyn, in 1931, watching the students, writing in her notebook. A seventeen-year-old in Cleveland dials into the nation's largest Free-Net. Outside a school in San Francisco in 1999, children plant two walnut saplings, identical clones. In a theater in Birmingham in 2003, a woman is on her hands and knees, carefully counting out 2,435 grains of rice. In the highlands of Angola in 2015, a convoy of mine-clearing vehicles rumbles through a pristine forest. On the north side of St. Louis, a group of ninth graders project census data onto a hand-drawn map. On a glacier high in the Canadian Rockies, a sensor records a sudden movement of the ice.

There is no straight line to be drawn between these heres and theres, these nows and thens. This book will, by necessity, meander. It will double back and reverse course.

Step back, though, climb up onto a ladder, and I hope you'll see a bigger story.

Now it flows like a broad billow over
the whole land, now it divides itself into
a gigantic net of thin streams; now it
bubbles forth from under the ground . . .
All run through one another, next to
each other, across one another, flow in
and over one another; it is an eternal,
moving, changing sea of appearances.

—ROSA LUXEMBURG

LIVING IN DATA

**THESE HARROWING SECONDS**
*OKAVANGO DELTA, BOTSWANA*

J. T.  |  GITHUB.COM/BLPRNT/LID/HIPPOS

# 1.   Living in Data

It's 11:01 a.m., and I'm about to be attacked by a hippopotamus.

I've replayed this event many times in my mind's eye: the swell of the wave approaching in the clear water. The rock of the boat as we try to brace ourselves for impact. The shouts from the people around us as they realize what is about to happen. *Kuba! Kuba! Hippo! Hippo!* These harrowing seconds are being recorded as data, as the output of a heart-rate monitor I'm wearing across my sweaty chest. Looking now at those numbers, the actual millisecond-by-millisecond beats of my heart, I can see my distress building. As a graph, it reads like an elevation map of terror, each successive peak taking me closer to the hippo's arrival, or to cardiac arrest.

I recently wrote a piece of software to turn those numbers back into sound, a kind of a thump-by-thump re-creation of the attack, and I've got headphones on right now, listening. As the Jer sitting in that boat gets more and more terrified, so does the Jer sitting here in this chair, in my studio in Brooklyn. It's pretty easy to tell myself that there isn't a hippo here, in this room, but at the same

time the data is a convincing record of the most nerve-racking experience of my life.

Despite being the world's largest amphibious animals, hippos aren't great swimmers. The adult males weigh about as much as a minivan, and they don't float. They prefer to stay in the shallows, where their feet can touch the ground. Just deep enough that their eyes and ears and nose—stacked up at the top of their enormous heads—remain out of the water. A scared hippo, though, or a very agitated one, will venture into a lake or a pond or a river channel, moving with great porpoise-like leaps off the bottom. Hydrodynamics be damned.

I wondered, as I watched the hippo-sized bow wave surge toward me, what am I doing here?

I tripped and fell into data, into that boat and this book, one Saturday in the spring of 2009. I was sitting at the little Ikea desk in my East Vancouver flat. The cherry trees that lined my street had just burst into bloom, and the floor under my chair was sticky with the pink petals I'd tracked in after my morning dog walk. I was just about to give up (again) on a project I'd been working on and reworking for nearly four years. Its central question had come to me one day while I was staring at my screen: What if pixels could do what they want? What if we could unbind them from their tedious life of following instructions: how bright to shine, when to blink on and off, what exact shade of orange they must display.

In my project I'd set the pixels free, letting them trade color with each other in a miniature economy. I coded the pixels to each have a kind of personality: some were conservative; others were happy to take risk. Some of them looked at trends in the color "market" to decide which trades to offer; others listened to a coded oracle, which spit out a series of predictions based on random numbers. Each color block had agency; it was free to make whatever deci-

sions its little programmatic brain might settle on. As a group—a population—these individual foibles would emerge into pattern, and the system would be, in a small sense, alive.

The problem was that it didn't work. No matter how I set the parameters, the economy would collapse within ten thousand or so rounds of trading. I'd be left with two or three extremely wealthy pixels, and the rest would be broke. And dead. I tried changing the starting conditions, setting the color "wealth" of each pixel from different images, photos of sunsets or deserts or wildfires or drawings of national flags or snaps from my webcam. I tried implementing a taxation system, where money was distributed to the poor pixels from the wealthy ones. Some of these solutions worked, for a long minute or two, and then the whole thing collapsed again to the very rich and the very dead.

I decided what the system needed was some chaos, some noise from the real world that might keep the economy on its toes. I looked first at feeds from the stock market, but that seemed far too literal for my pixel population. And then I had an idea: What if the real-world usage of the words "red," "green," and "blue" drove their value in the color economy? If I could get the text from news articles, I could write a program to count these color words and then feed the numbers into my system. I googled. In what I now recognize as a moment that crackled with serendipity, the first result I read was about a new data service that *The New York Times* had released the day before, an interface that allowed anyone to search thirty years of articles and get back lists of results. Headlines, bylines, content summaries, web URLs, and, with a little bit of work, occurrences of specific words and phrases.

I never did finish the color project. I got caught instead in the sweeping currents of data's possibilities. That afternoon I wrote a program to download 972 numbers from the *Times*. The numbers were counts of how many times "red," "green," and "blue" had

appeared in the newspaper between the years 1981 and 2008. My computer dutifully packaged up the requests for the numbers, twelve at a time, and after a few minutes of a gray screen a graph appeared. It was my first data visualization.

The graph itself was hardly auspicious. It was rendered in the gaudy primary colors of a day care (or a Google office), the bars sat on top of each other, and there was no way to tell one month from another or one year to the next. Still, looking at this ugly thing, I could see some promise. There was pattern, if you looked closely. While blue and red seemed to oscillate with no regular pattern, the bar graph for green was a line of rounded hummocks, each twelve months long, the color of the seasons reflected in the language of the news. There was a big spike in the red graph in March 2002—the result of Homeland Security Presidential Directive 3 and its rainbow scale showing "the risk of terrorist acts." I spent hours reading the data returns and matching them to every little peak in the graphs; there was a whole history wrought in color: Deep Blue and Red Square and green energy, Blue Cross, Red Cross, Green Berets.

I tried new combinations of words: first "sex" and "scandal," then "internet" and "web," then "Iran" and "Iraq." "Innovation" and "regulation," "Christianity" and "Islam." "Superman," "Batman," and "Spider-Man." "Global warming" and "climate change." "Hope" and "crisis," "science" and "religion," "communism" and "terrorism." Each of these sets of words told its own visual story; each of them showed some change in how the words were used by the writers and editors at the *Times* and how they were read by millions of readers. How satisfying this simple thing was, this trick of turning numbers into shapes and colors.

I discovered that I could draw connections between people and organizations if they appeared in the same article, and from this realization came dense maps of entire years of news. Ronald

Reagan, the Roman Catholic Church, the United Nations, Michael Dukakis, George Bush, Salman Rushdie. The ANC, David Dinkins, General Motors, Bill Clinton, Jim Bakker, the PLO. Reading the maps, year by year, was like a fast-forwarding through history, or at least through the history that had been told by *The New York Times* (presidents, for the most part, occupied the center of the maps, except in the years when the Yankees won the World Series).

I spent months adrift in the possibility space of visualization, where, it seemed, I could conjure pattern from nothing and from everything. When I got tired of the *Times*, I visualized the U.K.'s National DNA Database, the influenza genome, Obama's foreign policy speeches and State of the Union addresses, and international relief donations to Haiti. I mapped everyone who said "good morning" on Twitter in twenty-four hours, and analyzed language from sixteen hundred issues of *Popular Science*. I plotted vessel traffic in the world's biggest shipping ports and mapped the narrative structure of Haruki Murakami's short stories. I created time lines of every character in every issue of the classic *Avengers*. In one of my favorite projects, I reverse engineered a map of global air travel from people tweeting "I just landed" as they touched down in airports all around the world.

I became captivated with what I call "question farming": using visualization not to simplify something but to unfurl its complexities in interesting ways, exposing things that weren't before able to be seen. John Tukey, one of the great defining figures of modern statistics, would describe this kind of work as exploratory analysis, rather than the more task-oriented confirmatory analysis. Personally, though, I discovered that this wide-open exploration brought *joy*, as opposed to data visualization's defining emotion, *satisfaction*.

In the early fall of 2010, I walked into the New York Times Building on Forty-Second Street and took the elevator to the fourteenth

floor, where I'd spend two and a half years as the company's first data artist in residence (a title I made up). It was fertile soil. With my colleagues there I built the first large-scale tool for exploring social media data, a kind of interactive forensic instrument for conversations on Twitter. With it you could clearly see both the exhilarating expansiveness and the tangled complications of the then-nascent social network. While I was at the *Times*, I started teaching at New York University's Interactive Telecommunications Program (ITP), a kind of punk rock version of MIT's Media Lab, where I set my students out into the loamy dirt at the edges of data's possibility space, digging, planting, seeing what would grow.

When I left the *Times* in 2013, I started a studio, the Office for Creative Research (OCR), and for almost a decade we tried to break as many of data's rules as we could. We performed data at the Museum of Modern Art and built it into a sculpture in the middle of Times Square. We made tools to give people ways to navigate data's wash: a browser extension that analyzes the web ads that swamp our browsers, a pop-up data community center in North St. Louis, a citizen science platform for chronic pain sufferers. Somewhere in the midst of all this I was (much to my surprise) named a *National Geographic* Explorer, and my work (and the OCR's) seeped out of screens and cities and into wilder places. Keen to put my new credentials to work, I joined an expedition into the heart of Botswana's Okavango Delta, having traded my data skills for three square feet in the front of a boat.

Spoiler: I didn't die. The hippo decided, having run the energetic equations, that we weren't worth the effort of a capsize. Or all the mess and noise of a thorough goring. He came out of the water a stone's throw away, with an openmouthed roar, showing us four gleaming tusks the size of short swords. We poled quickly away. My pulse didn't settle down for eleven minutes. That afternoon we negotiated past eleven more hippos on the way to camp.

Living in Data

Three the next day and twenty the next. Each of them filed into a database with an exact time, a latitude and longitude, and a clear uptick in the speed of my heart.

Back in New York, we kept working. When our little office on the Bowery got too crowded, we moved into a bright space in an old telephone company building in downtown Brooklyn. Before the new OCR opened, I paid a sign maker to hand letter a Pynchon quotation in deep black letters around the whole office:

> She looked down a slope, needing to squint for the sunlight, onto a vast sprawl of houses which had grown up all together, like a well-tended crop, from the dull brown earth; and she thought of the time she'd opened a transistor radio to replace a battery and seen her first printed circuit. The ordered swirl of houses and streets, from this high angle, sprang at her now with the same unexpected, astonishing clarity as the circuit card had. Though she knew even less about radios than about Southern Californians, there were to both outward patterns a hieroglyphic sense of concealed meaning, of an intent to communicate. There'd seemed no limit to what the printed circuit could have told her (if she had tried to find out); so in her first minute of San Narciso, a revelation also trembled just past the threshold of her understanding.

As the team grew, so did our commitment to doing work that wasn't tangled up in advertising, in the selling of more stuff to more people. If an email arrived with the word "branding" in it, it'd go straight into the trash. We said no to Google, no to Facebook. Yes to the epidemiologist with no budget. Yes to the community art center in St. Louis. For every project we did that paid us, we'd

do two more in the service of our own curiosities and convictions. More farming. People were often confused about whether the OCR was a design studio, or an R&D lab, or a nonprofit. We were somewhere in between. When people asked me what kind of business I ran, I'd say the OCR was a "not-for-enough-profit." Which was a joke, until it wasn't.

After the studio closed in 2017, I spent eighteen months at the Library of Congress, this nation's house of data. I waded, waist-deep, into its millions of books and manuscripts, maps and photographs and recordings. Again I dug, into the library's infrastructures and file formats, its hallways and its card catalogs and its open APIs. I planted ideas into neat rows, watered them, tended to them. Through toolmaking and performance and storytelling, I learned how data at the library works and how it might work differently if we freed it—and ourselves—from technology's incessant expectations and constraints. While I was there, I started writing.

This book is a record. It *is* data. It's data about these last ten years of my life, a document of the work that I've done to expand my own ideas about what data is and what data can be. It maps, in more detail and with less linearity, my path from that basement studio in Vancouver to the *Times* to the Library of Congress. From a submarine at the bottom of the Gulf of Mexico to the rocking boat in the middle of Africa's Okavango Delta to a windy rock face in the Canadian Rockies. It follows my work as I've explored new methods for showing and exploring data, from visualization to sound and sculpture and performance. Importantly, it also tracks the changes in how I've thought about data, first as a kind of inert fuel for investigation and then as something much more ominous. How we might navigate the risks it presents to ourselves and others. How we might look directly at its harms without breaking our

gaze. How, with some bold revisions, data might offer a rich and fractal medium for personal and community growth.

Mostly, though, this book is a guide. It's a guide for those who have to live in data and for those who want to create data worlds that are more livable. It's a guide for the person who woke up one day, thinking about how they are being tracked moment by moment by their phone and their social media platforms and their cars and their cities, and thought to themselves, how did we get here? It's a guide for the entrepreneur who is setting out with a new company, looking back at the havoc that big data has wrought on our selves and our society, and thinking, we can do better than this. It's a guide for individuals and communities who are looking to speak their own data stories louder than those that are being told about them by others.

Because we can do better than this. We can create new data worlds that put humans first.

=

On a cloudy September morning in 2013, the students at Hunter College High School filed past security and into the hallways, to be faced with a much different kind of trauma: their school had been named the saddest place in Manhattan.

Five months earlier, researchers in Cambridge, Massachusetts, had pulled more than six hundred thousand tweets from Twitter's public API and fed them through sentiment analysis routines. If a tweet contained words that were deemed sad—maybe "cry" or "frown" or "miserable"—an emotional mark for sadness would be placed on a map of the city. As more tweets classified as sad happened near a specific area, more marks would be put on the map, and more sadness would be ascribed to that particular

place. The result was a kind of sedimentary layer of emotion data on top of New York City. If you looked at the sadness map that came out of the study, you'd probably ask about a deep purple spot of lament just to the right of Central Park's reservoir. If you looked that spot up in Google Maps, you'd find that it sat right on top of Hunter College High. If you then thought about when the tweets had been collected (in the spring), you might arrive at a hypothesis similar to that of the president of the New England Complex Systems Institute (NECSI), Yaneer Bar-Yam:

> I checked the high school calendar and found that the spring vacation period in 2012 was April 9–13, so that students would be returning to school on the 16th, just during the period of the data collection, April 13–26, 2012. This provided a rationale for the low sentiment there.

Sad students returning from spring break—it seemed to Bar-Yam like an interesting finding. The press agreed. Stories about the study, and about this sad Upper East Side school, appeared in *Science*, then in *The New York Times*. In advance of its piece, the city's newspaper of record dispatched a reporter to talk to the students at this "saddest spot in Manhattan" to gauge their reaction to the study. "I mean, I can see why it could make sense," one fourteen-year-old student told the reporter. "The school has no windows, so being inside can seem dark and depressing. And some kids do get stressed out from the workload."

Unwittingly, the staff and students at Hunter College High had found themselves inside a microcosm of the data world that by 2012 we were already very much inhabiting. It's a world in which we are all being data-fied from a distance, where our movements and conversations are processed into product recommendations

and sociology papers and watch lists, where average citizens don't know the role they are playing, surrounded by machinery built by and for others.

Three decades ago, Ursula Franklin, a Canadian metallurgist, physicist, author, and ardent pacifist, delivered a series of lectures about what she termed the "real world of technology." This place, in which Franklin believed by 1989 we were already firmly entrenched, was one where "most people live and work under conditions that are not structured for their well-being." One defining condition of Franklin's real world of technology is that the authority of data overrides that of lived experience. It's a place where, as she writes, "abstract knowledge is forcing people to perceive their experience as being unreal or wrong." A place where students might accept that they are sad because the data told them so.

It's very easy, as the Cambridge scientists found out, to get carried away with the long-distance magic of APIs and machine learning, to use these technologies to scan from afar. But our scanning isn't harmless; our analyses are not without effect. Those high school students that you've classified as sad feel something when they read the results of your study.

=

Two years after the *Times*'s "saddest school" article was published, I stood in the lobby of Hunter College High School, waiting to speak with Lisa Siegmann, the school's assistant principal. I couldn't get the story out of my head. I didn't at the time have an inkling that I'd be writing this book; somehow I needed to understand how the story had felt to those who had been so publicly data-fied. I was interested in how the *New York Times* article had been received by students and staff and what the aftermath

(if any) was of being so publicly labeled as the saddest spot in the city.

Actually, I wanted their reaction to the school being labeled as sad and then *unlabeled* three weeks later. As it turned out, the researchers from New England had made a big mistake. Their geocoding code, the part that turns a place name or an address into a point on a map, was faulty. Hunter High was not the saddest place in the data set; it was merely sad-adjacent, coincidentally located near a single Twitter user who had been posting a lot of content that was getting labeled as unhappy. If that weren't bad enough, the scientists had missed a deeper error in their sad-student hypothesis that left the premise completely indefensible.

The assistant principal was running late, so I stood by the security desk with a small group of parents and waited. There was a poster on the wall for an upcoming TEDx event that would feature students and teachers; the theme was "The Care of the Future Is Mine." I couldn't help but look at the students who walked by and try to assess their emotional state. When Siegmann arrived, she led me upstairs, past a small lineup of students waiting to see her, and into her office. Siegmann seemed wary of dredging the article up again, but she was candidly direct about how she and the school had reacted.

"Nobody believed the article," she said. "First, this is not a sad school," she added, taking a minute to explain the various activities that the students participate in and the awards that the school and the students had won.

"Second," she said, "no one in this school uses Twitter." She paused for a minute, then laughed. "Twitter is for old people."

As it turns out, Hunter College High didn't permit students to use social media while they're in the building. The administration knew that students were breaking the rules, and they also

knew which social platforms they were surreptitiously using: Instagram and Snapchat, mostly, and sometimes Facebook. But not Twitter.

The Hunter College High fiasco is a perfect example of how data can and does fail end to end: a retracted story about a false statement, spit out by a faulty algorithm, feeding on bad data. All balanced on top of an impossible premise. It's also a clear reflection of the kinds of data stories that we've been so eager to believe: where a large data set combined with novel algorithms shows us some secret that we would not otherwise have seen. "To be human," as Richard Powers wrote, "is to confuse a satisfying story with a meaningful one." Stories told through data can be very satisfying indeed.

What brought me to the assistant principal's office that morning, though, was not to find another way to critique a study or to place blame on the researchers or their broken algorithms. Though I didn't know it at the time, reading that *New York Times* story in 2013 had set a fracture into my thinking. Until then I'd given little thought to the downstream effects of working with data, to the idea that the kind of work I myself was making might have real-world consequences

At first our work at the OCR was centered on building new ways to explore and tell stories with data. We visualized language patterns across 140 years of *Popular Science*, made a touch-screen interface to sift through terabytes of botnet activity, plotted the import and export of the nation's fruits and vegetables. Slowly, though, the Hunter College High fracture found its way into our work, and we began to think more about how data was tangling itself into the quotidian, how it was affecting the way people worked and lived. Our projects—many of which you'll read about in this book—made their way out of browser windows and art galleries and into public spaces. They became less about finding

answers in data and more about finding agency, less about exploration and more about empowerment.

In writing this, I've realized there was another reason I was there in that office. I was there because I can remember so clearly what it was like to be in high school, to be vulnerable and afraid and powerless. How being labeled could feel like being struck. How nothing seemed to be under my control, and no one seemed to hear my voice. I can also remember how I found agency in the face of all that overwhelming possibility through, of all things, computer programming. How could it be that the very same thing that offered me escape three decades ago was now being used to make the lives of high school students worse?

=

Eighty years before and one borough over, a young woman named Helen Hall Jennings sat in the back of the seventh-grade classroom at P.S. 181. The school was a mile from Prospect Park and was set into the tree-lined streets of East Flatbush, which since World War I had been home to large families of recent immigrants. The 1930 census counts significant numbers of people living near the school who were born in Russia, Syria, Ireland, Scotland, Czechoslovakia, and Austria. This part of Brooklyn was then one of wide boulevards, serviced by busy trolley lines. Maps drawn by fire insurance companies in the late 1920s show narrow streets of single-family houses with modest backyards. P.S. 181 was built just after the turn of the century on New York Avenue between Tilden and Snyder, a sturdy four-story brick building that still stands today.

Jennings observed the classrooms at first and then asked each student a question: Given the choice, who else in the classroom would you sit beside? Back in Manhattan, she worked with her collaborator J. L. Moreno to assemble diagrammatic maps of the students and their chosen relationships. These maps, which Moreno called "sociograms," show, fifty-three years before Mark Zuckerberg would be born, a language of social networks. Indeed much of the visual language that we find in social network renderings today can be seen in these 1931 drawings: people are shown as nodes (in Jennings's case, triangles for boys and circles for girls) with lines connecting them into a kind of structured web. If you close your eyes and imagine a network, you might very well be seeing something like these sociograms, nearly a century old.

Looking at all of the P.S. 181 sociograms together (Jennings recorded data for every grade from kindergarten to seventh grade), you can immediately see how these types of visualizations are useful to see pattern. In kindergarten, boys and girls are mixed together, and most of the connections are reciprocal— meaning that a student indicated a choice to sit next to another student who in turn wanted to sit next to them. Jennings and Moreno used a geometric terminology to describe the structures formed when three people selected each other (a triangle), or when four people are interconnected (a star), and these shapes are common in the early grades. By the fourth grade, though, students at P.S. 181 indicate preferences that are largely intra-gender. The boys want to sit with the boys, and the girls want to sit with the girls. You can also notice (as Moreno and Jennings did) that there are more frequently isolated students, students whom no other person in the class expressed a choice to sit next to.

It's easy, looking at these simple diagrams, to find narratives of friendship and trust, of loneliness and exclusion. I read with

some admiration of lucky SR, who "makes three choices all of which are mutually reciprocated." Five of her fellow students in seventh grade were unchosen.

Moreno and Jennings used their sociograms to draft new seating plans for each P.S. 181 classroom. Moreno believed that many social ills fell out of authoritarianism. He thought that if the students were allowed to find their own social order in the classroom, they would be less lonely, more engaged. The sociograms offered a kind of road map for how change might be implemented, driven by students' desires rather than administrators' whimsy. "Every sociometric test," Moreno wrote, "brought out the contrast between an authoritarian and a democratic pattern of grouping."

Moreno's interest in mapping social dynamics seems to have been born from his time working as a doctor-in-training in the Mitterndorf refugee camp during World War I. The camp, located twenty kilometers south of Vienna, was one of twenty-three that had been set up by the Austro-Hungarian government. The camps were divided by ethnicity in an attempt to mitigate cultural clashes; at Mitterndorf there were more than ten thousand Italians, housed in two hundred identical wooden buildings in a fenced compound. Each building held up to a hundred refugees, placed together under no other logic than the order in which they arrived. Moreno, who worked at the camp's children's hospital, spent time observing the social interactions between the people within the buildings, the dynamics between buildings, and the associations between refugees who shared similar religious and political beliefs. He came to believe that some degree of happiness could be achieved, even in extremely arduous situations, if attention were paid to people's preferences about whom they preferred to live with.

In the first half of the 1930s, Moreno and Jennings conducted sociometric experiments in New York State: in a hospital nursery, at Sing Sing prison in Ossining, and at the New York Training

School for Girls in Hudson, a reformatory school for "delinquent girls" under the age of sixteen. In each of these institutions, the process was similar to that at P.S. 181: using specially developed "sociometric tests," Moreno and Jennings would gather data about the preferred social relations of individuals. Inmates were asked with whom they'd like to share cells; girls were asked with whom they'd like to share cabins. Sociograms would be drafted in order to reveal relational structures between people, and then these diagrams would be used, along with various psychodramatic exercises, to construct new orders of cohabitation.

I believe what is remarkable about Moreno and Jennings's sociograms is that they are nearly the exact opposite of what they are often mistaken for. Social scientists have pointed to these pencil-and-paper diagrams as low-tech precursors of the kinds of network maps that software today can assemble with ease, maps of Facebook friends or Reddit users or alt-right groups. J. L. Moreno's Wikipedia page describes the sociograms as "graphical depictions of social networks," missing a critical point. Moreno and Jennings's diagrams were not in fact depictions of a social network as it existed: they were visualizations of a social network as the individuals within that network *wished it were*. They were, in reality, fictions. They were maps to a new reality for these people, renderings of a social order they desired, as opposed to the one they had been set into.

Moreno and Jennings didn't seem to consider the sociograms as the end point of their research. Instead, these visualizations were instruments for change. The data was *of* the students, *of* the prisoners, *of* the girls, but it was also *for* them. After the collection of data for the sociograms, Moreno and Jennings conducted sessions in which the inmates would role-play (a term Moreno himself coined), prisoners playing the role of the wardens and vice versa. Rather than keeping the data from his

subjects/collaborators, he and Jennings used it as a participatory medium, a locus for dialogue and interaction.

The comparison between the philosophies and methodologies of Moreno and Jennings with those of Bar-Yam and his colleagues at the New England Complex Systems Institute is stark and instructive. The NECSI work is pure research. As far as I can tell, neither Bar-Yam nor his colleagues set foot in Hunter College High during their work, nor did there seem to be any consideration of the impact their published work might have on the students themselves. There was certainly no remedy proposed in their study, no suggestion about how these supposedly sad students might be made supposedly happy. Bar-Yam's 2013 paper is now conveniently scrubbed of mentions of Hunter College High, but it lists plenty of other supposedly sad places in the city: cemeteries, jails, Superfund sites, Penn Station. There is no mention at all about how these places might be made more livable for the people who are presumably tweeting from them, how they might be restructured for well-being.

J. L. Moreno would have termed the New England study "cold sociology," a kind of from-a-distance practice that he abhorred. Moreno's son, Jonathan, a philosopher and bioethicist, wrote in his biography of J. L. that he rejected a distinction between research and application. "J.L. believed that the results should always be the basis for intervening in the life of the group to improve the lives of its members." In a 1954 paper, J. L. writes that the core purpose of the social scientist must be to "arouse" individuals, to push them toward spontaneity, something that he believed could happen only through the kind of dynamic means his sociometric approaches employed. "The invention and shaping of methods for social investigation," he wrote, "and the stirring up of the reactions, thoughts, and feelings of the people on whom they are used must go hand in hand."

Using the diagrams he collected at P.S. 181, along with a study of 250 boys at the Riverdale Country School and another of 500 girls at the Training School for Girls, Moreno and Jennings studied the network effect of isolation; he was specifically interested in people who were stranded in these diagrams, without social connection. The original purpose of this focus on isolation was practical: his work at the Training School for Girls had been aimed at predicting and preventing runaways. But he believed the character of the social networks he and Jennings drafted with the students in these schools mirrored that of society writ large.

In an interview published in *The New York Times* on April 3, 1933, Moreno postulated that there might be between ten thousand and fifteen thousand people in the United States who were "rejected by the groups in which they lived." Moreno believed that his network analysis techniques could not only find these "rejected" among us; he also believed that, working with these individuals, he could identify new networks in which they might thrive, "other environments in which they might become happy human beings." In the pursuit of this goal, Moreno stated his plans to produce larger sociograms, not at the size of classrooms, but at the size of cities. "Plans have been completed," he told the *Times*, "to chart the psychological geography of New York City."

This work from nearly a century ago gives us a picture of something that is so rare as to seem almost counterintuitive: data in the service of belonging. Moreno and Jennings did something simple but critical. They brought data back to the students and prisoners from whom it was gathered. The necessity of this act—of "closing the loop" between data and the people from whom the data comes—is a critical theme of this book.

=

I went out into the densely hippo-ed flood plains of Botswana to get an up close look at data's moment of genesis, to see how the chaotic human experience of grueling, dangerous fieldwork could be recorded alongside the dry, objective, instrumented data of science. I found out that data collection was inherently messy. In a muddy, leech-ridden, bloody-limbed way, but also in an imprecise, human way. As much as we might work to calibrate our instruments and perfect our methods, our measurements are almost never going to be exact.

I learned that even with the best intentions of objectivity, every record is made in its own particular climate of politics. I came back from that trip having learned that data is never perfect, never truly objective, never real. Data is, after all, not a heartbeat or a hippo sighting or a river's temperature. It is a measurement of a heartbeat. A document of a hippo sighting. A record of the river's temperature.

The students at Hunter College High learned a similar lesson, albeit in a different way. They learned that they could be measured from afar without even knowing it. They learned that judgments were being made about them based not on who they are but on what a set of algorithms and software routines believed them to be. They learned that these judgments were biased—by the computer code, yes, but also by the humans who framed their measurements and their cold analysis inside a hopeful theoretical framework, dreaming of journal articles and tenure. The students learned that they and the data that was meant to represent them were very far apart indeed.

They learned that the real world of data is one that flows in one direction: data comes from us, but it rarely returns to us. They learned that its systems are largely designed to be unidirectional: data is gathered from people; it's processed by an assembly line of algorithmic machinery and spit out to an audience of different

people—surveillants and investors and academics and data scientists. More and more this data is directed back to other computers, machine learning systems that will attempt to sort, classify, and make decisions based on the data without a human being involved. Data is collected not for high school students but for people who want to know how high school students feel. This new data reality is from us, but it isn't for us.

So how can we turn data around? How can we build new data systems that start as two-way streets and consider the individuals from whom the data comes as first-class citizens? To get there, to a new, more equitable life in data, some things are going to have to change.

This will all take as much unmaking as making, as much erasing as drawing, as much unthinking as thinking. In *Seeing Like a State*, James Scott described the twentieth century's urban planners as "tailors who are not only free to invent whatever suit of clothes they wish, but to trim the customer so that he fits the measure." The men of data have done much trimming in the last decades. Systems designed at first to track and measure people now manipulate, change, and with greater frequency harm them. To the great benefit of Facebook and ICE and Russia and Jack Dorsey, almost all of the ways we have to describe how we're being manipulated, changed, trimmed, and cut come from the suit makers themselves.

I write this book with a great sense of urgency, though not, I admit, with a surfeit of hope. Living in data today is, for the most part, terrible. To live in data is to be used, to be without agency, and to be overwhelmed with complexity. It is to be lost, bewildered, marginalized, harmed. It may be that we are learning, slowly, how to adjust to these conditions. We install ad blockers and delete Facebook. Survival techniques, ways to make it suck a little less.

These have been difficult years. As I'm writing this, thousands of migrants sit in detention camps along this country's southern border, their incarceration "optimized" by facial recognition and risk assessment algorithms. States are passing laws that would enable employers to discriminate against LGBTQ+ people, a process that will be greatly enabled by high-tech HR systems with "social media monitoring" built in as a feature. When I look at the training images for computer vision algorithms, I keep checking for the face of my three-year-old son. The four companies that hold much of our data are worth a combined two and a half trillion dollars; to imagine ways to resist these scales of power—financial, political, and computational—is daunting. And yet if the alternative is to keep living this way in data, for blustering despots and avaricious companies to hold us in data's sway, to continue to be indexed and classified and sorted at every turn, then we must find another way.

The Detroit activist and labor organizer Grace Lee Boggs left much for us to learn about hope in the face of great opposition. In *The Next American Revolution*, published in 2011, just four years before she died, Boggs wrote of how we might attempt to rewrite the conditions of inequity that we find ourselves in as a nation and as a world. "We are coming to an end of the epoch of *rights*," she told us. "We have entered the epoch of *responsibilities*, which requires new, more socially-minded human beings and new, more participatory and place-based concepts of citizenship and democracy."

This sentence captures much of what this book sets out to achieve. I do have a fundamental hope that data can work to serve exactly these purposes: to cultivate more socially minded humans, and to make us into more conscious, active, participatory citizens of both the old, dusty, wonderful real world and the new, malleable data one. The word "citizens" bears repeating. You and I, the students at Hunter College High School, the kids in those cages,

everyone on this planet, we live in data, but we have not, as of yet, figured out how to be citizens of it. To not only inhabit data, but also to participate in it, to find agency, to actively engage and meaningfully resist.

"If we want to see change in our lives," Boggs wrote, "we have to change things ourselves."

There is much work to do.

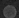
flag

nodes

label

citations

section

fires

List

links

encyclopedia

template

summary

every

file

across

planet

notes

yesterday

notability

later

nothinghalt

twice

upon

together

· recently

automatically

cent

soon

Articles

thus

recent

addition

maybe

ever

several

whose

although

wikipedia

forward

undoubtedly

nearly

almost

quickly

despite

sometimes

completely

usually

largely hope

typically

e.g.

contribs

effectively

Same

speedy

believe

frequently

## 2. I Data You, You Data Me
## (We All Data Together)

Open the window and let the words in. Let them flow into the room in a stream, all of the words, hundreds of thousands of them, let them fill the space, let them hang in the air, tiny sparkling motes of language. Let them drift, and organize. Let them be carried by eddies of usage and syntax until they find a place to rest. When they've settled, when they've coated every surface like ash, get up and walk the room, see each word and its neighbors, read the room like a map.

Over by the door you see a cluster of fruit words: "pear" and "apple" and "orange" and "kumquat." "Strawberry" and "yuzu" and "lychee" and "banana." Above your head, on the ceiling, are "hope" and "dream" and "imagination," "whimsy" and "fancy" and "caprice." Right under your chair you find all of the synonyms for "love." Proper nouns are here, too, in dense clusters. You find the presidents over near the window, and just beside them all the countries and states and provinces and cities.

Each word has found its particular place in the room by seeking out those with which it has the most affinity: the words with which it has been most often written. Near "business," you spot

"money," of course, and "bank" and "Warren Buffett" and "the Federal Reserve." Further out, there's "power" and "politics" and "economics," "number" and then "math" and then "Newton" and "Poincaré." Further still and you're reading words that are almost never written in the same sentence as "business": "Cretaceous" and "alabaster" and "millipede" and "orgasm."

Data's closest neighbors in this room are "statistics," "information," and "database." "Indicators," "analysis," "metrics," "graphs," "analytics," "measurement," "surveys." "Terabytes," "files," "metadata," "end points." It's in a clean neighborhood, with well-groomed streets and good schools. A suburb of science, just a short train ride from "truth," "fact," and "evidence." Data lives on this map of words comfortably apart from "human," and even further still from "art" or "dirt" or "laughter."

Sit now, and watch the words.

It will seem, if you wait for only a minute, that nothing is happening. Even if you sit for an hour, a week, a month, you might not notice anything. But if you were to find a more patient eye, to find a way to sit and watch for years and decades, you would see that there is much activity. Each time it is written, used in a sentence somewhere in a newspaper, in an essay or a novel or a textbook, a word shifts in space. Fast-forward over centuries and our room is alive. Words bustle and budge with each other within their syntactic clusters; they dart from one side of the room to another. Whole new groups of words appear. Systems of meaning collapse like sandpiles.

"Data" has always been a restless word. It first appeared in the English language on loan from Latin, where it meant "a thing given, a gift delivered or sent." It spent its early years in the shared custody of theology and mathematics. The clergyman Thomas Tuke wrote this in 1614 about the difference between mystery and sacrament: "Every Sacrament is a Mysterie, but every

Mysterie is not a Sacrament. Sacraments are not Nata, but Data, Not Naturall but by Divine appointment." Here "data" holds its Latin meaning as something given, but because its giver is the almighty God, it carries with it a particular strength of truth. In 1645, the Scottish polymath Thomas Urquhart wrote *The Trissotetras; or, A Most Exquisite Table for Resolving All Manner of Triangles*. In it, he defined "data" as "the parts of the triangle which are given to us." By 1704, data had found a hold in mathematics beyond geometry. Another clergyman, John Harris, defined "data" in his *Lexicon Technicum* as follows: "such things or quantities as are supposed to be given or known, in order to find out thereby other things or quantities which are unknown." Data as givens, things we already know, truths like gravity and pi and the Holy Ghost.

The linguistic neighbors of "data" remained, for a century or two, consistent. "Math," "numbers," "quantities," "evidence," "unknowns." Some new words arrived as mathematicians and philosophers worked to order their universe: "qualitative," "quantitative," "ordinal," "cardinal," "ratio." At the turn of the twentieth century, with Galton and Pearson and the birth of modern statistics, came a new way for data to be thought of, and a new way for it to live: as the contents of a table. Fifty years after that, data became bound to one of its stalwart allies, a word that would change the way in which data is commonly understood: "computer." Between 1970 and the end of the millennium, data changed quickly: from a thing of God and mathematics to a collection of bits and bytes. The word still adhered firmly to concepts of truth, but it was a different kind of veracity, one stamped into thin layers of silicon.

In the twentieth century, the tech industry and its marketing departments drove a lot of changes in our linguistic landscape. In 1964, Doug Engelbart put two orthogonal wheels in a wooden box. Two decades later "mouse" had crawled away from "rat" and

"shrew" and "hamster," toward "keyboard" and "joystick" and "terminal." In 1989, Tim Berners-Lee wrote a set of programs on his NeXT computer in Geneva, Switzerland, and set a whole cadre of words on the move: "browse," "web," "page," "surf," "highway." "Link," "refresh," "bookmark." Starting in the 1990s, Silicon Valley went about its own program of linguistic disruption, with "Google" and "timeline" and "tweet" and "snap" and "swipe."

In the last decade, the way in which we collectively define "data" is undergoing perhaps its most dramatic change. "Data," born of God and raised by computers, has found its way to the mess of human lives. It's there now with "social" and "genetic" and "sentiment," with "migrant" and "gender" and "identity." As "data" settles in with its new neighbors, it is changing the way we think of each of them.

=

The room of words we're in is imaginary, but the map of meaning that defines it is real. I made it by taking a corpus of text gathered from Google News and processing it with a program that calculates word vectors. What this program does is look at the position of every word in every sentence and keep a running tally of the relationships between them. Each word gets a position—a vector—in relation to each other word. This means that every word ever used in a Google News story gets a position in relation to every other word, "cat" or "zeitgeist" or "religion." For words that often appear close to "religion"—"God" or "church" or "pew"—this position will be close to zero. For words that almost never sit in the same sentence with "religion"—"squid" or "pappardelle"—this number will be close to one. The number of vectors in the map that I'm using is huge—remember that every word gets a position in relation to every other word. Think of any strange combination

of words you can—"rhizome" and "whiskey," "harness" and "Bob Dole," "zeitgeist" and "origami"—and there's probably a vector that's been calculated. The corpus from Google News contained roughly a hundred billion words, with a total vocabulary of three hundred million words. Out of this come nearly a billion vectors.

So far we've been content to use this map of words to investigate proximity: how close one word is to another, and how this changes over time. A word map this vast and multidimensional allows us to do some other things, though, that speak to us about the ways that language is interconnected, and also about how the data set was created and assembled. In particular, we can map the unique relation between a pair of words and a different pair of words. This is done using a neural network. The network is trained on the relations that exist between all of the words in the vocabulary (in this case three hundred million) and then can be asked to conjure new links. These "fill in the blanks" connections are fun to explore:

"Air" is to "bird" as "water" is to "fish."
"Joy" is to "child" as "thrill" is to "adult."

The example that was offered by the Google engineers who produced one popular word-vectorization software package called word2vec is this: What word is connected to "woman" in the same way that "king" is to "man"? The trained neural network dutifully offers up an answer: "queen."

In 2016, Tolga Bolukbasi, then a machine learning student, exposed troubling gender bias in word2vec's output. When queried, for example, as to what word is connected to "woman" in the same way that "doctor" is to "man," the system answers "nurse." When asked about "computer programmer" in the same context, word2vec offers up "homemaker." There are other word pairs

that show extreme female-male gender differences in word2vec: "sewing" and "carpentry," "hairdresser" and "barber," "interior designer" and "architect," "diva" and "superstar," "giggle" and "chuckle." Gendered relations are evident even indirectly; "receptionist" is closer to "softball" than it is to "football."

After reading Bolukbasi's paper, the artist and researcher Matthew Kenney investigated similar biases around race. "If we think about historically where algorithms have had the most dire impact," Kenney told me, "it's really around marginalized groups." Kenney started digging into "word embedding" models like word2vec, with a particular focus on how biases in the model might affect what he calls "downstream classification tasks." How might racial biases in these models trickle down to processes in which Black people are being considered for jobs? Or for home loans? Kenney found that word2vec, trained on a corpus of news articles, positioned the word "black" more closely to "criminal" than it did "white." Digging deeper, he tested a variety of given names against the word "criminal." The word2vec placed stereotypically Black names, such as Darnell and DeShawn, closer to "criminal" than it did Mike, Conner, Jake, or Brad.

Where does word2vec's racial and gender bias lie exactly? In the words of the news stories written by journalists? In the selection of a subset of those stories from particular publications by Google News? In the vectorization of language by word2vec, or in its neural-net learning of linguistic relationships? There's a layer cake of decisions here, and each one likely carries at least a part of the responsibility for binding "nurse" so closely to "woman," and "black" so closely to "criminal."

There's an instinct perhaps to forgive word2vec in this case: Isn't it after all simply mirroring biases that exist in the English language and in culture as a whole? To understand where the real danger lies, we need to consider why word2vec exists. It is not a

tool that is intended to be used only to create a map of language, a playground for the linguistically curious. It's a tool that is built to be able to make decisions—specifically classifications based on language. In a talk in 2018 in Minneapolis, Meredith Whittaker posited an example very close to what Kenney had been imagining: where a developer at a large corporation uses word2vec inside a piece of software she's written to process HR applications. The software goes on to be used company-wide, and thus word2vec's peculiar and problematic biases are now part of hiring practices, playing a role in who gets hired and who doesn't, or perhaps more important who is even offered an interview.

As it turns out, Whittaker's HR analogy was remarkably prescient. A software system developed internally for Amazon over the course of four years was scrapped in October 2018 when it was shown to be dramatically biased against women. The system rated résumés lower if they contained the word "women's" and if they listed all-female colleges and higher if they used words that have been shown to be more common in male résumés, such as "executed" and "captured." As if to demonstrate the absurdity of these systems' flaws, researchers studying another algorithmic HR system uncovered the two things that were most likely to flag a candidate for an interview: if their first name was Jared and if their résumé contained the word "lacrosse."

This issue with tools like word2vec seems a modern problem, but the roots of it are set into the soil of the seventeenth century, when "data" drifted into English from Latin. We are still stuck with the idea that data is given to us, if not from God, from somewhere similarly divine. In the case of word2vec, there seems to be some common belief that we can use it to investigate language itself, rather than a very particular model of language, gathered by particular humans working for a particular company, in a particular culture and time.

In the research paper that Bolukbasi and his colleagues published, they suggested there might be two methods for "debiasing" a model like word2vec. They called the first method "hard debiasing": a scorched-earth tactic where words that are known to contain bias would be removed from the model. They also proposed a second, very engineery solution to word2vec's problems: if they could mathematically measure the system's bias, they could then mathematically remove it. If we know that "nurse" is closer to "woman" than it is to "man," we can scale the relations in the vector space and, voilà, no more bias. It is perhaps conceivable that this approach, which the authors termed "soft debiasing," could work to remove gender bias, but it would rely on the (mostly male, mostly white) engineers knowing exactly what that bias looks like. Engineers would have to work closely with linguists and gender theorists to find not only the blunt examples of gender bias but the subtle ones. Once they were done with that, they would presumably move on to other forms of bias. Kenney's work shows us that racism would need a cleanup, and after that there would still be ageism, ableism, and countless other isms to be addressed.

For Bolukbasi, now a researcher at Google Brain, bias was a problem to be debugged. What he seems to have missed—what so many programmers seem to miss—is that the issue is not so much about bias as it is about power, about exclusion and authorship. Whittaker argues that any technical solution to debiasing data will hit a fundamental snag. "Data is reductive," she explains, underlying the fact that any tool like word2vec is necessarily a subset of the real, messy linguistic world. "So whose vision of what is significant and is not significant are we adhering to? Who gets to make the determination about what is or is not muted?" Developers are still looking at the data *and the bias in the data* as things plucked from reality, rather than things that are authored by the

developers, the code they write, and the social and political realities in which they were educated and in which they live. As the novelist and photographer Teju Cole reminds us, "Authorship, after all, is not only what is created but also what is selected."

=

Johanna Drucker, an author and cultural critic at UCLA, has taken perhaps the most drastic stance to date on the word "data": that it should be replaced wholesale. In a 2011 essay, she argues that the original root of "data," as a given, is anchored in a realist take on the universe: that there are real truths out there, given by God or physics, just waiting to be discovered. If I take a thermometer and measure the temperature in the room I'm sitting in right now, I might get a number: 22.3 degrees centigrade. If I take that number as a given, something that existed before my measurement, it's too easy for me to think of my 22.3 as a real, indisputable truth. The number 22.3 was in the room already; my thermometer simply captured it. Drucker and her humanist compatriots would see my 22.3 differently. The number, they'd argue, is actually an artifact of a system of real-world things: an instrument (a thermometer), an act (my measuring of the temperature at the particular time and place I chose), and a set of cultural constructs (the centigrade scale, Arabic numerals, the concept of temperature).

The very word "data," Drucker argues, is wrapped tightly in realist rhetoric and needs to be discarded. In exchange, she offers up a new word: "capta," from the Greek root "to take" rather than "to give." The key for Drucker is that "take" is active; if we understand that knowledge is something that is constructed, rather than picked up off a metaphysical curb, we accept the truth of our own role in its creation. "Capta," Drucker explains, "is not an expression of idiosyncrasy, emotion, or individual quirks, but a

systematic expression of information understood as constructed, as phenomena perceived according to principles of interpretation." We need only to look at an example of the creation of data to understand Drucker's argument.

This sentence that you are reading right now is not data. It doesn't take long, though, if we consider the sentence for even a few moments, for data to emerge. The number of words, the composition of the sentence's grammatical parts, verbs and nouns and prepositions. The number of vowels. The height of the sentence, in millimeters. Its length, in inches. The kerning between that first capital *T* and the *h* that follows. The amount of time it takes you to read it. How it makes you feel. It's a human instinct to measure, to describe, to make records.

When I see a bird fly past me, I file that experience into my brain, and I accompany it with a set of observations. The bird was small and brown, I might say. It was fast. Small, brown, fast—these are data that have been born from my brief flittering experience. Both the number of data and their character are constrained by who was doing the measuring (me) and what instrument was being used to measure (my forty-four-year-old eyes). Maans Booysen, a friend of mine and a legendary birder, would have come up with a set of different data from the same experience. He would surely have noted that the bird was a male barn swallow. Catching sight of a few stray white feathers on its undercarriage, he'd note that it was young, less than a year old. Having seen that the bird was carrying a small twig in its beak, Maans would have guessed that it was building a nest. Male, barn swallow, four months old, nesting. Maans has an almost supernatural ability to catch birds in flight with his camera (often held in one hand, a cigarette in the other), and if he'd had it with him, he likely would have snapped an image of the bird on the wing. From that image we could have

found out more: that it was seventy-eight millimeters beak to tail, that its beak was the perfect orange of a clementine peel, that its outside right toenail was slightly bent. Taking this analogy to its furthest flight, we might catch the bird, photograph each of its forty thousand feathers, analyze its DNA, assay the bacteria living in its gut.

We might, in other words, end up with a lot of data about the bird that briefly flew past us. Depending on who we were, and what instrument we were using, that information varies in detail and accuracy. It also varies in character. "The bird seemed to be happy," my son might say, an observation that could be placed right alongside the flight speed in meters per second, measured by comparing successive images from a tripod.

Data about anything—a sentence, a bird, the temperature of a room, the age of the universe, the sentiment of a tweet, the flow of a river—is an artifact of one fleeting moment of measurement and is, as Drucker's concept of capta gets at, as much a record of the human doing the measuring as it is of the thing that is being measured.

This idea that all data are constructed, that they are results of human action, is crucial, and I will return to it in the next chapters. For now, though, I'd like to consider a fate for the word "data" that is in many ways even more drastic than Drucker's revisioning.

=

So far we've focused on the meaning of "data," the ways in which the word is understood, and the linguistic neighborhoods it has, over time, come to occupy. We've seen that the definition of "data" has changed—from mathematical givens, to pieces of evidence, to assemblages of electronic bits and bytes. In all of these definitions,

"data" is a thing, a noun. What if, along with a change in meaning, "data" could undergo a shift in use? What if "data" was a verb?

I data you; you data me. They data us; we data them.

As your *Concise Oxford* sails toward me from across the room, let's take some time to consider the arguments.

Since it drifted into the English language, "data" has been a plural noun. Specifically, it is the plural of "datum"—one datum, two data. Data purists have long made it a personal cause to nitpick improper usage; indeed there may be some of you who have already been irritated by my fast-and-loose changeups, my tendency to say that data is as well as data are. I could argue that I am trying to be true to data's roots—in Latin, the word "data" is both a neuter plural and a feminine singular—but the truth is that I am mostly standing in line with modern usage. Over the last decade, "data" has turned into a particular kind of singular: it has become, commonly, a mass noun.

Mass nouns are words that are treated as a single thing, no matter how much of that thing there may be. Blood, homework, software, trash, love, happiness, advice, peace, confidence, flour, bread, and honey—all mass nouns, because they cannot be counted. I promise that you'll only read the phrase "big data" once in this chapter, and it's already over: this particular catchphrase was adopted exactly because we'd together passed a kind of Rubicon, where data could no longer be counted. It had become so vast that it could no longer be operated on by lowly humans, but instead had to be computed by always vaster and more elaborate systems of algorithms and semi-structured databases. As technology reacted to this dramatic shift in scale, so did language, and the word "data" found itself massified.

Because "data" has already endured such a drastic grammatical change, surely we can persuade the gods of common usage to shift the word's accepted part of speech entirely: Can we make

"data" into a verb? In case this still seems too outlandish, consider two synonymic neighbors of "data": "record" and "measure." Both of these words exist as nouns (*I made a record*), as verbs (*We measured the temperature of the room*), and indeed as verbal nouns (*They found a list of measurements and recordings*). In comparison, isn't it strange to keep "data" confined to the dull, inactive realm of the noun?

The verbal forms of "record" and "measurement" make communication about the act of making records and taking measurements much easier. Rather than saying, "I am going to be making a record of this conversation," I can simply say, "I am recording this conversation." If we verbified "data," rather than having to say that the National Security Agency (NSA) is collecting data on our every interaction, movement, and metabolic function, we could simply say, "They data us."

Data is not inert, yet its perceived passivity is one of its most dangerous properties. When we are warned that a government is collecting data about its citizens, we may be underwhelmed specifically because this act of collection seems to be so harmless, so indifferent. But of course data is not collected and then left alone: it is used as a substrate for decision-making and as an instrument for differentiation, discrimination, and damage. Drucker's "capta" means to address this by reminding us that data is taken, but the fact that the word remains a noun still gives it a character of inertness. Putting an active form of the word "data" into common parlance could serve as a reminder that the systems of data collection and use are humming with capacity for influence, action, and violence.

Making "data" a verb also exposes to us the power imbalances that have kept our collective endeavors drastically off-kilter. Grammatically speaking, "data" as verb would present a number of possibilities for subject/object combinations: I data you. You data

me. We data you. You data us. They data me. They data us. We data them.

Exposed to this rich possibility of cause and effect, the common usages of data today become strikingly narrow: in our lived data experiences, we are objects rather than subjects. Google reads our every email, placing us ingloriously in marketing buckets based on what we write to our friends, colleagues, and lovers. Uber's algorithms note our late-night voyages as records of romantic trysts. Images of our faces are captured by cameras on street corners, stored in databases to be cross-referenced by police departments and immigration enforcement officers. They data us; then they data us again.

Both my verbification of "data" and Drucker's wholesale replacement of it are probably bridges too far for common usage. I don't suspect we'll find any textbooks on data-ing science on bookshelves anytime soon, nor will we hear about captabases or capta warehouses. Capta and data-ing are both useful constructs, though, in reminding us of two important things. First, that data is not found; it is constructed. Neither God nor the universe gives us data; we make it ourselves. Data is a human artifact. Second, that data's construction acts in a real way on the world, that in making data we change the systems from whence it came.

Occasionally in the rest of this book we'll return to these linguistic hacks as shortcuts for remembering these two things: data's human provenance and its fundamentally active nature. I recommend that you try the same thing in your life: if you read a headline about data, try replacing it with "capta," or rewriting the text with "data" as a verb. Try using "capta" or "data" as a verb in conversation, however jarring it might seem. The environmental scientist Lauret Savoy has written that "names are one measure of how we choose to inhabit the world." So, too, are definitions.

I'll admit that we're probably stuck for now with "data" as a

noun. It is, however, a noun adrift. In the last ten years, "data" seems to be undergoing its most drastic change in meaning, one that I think offers a chance for the word to be broadly redefined. To understand this, let us shoo out the words that we had gathered in our room and welcome in another particular set: the words used in *The New York Times*. Specifically, let's gather 19,057,600 words in 10,325 stories written about data between 1984 and 2018. Whereas our last set of words contained the entirety of the English language, with all of its nuance, this new set is restricted both in its range and in its structure. We are less likely to find "pomegranate" or "cephalopod" or "Wurlitzer" in this new set, nor will we find any of the hundreds of words and abbreviations that are banned by the *Times*'s style guide. What this new map of words does give us, though, is a setting well suited to exploring how the usage and meaning of "data" have changed in very recent times.

Something we can ask with this *New York Times* set is which words are changing their position relative to "data"; which nouns and verbs and adjectives are becoming less associated or more associated with "data" in the language of the news. Here is where we find evidence that something is indeed afoot. The words that are moving away from "data" are the ones that it has lived closely with for much of the last century: "information," "digital," "software," "network." Among the words that are moving toward "data" are some that seem to summarize recent events: "scandal," "privacy," "politicians," "misinformation," "Facebook." There are also words that we might not previously have expected to find in the same sentence with "data": "lives," "deserve," "place," "ethics," "friends," "play."

"Data," it seems, is being pulled by strong currents. One eddy seems to be drawing it toward a dystopic future, an inevitable payback for a decade of unsavory practices. The other, seen through

a hopeful lens, might bring data to a more utopian place. One in which it is bound tightly to our lives, to the places where we work and play, to the friends with whom we share the experience of being. A future where "data" is in fact closer to "art" and "dirt" and "laughter." Also to "community" and "empowerment" and "equality."

Is it possible, then, that we might give it a push?

To do this, we need to unfold and examine the act of data. We need to understand how data is created, how it is computed upon, and how it is communicated. How it is made, changed, and told. We need to recognize that each of these steps cannot be looked at in isolation, that to know data we need to be able to look at the end-to-end process of it, to view data not as a noun, or a verb, or a thing but as a system and a process.

In doing so, we might begin to imagine a future perfect for data, where not only will they have data-ed us, but we will have data-ed them. A future, perhaps, where we might all data together.

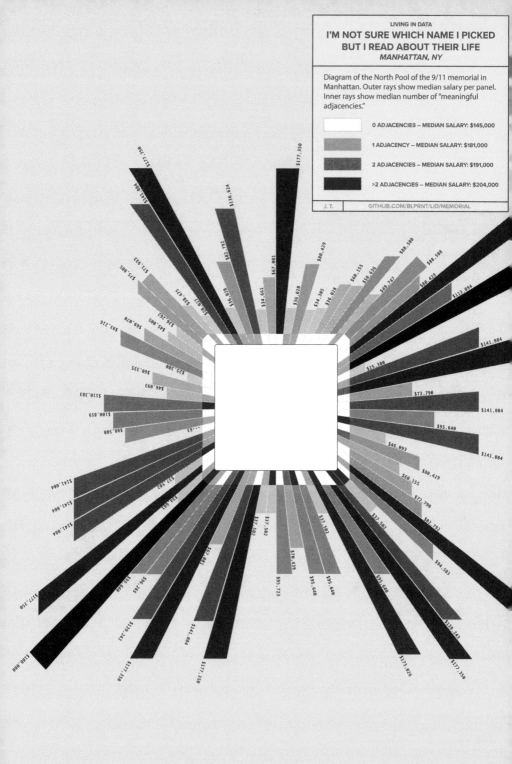

Diagram of the North Pool of the 9/11 memorial in
Manhattan. Outer rays show median salary per panel.
Inner rays show median number of "meaningful
adjacencies."

0 ADJACENCIES — MEDIAN SALARY: $145,000

1 ADJACENCY — MEDIAN SALARY: $181,000

2 ADJACENCIES — MEDIAN SALARY: $191,000

>2 ADJACENCIES — MEDIAN SALARY: $204,000

# 3. Data's Dark Matter

In the fall of 2009, I wrote a pair of algorithms to place nearly three thousand names on the 9/11 memorial in Manhattan. The crux of the problem was to design a layout for the names that allowed for what the memorial designers called "meaningful adjacencies." These were requests made by next of kin for their family members to appear on the memorial next to—or as close as possible to—other victims. Siblings, mothers and daughters, business partners, co-workers—these connections were meant to represent deep affinities in the real world. There were nearly fourteen hundred of these adjacencies that a layout of the names would ideally honor.

In December of that year, I flew to New York to meet with some of the project's stakeholders and to present the results of the algorithms that I'd developed. I came into the meeting disheveled and nervous. Disheveled because I'd flown into LaGuardia that morning, having spent much of the plane ride revising and re-revising my presentation. Nervous because I had found out the day before that another team had also been working on the layout

problem: a group of financial analysts (quants) who almost certainly all had at least one PhD.

It must've been a strange sight. A small army of besuited financial professionals across the table from a long-haired artist from Canada with an old, broken laptop. The quants went first. They'd run permutation after permutation on their server clusters, and they were confident they'd found the optimal solution for the adjacencies: a maximum of about 93 percent of them could be satisfied. They'd asked to speak first because they wanted to "save us all some time," because they knew, mathematically, that they had found the most highly optimized solution.

It was a persuasive argument. I let them finish; then I turned my screen around to show them a layout that I'd generated about a week before—one that was 99.99 percent solved. There was a long moment of silence, broken by the VP who'd led the team of mathematicians. "How the !$@% did you do that?"

How the !$@% did I do it? Certainly not with my mastery of high school math and obviously not with computational power. The quants' approach had been to reduce the memorial layout to a simplified model and to run millions of iterations, to cover as much as possible of the problem's "solution space." Mine was to consider as many of the problem's nuances as I could. The length and spacing of each individual name, the typeface, the quarter-inch expansion joints between parapets—the software I wrote considered all of these things. It might seem that all of these constraints would make it harder to find a solution, but they ended up giving my model some mathematical "give" where the quants' had rigidity. Their model was a Lego set made up only of four-by-two blue bricks; mine was a jumbled pile, with pieces that could fill gaps of irregular size.

The lesson that I (and the quants) had learned was one that has guided my approach to solving data problems for the last decade:

to treat the data and the system it lived in not as an abstraction but as a real thing with particular properties, and to work to understand these unique conditions as deeply as I can. I learned other things from the project, too, about paying careful attention to what is missing in data. There are other lessons that are just coming into focus now, more than ten years later.

A few months before that meeting in New York, I was sitting in the audience at a small conference in a rowing club in Vancouver. It was a rainy day, and although the talks were interesting, I was feeling a combination of lethargy and unsociability that had me watching my phone screen more than the stage. There wasn't much to look at—I didn't have a Twitter account yet, and there wasn't a Facebook app on my phone—so I bounce-scrolled my inbox idly, waiting for a new email to appear. Surprisingly, one did, a message from someone I'd never met with a bland enough subject line ("Potential project") that I might have flagged it as spam had I not been in such a distractable mood.

Two weeks and several phone conversations later, a hard drive was delivered to my basement apartment with a password-encrypted Microsoft Exchange database. It was not, in any real sense, big data. Two tables, one some three thousand rows long and the other just under half that. The first contained a list of every name that was to appear on the 9/11 memorial in Manhattan: 2,977 people killed one September morning and six who had died eight years earlier in a bombing below the towers. In the other table were the requests that their next of kin had made, the "meaningful adjacency requests." At random, I copied and pasted one of the names into Google. I'm not sure which name I picked, but I read about their life. About their work and their families and their softball team and the joke they'd always tell at the holiday party.

It was something I'd do hundreds of times over the coming months whenever I found myself thinking that what I was working

on was just a data problem. I did it most when I was working on the space-filling algorithm, the part of the code that would take linked clusters of names and try to find the best place for them on the real layout of the memorial. It was an interesting computational problem, mathematical, spatial, multidimensional. Those nights I'd go to sleep with a strange kind of Tetris playing out against my eyelids. In the day, with the frequency of a cigarette break, I'd google the names. Joyce Carpeneto. Benjamin Clark. The googling was a bulwark against the impersonal code, against the graphical abstractions that I'd use in the place of the names as I worked. William Macko. Nurul H. Miah. Eventually the names became entrenched in my mind, and by the time I was working on the layout tool that the architects would use, I felt close to so many of them, knew so many of their stories. Matthew Sellitto. Daniel and Joseph Shea. Mohammed Shajahan. Dianne T. Signer and her unborn child.

I've visited the memorial only twice. Once, a few weeks before it opened to the public, and then again in 2018 with my partner and my thirteen-year-old niece. The first time I walked along one edge of the south pool, tracing out the names with my fingers. There they all were again. Anthony Perez, Sandra Campbell, Kaaria Mbaya, Hashmukh Parmar, Yudhvir Jain. It was too much. I excused myself from our tour and leaned against the construction scaffolding, tears in my eyes. The second time I didn't get close enough to read the names. I stood under a tree and watched as Nora and Olivia walked around the pools.

The names on the memorial are cut into 152 heavy bronze parapets. There is a very intentional feeling of permanence to the whole structure, of completeness, of lack of malleability. After that second visit, though, I was left thinking not of what was there but of what was missing. Where were the names of the thousands of New Yorkers who have died, and are still dying, from lingering

illnesses caused by the toxic aftermath of the attacks? Cesar Borja, James Zadroga, Mark DeBiase, Barry Galfano, Karen Barnes. Where were the names of the countless thousands dead in the ensuing conflicts? Husham Sabah Eadan, Idham Al-Taif Mahmoud, Ali Adnan Faraj, Ahmed Adil Hilal Al Nasir. Patient in ambulance, daughter of policeman, daughter of elderly man, wife of dead man, brother of dead man, sons of dead couple. Unidentified adult male, unidentified adult female. Unidentified male baby. The data delivered to me on that hard drive had no rows for these people, no columns for their names or their ages or their times of death, no listings of their brothers and sisters.

Even in the meaningful adjacencies that my algorithm dutifully satisfied, there is much missing. Mohammad Salman Hamdani was a Pakistani American scientist and NYPD cadet who, like so many other first responders, rushed to the scene on September 11 determined to help. Like so many other first responders, he was killed. Hamdani's name is inscribed on a parapet on the south pool of the memorial, on the very last panel dedicated to the victims who were killed in World Trade Center South. The algorithm placed Hamdani there, in part because there were no meaningful adjacencies recorded, no other names indicated by the data set for his name to sit beside. Why was this man, a police officer in training, not placed alongside the other first responders? According to memorial officials, Hamdani was not included with other police officers because he wasn't on active duty, an explanation that sits at odds with the fact that he was given a police funeral with full honors by the NYPD. We can find a more likely answer in a headline from the *New York Post* on October 12, 2001: "Missing—or Hiding?—Mystery of NYPD Cadet from Pakistan."

Hamdani's stranded place on the memorial is a result of the algorithm that I wrote, of its dependence on the contents of those

two data files, on its fundamental inability to see anything out-side the database it was designed to read. The layout the algorithm produced, the pattern of names on the parapets, is a visualization of a social network. Of a social network made from a very spe-cific data set, collected in a very specific way. The positions of the names on the memorial are prioritized by social connection, a strategy that was meant to produce a layout that reflected the real lives of the victims. The collection of this data defined the way the memorial took form, and the biases in collection are part of its permanence. Asking next of kin for social connections prior-itized those who were already socially elevated. Find a CEO or a vice president in the memorial's online guide, and you'll almost certainly find requested adjacencies, as many as ten. Look up a security guard, or a cook, or a janitor, and you'll more than likely find them alone.

Put into its most harmless verbiage, data is collected. The word "collect" appears seventeen times in Facebook's data policy: *We collect the content, communications, and other information you provide. We collect information about the people, pages, accounts, hashtags, and groups you are connected to. We collect, we also collect, we collect, we also collect, we collect, we collect, we use information collected. We require that each of our partners has the lawful right to collect. We collect.* You might imagine a group of lederhosened foragers in an alpine meadow, plucking data gently from a bush. The tenderness of the word might be part of why we hardly consider collection when discussing potential harms of data. And yet the decision to collect some set of data—or not to collect another—is the biggest one to make, and how data is collected and stored deeply affects the ways in which it might later be used to make choices, to tell stories, or to act on individuals and groups. Most important, each decision made at the moment

of collection is amplified as data are computed upon, inflated by algorithms, and distilled by visualization.

"Collect" is an asymmetric word. The experience of the collector is very different from that of the collected from; the benefits and risks are piled unevenly on one side. Much of the unease in our data lives comes from this lopsidedness, from being on the low end of collection's fulcrum. Some balance can be found by blocking the collectors, through shielding and camouflage and obfuscation. By installing ad blockers, turning off our phones, encrypting our email, quitting Facebook. With these tactics we lessen the burden of being collection's objects, but to reset the scales, we also need to learn how to be its subjects, to collect data for our own benefit and for the benefit of others.

The artist and data researcher Mimi Onuoha neatly distilled the importance of focusing on collection to the understanding of a data system as a whole in a 2017 talk at Eyeo Festival in Minneapolis. "If you haven't considered the collection process," she stated bluntly, "you haven't considered the data." Onuoha, whose practice focuses on absence and neglect, tells us that the very decision of what to collect or what not to collect is political. "For every data set where there's an impetus for someone not to collect," she writes, "there's a group of people who would benefit from its presence."

Since 2015, Onuoha has been assembling a collection of data sets that aren't. People excluded from public housing because of criminal records, undocumented immigrants currently incarcerated, trans people killed or injured in hate crimes, sales and prices in the art world, how much Spotify pays each of its artists per play of song, publicly available gun trace data. These are all data sets that for some reason don't exist or are not acknowledged to exist by those who hold them. The list, called *The Library of*

*Missing Datasets*, exists as a text file in a GitHub repository and has also been shown in galleries as a filing cabinet filled with neatly labeled (empty) manila folders.

Onuoha has developed a taxonomy of absence for her missing data. "There are four reasons I started seeing for why things weren't being collected," she told me. "The first," she explains, "is that there's a mismatch between incentive and resources." As an example, she points to data on civilians killed by police, where law enforcement lacks any kind of incentive to collect the data and where civilians are often blocked by the sheer amount of work it takes to scrape this data together from disparate sources. "The group that has the data has no incentive to make it available, and the group that wants the data doesn't have the resources to collect it." This is true also of environmental data: people living near polluted waterways or beside remediated waste sites are incentivized to collect data, but the high costs of sensors and data analysis make it prohibitive to do so.

The second reason for data absence, Onuoha explains, is that the burden of collection can be higher than the benefits that come from having it. She points to the #MeToo movement and reports of harassment and assault. "There's a burden of reporting for the individual, which is particularly hard because you're reporting something that you know is true," she says. "But, it has to be believed." The risk is too much for many people, and the data goes unreported, uncollected. Putting these kinds of reporting burdens on people can be an effective way to ensure a set of data doesn't coalesce—a criticism directed to the Trump administration's efforts to put a citizenship question in the 2020 census. If a person has some suspicion that answering a survey might put them in danger, this could be a risk too high to answer the census, and large swaths of the country could go uncounted, which trickles

down to federal funding amounts and the calculus around representation.

"The third reason," Onuoha says, "is that some data resist metrification." She points back to when the project started, in 2015, as a kind of heyday for datafication thinking—a time when the common narrative was that anything could be turned into data. "But there are some things that just can't," she says, "sometimes for reasons that are political, and sometimes for reasons that are cultural." As an example, *The Library of Missing Datasets* includes the amount of U.S. currency outside the nation's borders, a nearly impossible figure to count, because so much money is constantly flowing through so many (often untraceable) channels.

Onuoha's fourth reason for why data aren't collected is the simplest and also the most complex: data can be missing because someone didn't want it to be collected. "With any data set," she explains, "there's some entity that wanted it to exist, always, always. And so anytime there's something that doesn't exist, there's some entity that did not want it to exist." Onuoha's categorization rings with Lauret Savoy's words: "Neglect may reflect many things: commitment but lack of means; amnesia or apathy; perhaps forces more complex and sinister."

Thumbing through the label tabs of Onuoha's empty folders, we can indeed find some missing data sets that could conceivably be absent because they are simply too big to be measured (the number of global web users) or because their edges are too porous to reliably hold information (sales and prices in the art world). Most of Onuoha's missing data sets, though, are countable; they are lists and numbers that don't exist for political reasons. Muslim mosques and communities surveilled by the FBI or CIA. Statistics on how often police arrest women for making false rape reports. "More complex and sinister." This is the central lesson of the

project: that while the collection of data is an act of power, so is the decision not to collect it. More pointedly, data neglect can be a kind of violence, one that is inflicted most often on already marginalized groups: in particular women, Black people, LGBTQ+ people, migrants, and the disabled.

Onuoha's concept of the missing data set is complicated by the fact that absence doesn't always manifest itself at the granularity of a data set or data sets, but rather within data sets. Lists that are assumed to be comprehensive, and used as such, are often missing things that in turn bias the actions of the people who set out to use them. This is true of census data, which is the result of a country trying to enumerate each of its citizens. This data is crucial in allocating resources, yet minority groups all around the world have been dangerously undercounted. New Zealand's 2014 census undercounted the Māori population by more than 6 percent, a rate three times higher than the undercount of the country's European population. In the United States, about 7 percent of young African American children were overlooked by the 2010 census, roughly two times the rate for white kids. A conservative estimate is that 4.9 percent of indigenous people in the United States weren't counted in 2010. These figures get worse in areas of poverty, where a kind of perfect storm of missing data happens: the numbers are difficult to count, there's no incentive for people to be counted, and government is content to avert its enumerating gaze. In Toronto, a study by researchers at York University and St. Michael's Hospital estimated that the 2011 census undercounted the city's indigenous residents by as much as three-quarters; their study puts the indigenous population at 45,000–73,000, as opposed to the census's count of 23,065. When people are missing data, they become the remainders of data's equations, destined to be cast aside when choices are made and policies are set.

=

*The Library of Missing Datasets* was born at a time when a lot of the United States' attention was turned toward police killings of Black people. "I was really interested," Onuoha told me, "in the fact that there was actually just no data about the number of people who were killed by police every year." This absence seemed to sit in stark contrast to the worlds where her research was living. "There was a narrative where everything is data, everything should be data, and that we can collect it all," she said. "And I thought it was really interesting that at the same time this other narrative is emerging, there were these blank spots, these things I couldn't find anything about."

As it turned out, this particular blind spot, around police violence, had captivated a series of people over the previous half decade. In March 2009, David Packman, a systems engineer from Seattle, started the National Police Misconduct Statistics and Reporting Project (NPMSRP). Using local newspaper and television reports collected largely by hand, Packman's project gathered statistical information about police misconduct across the country. Before Packman's endeavor, this information was a missing data set, or at the very least one that was woefully incomplete.

In a 2011 article in *The Guardian*, Packman underscored the fact that his project had been produced out of necessity: that data on police misconduct was effectively unavailable. At the time, forty-five states placed restrictions on the release of information about police misconduct. Twenty-two states outright prohibited the release of any disciplinary information at all. This meant that even a well-meaning federal agency had no way of getting the information through "official channels." Packman's ad hoc method of news scraping was, as he described it, "the only feasible way to gather police misconduct data on a national scale." What Packman

didn't mention in *The Guardian* was that the site had also been born from personal experience. In November 2006, Packman had been badly beaten outside a Seattle nightclub, after what video would later show had been a case of mistaken identity. Finding him badly injured on the pavement, the police didn't call for medical assistance; instead, they handcuffed him and roughly threw him into their van. At the station, he was strip-searched, interrogated, and jailed for twenty-nine days without any significant medical treatment. Packman was later diagnosed with a traumatic brain injury and continues to this day to suffer from PTSD.

The NPMSRP produced a cascade of evidence about police forces across the country. In 2010, the project collected data about almost 5,000 reports of police misconduct, involving 6,613 certified law enforcement officers. A staggering 23.8 percent of the reports showed that officers used excessive force, and 137 of them resulted in deaths. In a particularly damning analysis, the NPMSRP demonstrated that, on average, levels of violence among on-duty police officers tracked with that of the regular population, while assault and murder rates were pronouncedly higher (5 percent and 13 percent, respectively). Packman had hoped to turn his attention to geographic analysis, identifying where police misconduct and violence were particularly rife, but work he was doing on the NPMSRP was an unpaid side gig. In 2012, he passed the project to the Cato Institute, which continued the data collection efforts for five years at PoliceMisconduct.net. In the summer of 2018 the project was suspended. "We simply lacked the resources to continue our policy work and maintain such a database at a level we find appropriate," the Cato Institute wrote in a press release.

Meanwhile, several other citizen-led efforts arose to collect data about police violence. Two new websites, Killed by Police and Fatal Encounters, used similar tactics to Packman's, ag-

gregating news stories and building databases, this time focusing specifically on police killings. Started in December 2013 as a Facebook page, Killed by Police tracked seventy-one deaths in its first thirty-one days of operation, from *The Des Moines Register*, *The Selma Times-Journal*, and *The Miami Herald*; from NBC Los Angeles, Fox Oklahoma City, CBS Boston, and dozens of other media outlets. Anthony Bruno, Robert Craig Perry, Robert Cameron Redus, Eric M. Anderson, John Harding, Mah-hi-vist "Red Bird" Goodblanket, Ricky Junior Toney, Dontae Hayes. Whereas the NPMSRP focused on aggregating statistics, Killed by Police brought the names of the victims forward, and as a result the page feels like both a data set and a memorial. Killed by Police's maintainer, who prefers to remain anonymous, seems to approach the project as more testimony than a political statement. The site sets out to list every police killing, "whether in the line of duty or not, and regardless of reason or method." Killed by Police's minimal design and complete lack of analysis underscore its stark purpose, as put forth by its maker: each post "merely documents the occurrence of a death."

Fatal Encounters, run by the journalist D. Brian Burghart, takes a decidedly more data-centric approach. The site uses paid researchers to aggregate and verify information from other sources (such as Killed by Police), checking each account and filling in additional information. Burghart and his team have also filed more than two thousand Freedom of Information Act (FOIA) requests to federal, state, and local law enforcement agencies. The result of these efforts is an extremely comprehensive data set, going back to 2000, listing the details of (at the point of this writing) 26,206 police killings. Burghart began his data collection project after learning firsthand how hard it is to find information about violent incidents involving police. "I was on my way home from work when I noticed a bunch of cop cars down

by the Truckee River," Burghart writes on his website. "It turned out the police had pulled over a stolen car, and they'd shot and killed the driver." When Burghart read news stories the next day, he noticed "a gaping hole" in the coverage: none of the articles mentioned how common these kinds of police-involved killings were. This absence nagged at Burghart. When, a few months later, a naked and unarmed college student was killed by police at the University of South Alabama, the press once again skirted around the context of the killing. Digging and researching, Burghart came to realize that the journalists writing these stories about police killings weren't ignoring the broader context: that context just didn't exist. There was no central place, anywhere, to find aggregated data. And so Fatal Encounters was born with the goal to answer a simple question: How often does this happen?

In 2015, Sam Sinyangwe, a policy analyst and activist from Orlando, realized that while data from Fatal Encounters and Killed by Police was crucial (together they listed more than twice as much information as the federal government recorded), it was very hard for the average person to make sense of it. Missing data made it hard, too, to answer a very specific question that he was interested in: How many Black people were being killed by police? So, together with Brittany Packnett and DeRay McKesson, Sinyangwe launched Mapping Police Violence (MPV). "We merged the databases," Sinyangwe explained. "We filled in the gaps by cross-referencing with obituaries and social media profiles, with criminal records databases, with information gotten directly from police departments, and with information found online." Crucially, Mapping Police Violence infilled data about the race of victims, records that were far from complete in previous databases. "We were basically like spies," Sinyangwe said. "We had to search online for people who had a picture of themselves online,

a picture of their family. We had to search criminal records databases, obituaries, anything that we could find to actually identify the race of the person who had been killed by police." Visit the site today and you'll see a map of every Black person killed by police in the current year. In 2019, that number was 1,164.

As Sinyangwe explains, the goal of Mapping Police Violence was to, "in two seconds or less, convince the person seeing it that police violence was indeed systemic." Leaning on his training in data science, Sinyangwe published a series of graphics that addressed some of the common misconceptions about police killings and race. Conservative critics, police representatives, and Republican politicians often pointed to "Black on Black crime" to explain why more Black people were being killed by police than white people. The argument was that there were more police in Black neighborhoods because there was more crime, and that because there were more police, there happened to be more police violence. Sinyangwe's analysis neatly disposed of this argument, showing that there was no correlation between the per capita violent crime rate and police killings in America's fifty largest cities.

Digging deeper still, Sinyangwe and his collaborators noticed that there were outlier cities, places in which police killings of Black people happened at much lower rates than they did elsewhere. "We looked at five years of data," he explained, "going all the way back to 2013. And we investigated, what were the incidents that happened? Where did they occur? What was going on that explains them?"

These questions led the Mapping Police Violence team to a key class of then missing data sets, those around police policy. "Every police department in America," Sinyangwe said, "has a policy that governs how and when police officers are authorized to use force. And what we found when we actually got access to these policies

of the hundred largest departments was that these policies are very different, depending on the police department." Campaign Zero, a project started by the Mapping Police Violence team and Johnetta Elzie, breaks police department policies into eight categories and assigns a score to each department they've been able to find data for. Does a city's policing policy require officers to de-escalate situations, where possible, before using force? Does it restrict choke holds and strangleholds? Does it require officers to intervene to stop another officer from using excessive force? Cross-referencing scores from all eight categories with MPV, Sinyangwe was able to show that there was a 72 percent difference between the rates of police killing in the cities that enacted all eight policies and the cities that enacted none.

Along with department policies and police union contracts, Campaign Zero has also collected and aggregated information about department budgets. Together, the data offers rare transparency into how law enforcement operates. This city-by-city data provides solid footing to support arguments for radically restructuring or defunding police forces: that under 4 percent of officers' time is spent responding to violent crime; that police violence increases crime in communities; that only a tiny percentage of complaints of police misconduct are ruled in favor of civilians; that taxpayer dollars are used over and over again to defend officers with long histories of violent misconduct. Eleven years after David Packman began collecting news reports, Sinyangwe and his collaborators seem tantalizingly near closing a decade-long loop between the birth of citizen-led efforts to collect evidence on police violence and an actionable, data-backed path toward policy change.

=

The decision to collect or not to collect data is an arbiter of which stories get told and which are pushed out to the margins. Which names are printed in newspapers, which ones are filed in police reports, which ones are inscribed on memorials, which ones are left out. In the absence of data, we can find a muting of particular channels of truth, truths that have too often already been estranged from the popular narrative. In Onuoha's *The Library of Missing Datasets* and in the long lineage of citizens collecting data on police violence, we find twin strategies for dealing with data's dark matter. First, to be able to see what is absent; to train ourselves to ask what is being collected but also what is not. Second, to recognize these areas of data neglect as places where we can find power.

There's a too-neat story here, though: that for the problem of missing data remedy arrives through collection. But even when it is done with the best of intentions, collection is not so innocent.

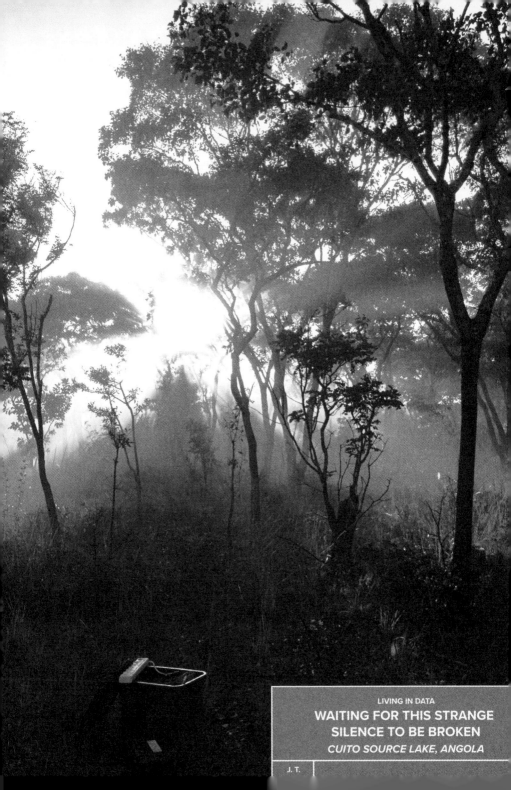

LIVING IN DATA

## WAITING FOR THIS STRANGE
## SILENCE TO BE BROKEN
### *CUITO SOURCE LAKE, ANGOLA*

J. T.

# 4. By Canoe and Caravan

"Back in your vehicles! Everyone back in your vehicles!"

I'd spent two weeks with Tim Gargan, the HALO Trust's director of anti-mining in this region of Angola, and until now he'd not once raised his voice or moved faster than a measured walk. He bore himself with all of the calm that you'd expect from someone who'd spent much of his career disarming explosives. Now he'd broken into something close to a run, waving his arms in an attempt to make sure that everyone in the convoy heard what he was saying.

"We've just gotten word that this is an active minefield. Everyone needs to get back in their vehicles. Now."

He took a few hurried steps toward the next vehicle, and then, in a quite remarkable display of Englishness, remembered his manners: "Please and thank you."

I was about ten meters from the truck I'd been riding in, having clambered over some tangled roots and loamy hummocks to find a semiprivate place to pee. I was glad now to see that my footsteps were still visible, pressed into the damp moss, and I stepped carefully from one to another as I made my way back to

the vehicle. Then it was the driver's turn to try to retrace; putting the truck in reverse, he slowly followed our tracks back from where we'd come. About half an hour before, the lead vehicle in the convoy had lost the narrow track we'd been following, and the smaller, lighter vehicles had spread out to refind the route. According to the map that had been prepared by an advance scouting team two months earlier, the area we were driving through was safe; we'd passed through two minefields earlier in the day, but this section of miombo woodland was meant to be clear. It was only when a man traveling in the other direction on a motorcycle had come upon Tim's vehicle that he'd found out we were in danger.

"Minas," the man said calmly, gesturing around. "Tem minas em todo o lado." *Mines. There are mines everywhere.*

The unbroken forests of the Angolan highlands have a particular fairy-tale quality to them. They are tremendously verdant, and in the valleys where our convoy traveled, they were often settled with a low mist. Moss and lichen covered the forest floor, and the undergrowth was knit together tightly in a way that made the tree lines feel impenetrable. This density of vegetation was partly due to the land mines and the thirty years of civil war that had planted them here. It was also due to a near-complete absence of wildlife. While the forests were here and there punctuated with birdsong, there were no large mammals to be found: no forest antelope or civets or vervet monkeys or any of the other animals you might expect to find in a West African forest. Most of these animals had been killed, hunted, and eaten as the local economies had collapsed in the face of war. Later, by deploying an extensive system of camera traps, the team would learn that some of these animals were here; they'd just become extraordinarily good at hiding. There were even elephants in these forests,

but they'd learned to become ghosts, traveling only at night, using their tremendous sense of smell to stay as far away from humans (and land mines) as they could.

A few minutes later the vehicles were back in the straight line of the convoy. Tim walked from vehicle to vehicle, explaining the situation. "I'm sorry," he said to us, in his northerner's brogue. "The intelligence we had about this region doesn't match what we've heard from the locals. So we're going to try to be a bit more careful from here on in."

In this case, being careful meant driving into the minefield. The lead truck, armored with fourteen inches of steel on its undercarriage, would lead the way. "The good thing," Tim explained to me later, "is that a road like that is unlikely to be set with anti-personnel mines, or if it was, they've probably gone off long ago." The bad thing was that there could be anti-vehicle mines, which were an order of magnitude more destructive, designed to disable tanks.

And so we rumbled and jostled slowly into the forest, waiting for that strange silence to be broken.

=

In the coming weeks, I'd ask myself a question over and over: Why were we here? I asked this on the next day, when our boat nearly capsized ten minutes into the expedition proper. I asked it the day after, when the river disappeared, when we strapped on portage harnesses to drag our boats across dry grass. I asked it when I stepped on a nest of biting ants, tenacious little beasts that pierced your skin with their pincers. I asked it five minutes later, lying naked in a cold stream, cursing. I asked it aloud on day seven, when we'd been pulling boats over land for six days, when

my legs were torn apart from the sharp reeds, when we all collapsed under a darkening sky onto our piles of gear.

At the time I had ready answers. We were collecting data for scientists—from Britain, America, and South Africa, observations of birds, specimens of reptiles and insects and fish and plants. The botanists on the expedition were particularly excited, because there hadn't been any "proper records" collected from where we were headed in more than a hundred years. This, more than anything, was the legitimating myth of the trip—that we were filling in a data black hole, left by a century of conflict and explosive devices.

A *Guardian* article about our 2015 expedition wrote of the "unexplored Cutio [*sic*] River," of "a landscape unseen by science," of a place that "remains wholly obscure." This wasn't exactly true. Even on the days when we felt the most distant from humanity, there'd be the smell of a cook fire wafting in from a village in the distance. This idea of an Africa that is unexplored, obscure, empty has long been a convenient one. "The production of an empty landscape," Nancy Jacobs writes, "had an imperial and economic motive." Defining a place as empty means it can be filled, with new "discoveries" and new species, new taxonomies and old ways of thinking.

As my scramble back to the vehicle in the forest underscores, the success of the expedition rested heavily on local knowledge—on the wisdom of those who live in this "unseen place." As Jacobs tells us in *Birders of Africa*, Western scientists and naturalists and explorers have for decades leaned on the experience and the labor of indigenous peoples. "Histories of scientific research in colonial Africa," Jacobs writes, "are often histories of labor relations." In Angola we were living and rewriting those histories. As the minefield in the forest demonstrates, our safe arrival at the Cuito source had depended heavily on local knowledge, and on local labor. Again and again through the expedition, the team would depend

on the people living beside the river, employed as polers and porters, and as guides and navigators.

We were living what Lauret Savoy calls the paradox of exploration. "To become oriented," she writes, "to find their way and fill their maps, venturers from Europe needed Native people's knowledge of the land." And yet this knowledge, so important for explorers' discovery and survival, is written over and erased by the lasting narratives of expedition. "Maps and names would then obscure that knowledge from its context, as Indigenous people themselves were removed from the land."

=

In November 1923, Colonel J. C. B. Statham read aloud to the Royal Geographical Society a kind of travelogue. In it, he described a voyage he'd taken the previous year from Mossamedes, on the coast of Angola, to Victoria Falls in Zambia (then known as Northern Rhodesia). His expedition would take him within a hundred kilometers of the Cuito source lake.

"Expedition" is a word that rings with romance, and colonialism. The word itself settled into Middle English via the French, where it was a military term. Early on, it was used in English to mean "setting out with aggressive intent." A cursory scan of texts from the eighteenth century offers some character: Historians write of Alexander the Great's Indian expedition, of King Ferdinand's "very powerful expedition to destroy the city of Algiers," of Whitelocke's expedition to seize Buenos Aires from the Spanish Empire. Documents from the colonies describe expeditions against the Penobscot, the "Indians of Rhode Island," and many other indigenous peoples. In a letter to George Washington dated April 24, 1779, General Goose Van Schaick reports on his "expedition against the Onondaga":

We entered their first settlement in the most secret manner and quite undiscovered by them; they soon received the Alarm throughout the whole, & fled to the Woods, but without being able to carry off any thing with them, we took Thirty three Indians, & one white Man Prisoner & killed twelve Indians; the whole of their settlements Consisting of about fifty houses, with a large quantity of Corn & Beans were burnt: a number of fine Horses & every other kind of Stock we found were killed.

In the nineteenth century, polar explorers captured the imaginations of much of the Western world. John Franklin's doomed voyage in 1845 was very definitely an expedition, and indeed its purposes were firmly political: to discover a shortcut through the icy northern seas from Europe to Asia. The next half a century saw a retinue of bearded Europeans heading for the poles, culminating with Peary's successful North Pole expedition in 1909 and Amundsen's South Pole trek in 1911. With these voyages came a change in the way the word "expedition" was generally understood. No longer confined to a military context, the word "expedition" bound itself to a different sort of heroism, one in which people seemed to have no purpose other than the thrill of discovery and the testing of human limits. This is not to say that the political part of exploration had been discarded. Expedition was still almost always a tool of colonialism: explorers set out to make maps and collect data, and those maps and data would be used in plans to expand territory, to conquer nations, and to overwrite local populations and their ways of knowing.

Statham published this account and others in a book called *With My Wife Across Africa by Canoe and Caravan*. To read about his travels today is to alternate between a brief moment's appre-

ciation for his meticulous attention to detail and long stretches spent aghast at his outright racism. To be sure, he was a natural data collector, and his records stretch from an indexing of flora and fauna to descriptions of soil conditions and geological features. Many of these observations were the "proper" ones we'd been talking about when we said there'd been no records in a hundred years, the science we'd come to update and replace and add to.

Statham's descriptions of the people he and his wife encounter are detestable: the indigenous peoples are by turns lazy and treacherous; his descriptions of them are absurd and wildly bigoted. Statham employed forty "porters" to carry all of the equipment he'd brought with him (we can only assume there was at least one tea set, a modest timepiece, and a travel piano), and much ink is given to complaints about their lack of obedience. At a certain point a group of people he'd employed seem clearly to have reached the limits of their patience with Statham and his whimsical demands: they quit en masse.

"Near a village called Yomba we had a mutiny among the carriers," Statham writes. "Paid and fed well, they had no reason for this refusal except the ingrained sloth and cussedness of their race." Clearly well armed, the colonel, his wife, and two other members of their crew then force-marched the twenty Yomba until they could find others to take their place. "After being watched and guarded for a day or two, they not only became reconciled, but joyfully helped us to find other carriers who could replace them."

The legitimating myth for Statham and his Royal Society peers was that the travels they were endeavoring on were, first and foremost, in the service of science. Admittedly, from a narrow perspective of ecological history there are many helpful things to be gleaned from his writing. Near the confluence of the Longa and Cuando Rivers, he lists out the kinds of animals they found: "Of the game of the country there were still giraffe, zebra, eland,

wildebeest, tsebbe, lechwe, reed-buck, duiker and steinbok." The phrase "there were still" stands out in this passage; already hunting pressures in the region had eliminated some endemic species. "A few black rhino were to be found," Statham writes, "but of the white variety none had been seen for many years, and it was doubtful if any survived."

Statham himself was a big-game hunter, and lists like the one above were less about a concern for conservation than they were a menu for people who might later like to come to Angola to shoot things. In introducing his talk at the Royal Geographical Society, the then president, Lawrence Dundas (the Earl of Ronaldshay), pointed out Statham's particular interests: "I am not quite sure what the object of Colonel Statham's journeys has generally been, but I rather suspect that a not unimportant object is the hunting of wild game." Even so, Dundas goes on to suggest that Statham's observations might "have much to tell us about an important problem which confronts those interested in the country over which he travelled, namely the gradual drying up of the series of rivers which run north and south in that part of Africa." This concern was likewise not bound as tightly as it might seem to an ethos of conservation: Britain's Bechuanaland Protectorate (which would later become Botswana) was the ultimate destination of the river system in question, and the colony's productivity depended almost entirely on that water.

When we think about colonialism, it's easy to jump right to the end goal of economic exploitation. To think of open-pit mines, of clear-cut forests, of ships packed with goods, sailing back to the motherland. We don't often bind "data" to "colonialism," yet any of the endeavors listed above must necessarily have been born from data. Before a mine can be dug, a map must be made; pits must be dug and samples drawn. "Data," James Scott wrote, "are

the points of departure for reality as state officials apprehend and shape it."

=

The way through the miombo continued to be slow going. The route had been scouted a few months before by smaller vehicles, and although it had been deemed passable, the way that had been mapped didn't take into account the bulk of the eight-wheel ten-ton truck that now led our convoy. Frequently we'd stop and wait as the crew cut low-hanging limbs off the trees that seemed impatient to reclaim the paths. Even though Tim was convinced that the land-mine risk was near zero as we moved even farther away from settled areas, I stayed in the truck.

Just before five o'clock, as the afternoon sun was starting to lose its violent heat, we cleared the tree line, emerging onto an expanse of grassland that was still smoldering from a recent wildfire, much of it rendered to a charcoal black. We followed a motorcycle path around a bend. The ground was rough and rocky, and the Land Cruisers bumped and jostled downhill. Many of us got out to walk through the tall grass, shouting to each other back and forth along the convoy. There was a ridge of forest blocking the view down to the valley, and although we were less than a kilometer away, we couldn't see what we'd come for. So close to our goal, there were many questions, each of which would affect the way we could go about our work: Would there be water there, now, in the dry season? If there were, would it be turbid or clear? Would there be crocodiles?

It wasn't until we'd come over a last ridge, past the line of trees, that we saw the gleaming source lake of the Cuito River. That evening we settled into a camp beside the lake. I drank the cool water,

which tasted of weak tea, ate a meal of rice and beans, pulled my road-rumbled body into my tent, and went to sleep.

In the morning, I knocked a thin sheet of ice off the nylon of my tent, put on my sandals, and made my way to the fire. It was barely five degrees Celsius, but it would be thirty by noon. If my weeks in Angola taught me anything, it was the value of layering. After breakfast, I set up the satellite gear, and the science teams got to work, wading into the lake with nets and buckets. By 10:00 a.m. they'd collected their first fish, and by 11:00 they'd entered the details into a custom-built form I'd made. By noon, the data had been uploaded to the web; it was free to view and to download for anyone in the world with internet access.

Much of the narrative of data has leaned on the idea of discovery. After all, as marketing seminars and TED talks have told us again and again, we collect data to climb a hierarchy of knowing, up to information, then to knowledge, and finally to the sharp peak of wisdom. In our ascent, we are filling in the blanks, shading in areas that are unknown (or at least unknown to us). Using a more critical eye, though, we start to see that the goal of the climb isn't so much to find wisdom as to stake a claim—a claim to customers and insights and ad dollars, but also to territories, to names, to ways of knowing. As Kate Crawford underscores in an essay, today's complex AI systems require "a vast planetary network, fueled by the extraction of non-renewable materials, labor, and data."

We are told that the seemingly light and transitive computational processes of data systems happen in "the cloud." Crawford shows us that they in fact are anchored in real places, are reliant on real people. Lithium crystals forming on the salt flats of Bolivia, labyrinthine assembly lines running 24/7 in Chinese factories, Congolese mines staffed by children as young as seven, cargo ships emitting ton after ton of $CO_2$, Amazon workers struggling

to survive in workplaces that have become surveilled to a point of absurdity. There is, as Crawford writes, "a complex structure of supply chains within supply chains, a zooming fractal of tens of thousands of suppliers, millions of kilometers of shipped materials and hundreds of thousands of workers included within the process even before the product is assembled on the line."

When the scientists dipped their nets into the Cuito, when I sent their data up to our servers, we were part of our own fractal system. A system that touched not only the place around us and the people who lived there but also countless other places and people, unseen and away from our minds.

Two years before Angola, my friend Brian House and I duct-taped together a data collection system for the South African ornithologist Steve Boyes. Steve was about to cross the Okavango Delta in Botswana for the third time, as part of an ongoing biodiversity survey. Because our software development cycle was to be measured in weeks, we worked quickly to get something in place that would allow for data collection in the field, transmission via a limited satellite connection, and visualization on the web. The first version of Into the Okavango was shaky—data was sent and parsed through email attachments—but it worked. As night settled in the delta in August 2013, I'd wait with anticipation for the data to load, after which I'd see the expedition's trail on a map, decorated with every wildlife sighting they'd made and the occasional terse comment. Thirty-nine African pygmy geese. One Nile crocodile. Seventy-five red lechwe. "Rough going today. Tired."

Over the next five years, we built better and better versions of the platform. By 2018, Into the Okavango had tracked eleven expeditions with forty-three members and had collected more than seven million data points, which it offered up to scientists,

students, and the generally curious through an open API. It was an experiment in radical open science: we wouldn't give away our data after our paper was published; it wouldn't be embargoed or hoarded by an institution eager to preserve its investments. We'd give it away as it was created, and we'd bind it to the story of the work in the field. Lists of bird species could be downloaded alongside all of our tweets. Camera trap photos and Instagram photos of our campsites were equal citizens in our data structures.

All of this work had stemmed from a conversation over beers on a June evening in Washington, D.C. Earlier, I'd watched Steve talk about his work at the *National Geographic* headquarters, where we'd both been named Explorers. Steve's talk was full of stunning photographs of the Okavango, of herds of elephants wading through water, of sunsets behind baobab trees, of jewel-like kingfishers and delicate mantids. I was smitten right away by Steve, by his mission, by the place. I asked him after the talk how he was managing the project's data, and he'd laughed, describing soggy notebooks and broken pencils and laborious transcriptions into Excel spreadsheets. I immediately began scheming.

That night at the bar I asked Steve a question, one that I wasn't sure he'd have an answer for: "Who do you think owns the data you collect out there?"

Steve had already by that point been asked a lot of questions, by reporters and filmmakers and grant funders and politicians. He had a trick where he'd nod as if he were about to give you an answer, and then he'd take a long sip of beer, a long enough sip to find a good response. With foam still in his mustache, he answered. "Mother Okavango," he said, never one to stay away from the spiritual. "The delta. The delta owns the data. We're there to ask her to give it to us."

And so we built Steve his software system. Two years later, I went along on the fourth transect of the Okavango Delta, dodging

hippos, recording heartbeats, and sleeping among elephants. And then, in 2015, I was in that convoy of trucks, rumbling through the forests at "the end of the earth," setting out to persuade another piece of the Okavango to share its data. The whole project was grounded in the best of intentions: by going out in the field and collecting data, we were reaching a better understanding of the watershed; with this understanding we could more convincingly argue for long-term protections. After the longest days spent pulling boats through the tall grass, collapsed on the bank of the river, tired, bloody, spent, I leaned heavily on a belief that our work was good and right.

After breakfast, I sat down with Tim from the HALO Trust. I made a makeshift tripod for my microphone out of some dry wood, and we sat on camp chairs in the tall grass. Steam rose around us as the sun pushed above the tree line. Tim told me how he'd returned from two tours in Afghanistan with a desire to make some kind of a real difference in the world, to find a role that was less ambiguous than the one he'd had in the British army. He found what he was looking for with his work in HALO, where he was quite literally undoing a war, one deactivated mine at a time.

Tim inventoried the types of ordnance he and his team spent their days handling. "There are really small antipersonnel mines, set so that a person or even a dog could set it off." He explained that these small explosives were designed not to kill but to maim, to cause a burden on the enemy's logistics chain. "They're also there to spread fear among the guys who are working in the area," Tim said. "To damage morale." Then there are larger antipersonnel mines, which Tim and his team call anti-group mines. These explosives, Tim explained to me, "are the type that jump out of the ground and spread fragments over a large distance." And then there

are antitank mines, "the size of a decent-sized cooking plate, designed to immobilize armored vehicles." These are the types of mines that HALO had been particularly concerned about on our drive to the source lake.

HALO's work in Angola was, of course, focused on making the landscape safe for its inhabitants. But it was also a kind of archaeology, an excavating of one of the most violent conflicts of the twentieth century. Steve Boyes had described the Angolan landscape as a "layer cake of land mines," a description that Tim agreed was apt. The mines are left over from a conflict that went on for more than four decades. The struggle for independence from the Portuguese starting in the 1960s kicked off a civil war that didn't come to an end until 2002. The civil war became a proxy conflict for world powers in the 1970s and 1980s, with the Soviet Union and the United States supporting opposing Angolan factions. While neither of those countries put troops on the ground, they supported Cuban and South African forces. This convoluted history meant that Tim's team recovered ordnance made by the Soviets, the Americans, the Cubans, the South Africans, the French, the Israelis, and the Chinese.

"The Cubans laid some really complex, difficult minefields, probably the most complex or getting up to the most complex minefields that we deal with anywhere in the world," Tim told me. "There's devices that are all linked to each other by pieces of cord so that when one goes off, it sets the rest of them off. You know, designed to kill as many people as possible, and they're attached to all kinds of high-level ordnance like aircraft bombs, which ordinarily would be dropped from a great height and destroy huge areas. They've been planted in the ground with something small on top of them to kick them off."

Tim told me the story of delicately exposing a web of explo-

sives on an old airfield. The mines, each linked to another, were designed to detonate at once, destroying any aircraft that tried to land on the runway. Usually, ordnance is destroyed through detonation. But in this case the sheer number of mines made that too dangerous. "They could scatter over a huge area," Tim said, "dropping metal fragments everywhere." He and his team had no choice but to disarm each mine one at a time. "We have to take them apart bit by bit," Tim explained. "Which is quite scary." A sip of tea. "I suppose."

The airstrip that Tim's team had de-mined sits a few miles from the confluence of the Cuito and Cuanavale Rivers. This territory was the site of some of the fiercest fighting in Angola's long civil war, and it is the most heavily mined terrain on the planet. Tim told me that there were still millions of mines in the ground around the rivers, which had been fiercely contested as transportation routes during the war. "Our current estimate," he said, "is that on the current levels of capacity that we've got, we've got about twenty years of work left in this country."

Listening to Tim talk about disentangling ordnance, I couldn't help but wonder what kinds of legacies our data work in Angola might leave for the people of this region to untangle and remove. To compare our counting of birds and catching of fish to laying land mines seemed a stretch. I couldn't imagine how what we were doing might end up going wrong to the extent that it would affect anyone's lives. But this is exactly the point. The story of the work we were doing, like any data collection endeavor, held its own "complex and contradictory truths."

I was the conservationist, working to protect a crucially important ecosystem. I was the open science advocate, freeing data from its usual academic shackles. But I was also the Stanford engineer writing a facial recognition system, unable to imagine living

a life where the color of his skin might put him at risk. I was the hack-a-thoner modeling a bold intervention to poverty, having never understood what it's like to live on the streets.

Potential harms seem impossible when you don't inhabit the futures in which they might happen.

=

I've come to realize over my decade of work with data that there are crucial questions to be asked every time data is collected: Who is the data we're collecting benefiting? How might the data we're collecting put people, animals, and ecosystems at risk? Do the benefits of data collection outweigh the potential harms?

These questions hadn't come from nowhere. In 2014, safari camps across Africa had begun to post signs asking their guests to disable the GPS functions on their phones. Poaching had, like many conflicts, become a kind of technological race, with poachers and rangers now using sophisticated tracking devices and portable satellite phones. If a beautiful photo of a white rhino is posted to an Instagram feed, a message might be radioed to the field, telling a team of poachers exactly where to find the animal. Even if the image doesn't contain a location tag, it might be easy enough to recognize a particular tree or the crest of a hill in the background.

Outside conservation, humanitarian organizations around the world have embraced data collection with the same zeal (and myopia) as web advertisers. In a scathing critique of this trend, Sean Martin McDonald, the founder of Digital Public, writes about the Ebola outbreak in West Africa that began in 2013, calling it "the first pandemic of the Information Age." McDonald describes a chaotic situation in which, thanks to a kind of perfect storm of rumor, misinformation, and mistrust toward institutions, the

outbreak spread far too quickly: in eighteen months Ebola had infected almost thirty thousand people and killed more than a third of those. "That chaos," McDonald writes, "fed a growing narrative that the problem in the response effort was a lack of good information technology and, more specifically, data." Taking advantage of the dire situation, humanitarian groups (mostly from Western countries) began advocating for the release of normally private data that, they argued, would help to control the epidemic. In August 2014, the *MIT Technology Review* published an article advocating for the release of call detail records (CDR) data from the countries involved in the epidemic. This data, the authors argued, could be used to predict the spread of the Ebola virus, using a technique called contact tracing, where infected people's phone contacts are used to model whom they might have infected, and in turn where those people might have traveled.

There were two big problems with this idea, which seemed to get lost in the enthusiasm for a data-based solution. The first was that CDR data is almost impossible to anonymize and contains deeply personal information about people and their lives. Should this data somehow pass through humanitarian hands and into the grasp of authoritarian regimes, it would provide a nearly complete surveillance report for citizens. To determine from these records a person's religious affiliation, the address of their home, and a list of their friends would be trivial. The second problem was that the idea of modeling Ebola from CDR data probably wouldn't work. "Ebola is not a vector-borne disease," explains McDonald, "meaning that the same probabilities aren't a useful indicator of transmission." Ultimately, McDonald is most critical of the idea that humanitarians can be so comfortable deploying unproven techniques, carrying real and known risks, under the twin guises of emergency and innovation. There is not nearly enough focus on the long-term effects that "data humanitarianism" might have on

the populations that are meant to be helped. "Unlike many other forms of experimentation that happen during emergency responses," McDonald says, "data lasts forever."

The Wild Bird Trust, which led our expedition into Angola, has done much to disentangle itself from the problematics of techno-colonialism, moving leadership of the project to Angolans and doing real work with local communities to understand their needs and wishes. Still, there is an unavoidable truth: to go out and collect data in a place where you don't live, or from people who aren't your own, is to brush closely up to authoritarianism and colonialism. This is as true if I'm working ten thousand miles away as it is in my own city. It's only by acknowledging this directly that I can begin to work against it. "Complicity," writes Julietta Singh, "becomes not something to be resisted or disavowed but something to be affirmed in order to assume responsibility."

My own sense of responsibility has led me to boil my earlier questions down to a pair of principles that I try to apply to everything I do that involves data collection. The first is "no datafication without representation"; that is, no endeavor to collect data should happen without listening carefully to those whom you're collecting from. This could mean the people who live in a particular community, members of marginalized groups who might be put at particular risk by your data collection, or indigenous peoples who have traditional claims to a specific geographic area. It might also mean people who share a lived experience with the people in a data set, where that experience isn't your own. The easiest way to ensure this is to find collaborators who don't look like you, to build teams that are broadly representative. Are you a non-trans person working on a data project about trans issues? Make sure there's a trans person on your team, in a decision-making role. The work will be better, because it'll be checked against lived experience. The work will also be

safer, because your team will be more likely to spot and to mitigate potential harms.

The second is more drastic: "When in doubt, don't collect." If you can't be sure that your data collection won't be putting people at risk of harm, don't do it. The Data → Information → Knowledge → Wisdom (DIKW) pyramid teaches us to collect first, ask questions later. But what if the wisdom we arrive at is that we should never have collected data in the first place?

In 2010, the human rights investigator Nathaniel Raymond got a call, out of the blue, from George Clooney. Clooney had, it seems, read a memo that Raymond had written five years earlier about how tech might help to solve the digital invisibility gap: the phenomenon where, because of their access to mobile phones, predominantly white communities in disaster areas were more connected and thus more visible to humanitarian responders. Clooney was interested in Raymond's ideas, specifically that satellite imagery might be used, in combination with machine learning, to identify communities that were on the wrong side of the digital visibility equation. "Can you build that for me?" Clooney asked.

Raymond and a group of collaborators built it. The Satellite Sentinel Project bought satellite time and imaged areas where mass atrocities had happened or were suspected to have happened. In 2011, a year into the project, Raymond's team found images of recent grave sites in the state of South Sudan. Later they documented the razing of Maker Abior, Todach, and Tajalei, villages in a region where the Sudanese military had been targeting ethnic minorities. By most measures, the Satellite Sentinel Project was a grand success; Reuters called its work in Sudan "the most accurately predicted invasion, in history, by a civilian society organization." But Raymond grew increasingly concerned that they didn't have a real idea of how their work was affecting the people on the ground, the people whose houses and farms they'd been

poring over in satellite imagery. "How do we know if we're help-ing if we showed this? How may we be mutating the battle space in ways that could harm the very people we're trying to help?"

Early in 2012, Raymond and his colleagues issued a "human security alert" for the Nuba Mountains region of South Kordofan in Sudan. The satellite images in the report have neatly labeled boxes, white text on orange backgrounds. Some of them, dated in early January, point to objects inside military compounds. *Three vehicles consistent with T-54/55 tanks. Occupied artillery positions. Vehicles consistent with heavy transport. Three helicopters consistent with Mi-24 gunships.* A sequence of three images taken in November, December, and January seem to show roads being built. *Construction vehicles appear to be at work.* In a zoomed-in view, three whitish shapes seem to paint strips of black onto the sand. *Three vehicles consistent with excavators.*

The evidence of construction and military preparation in the report reflected with worrying accuracy the government of Sudan's activities in March of the previous year near Abyei, two hundred kilometers southeast of where the new images were taken. Two months later, in May, the Sudanese Armed Forces launched a bombardment and an invasion that killed dozens and displaced more than a hundred thousand indigenous Ngok Dinka people. For the Sentinel team, the things they found in the images pointed clearly to impending military action. "It was," Raymond said, "a pretty clear tell."

The road construction raised particular alarm. "In Sudan," Raymond told me, "the ground is very clay composed. And in the rainy season, it becomes mud." In the satellite images, the crews on the ground seemed to be building elevated roads, a couple of feet off the ground. "It's very hard to run a main battle tank on the mud," he explained. "So, we became very concerned where we saw efforts to build elevated road."

The Sentinel report went out on Wednesday, January 25. Four days later, the Sudanese government announced that twenty-nine Chinese road workers—very likely the ones shown in the satellite images—had been kidnapped by the Sudanese People's Liberation Army–North (SPLA-N). "They took everyone hostage," Raymond said, "including defendants of the road crew workers, who were women and children." There were casualties.

The timing—just seventy-two hours between the Sentinel report and the kidnappings—was damning. Raymond and his team had taken measures to de-identify the image such that locations wouldn't be identifiable. They didn't release latitude/longitude data, and they cropped the images to remove any terrain or landmarks they felt might be recognized. "But we realized at the corner of the image," Raymond said, "there was a crossroads that we had not clipped out." A crossroads that was the only one for two hundred square kilometers.

It seems possible—probable, even—that the road crew had been kidnapped as a direct result of the images in Sentinel's report. The group rushed to prepare a statement, asking for the SPLA-N to release the hostages. Behind the scenes Raymond got word that that there was going to be an effort by the Chinese, potentially with assistance from the United States, to rescue them.

For Raymond, this was a turning point. "The humanitarian principles are humanity, impartiality, neutrality, and independence," he told me. "And we realized that because we couldn't evaluate the way we were affecting the intelligence matrix for the parties to the conflict, that we had basically lost our neutrality and impartiality." The Satellite Sentinel Project, with all of its goodwill and best intentions, affected the conduct of war, placed its remote finger on a lever that caused suffering and death.

"So, what we decided to do is a radical thing," Raymond says. "We stopped." To explain this decision, he cites the Latin phrase

noli me tangere, which Jesus speaks to Mary Magdalene when she recognizes him after his resurrection. Translated directly as "touch me not," the expression is used in surgical training when speaking of organs that are particularly delicate, most commonly the heart. Raymond believes we need to bake this cautious medical thinking into our data endeavors: "When you don't know if you can do no harm, you should let go. Do not touch." To make this approach workable, he and his team have identified five human rights that all people have in crisis situations: rights to information, to protection, to privacy and security, to data agency, and to rectification and address. Any work that breaches these rights, however well-intentioned, shouldn't happen.

What I've learned since my travels in Angola is that all of us who live in data need to be better at imagining futures. Not only techno-utopian ones in which our work serves the greater good, but less hopeful paths in which our actions put people and environments in the face of harm. We need to understand that the act of collection does, in a real way, *touch* those who live in data. It touches them—us—in ways that can be immediately threatening, but also in small, repetitive, persistent, quotidian ways that accrue harm over time.

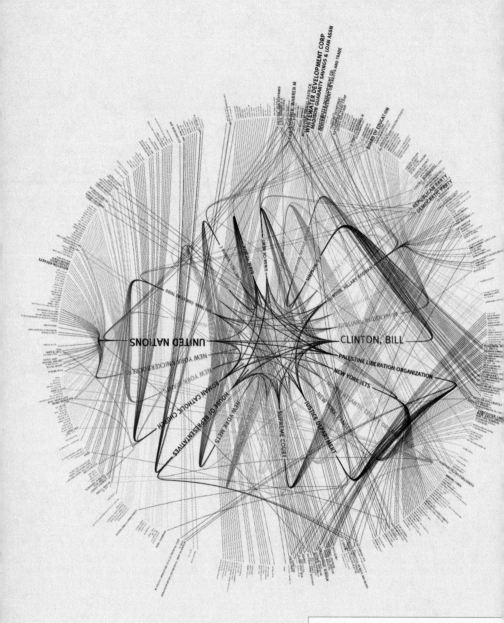

**WHITEWATER DEVELOPMENT CORP**
**MADISON GUARANTY SAVINGS & LOAN ASSN**

UNITED NATIONS

CLINTON, BILL

PALESTINE LIBERATION ORGANIZATION

NEW YORK JETS

ROMAN CATHOLIC CHURCH

HOUSE OF REPRESENTATIVES

SUPREME COURT

JUSTICE DEPARTMENT

## 5. Drunk on Zima

When I was thirty-five, I collected every targeted web ad that popped into my browser for a month. It was a lot of ads: more than three thousand in total. I hadn't done this on a whim. I was working with my team at the Office for Creative Research to build a tool called Floodwatch, a browser extension that allowed anyone to collect and view all of the web ads that were being targeted toward them. The project was born from a conversation I fell into one morning, on a train from Oxford to London, with Ashkan Soltani. Ashkan was, at the time, a privacy researcher and journalist with a byline at *The Washington Post*. In the next few years, he'd go on to win a Pulitzer and serve as chief technologist at the Federal Trade Commission. In between stories of computational intrigue and white-hat hacking and TSA harassment, Ashkan shared with me a particular lament. In his work investigating the vagaries of online advertising, it was extraordinarily challenging to gather data, because individual users spend their online days in their own personalized version of the web.

To get around this, Ashkan would set up little farms of headless browsers—virtual web users without screens or keyboards

or brains. He'd set these zombie users loose, wandering from website to website, following specific patterns that would fool ad trackers into thinking they were a particular kind of user, from a specific place, and belonging to a certain demographic. Using this approach, Soltani could see how the web looked from the perspective of a young Black man in Georgia, or a senior citizen in Greece, or a middle-aged white couple living on the Upper West Side with a keen interest in luxury goods.

There were two problems with these beheaded armies. First, as diligently as Ashkan might try to model a real user's behavior, the virtual users were just that: models. They contained few of the unpredictable whims that define your web-browsing behavior or mine. Rarely would they check travel prices to North Dakota on a whim, or tangent off to learn about flying squirrels. Second, there was a limit to how many headless browsers could be set into action. To get a real sense of the machineries behind web advertising, and the ways in which it discriminated, Ashkan and other researchers like him needed more data.

At first, Floodwatch was simple. It collected ads and then showed them back to you in a scrolling wall, a cascade of gaudy commercialism. In the background, it'd make your anonymized ad data available to trusted researchers, along with however much demographic information you were willing to share. When I started using the tool, I was surprised by the sheer number of ads that I was seeing, typically more than a hundred per day. Scrolling through weeks and then months of them, I could see patterns of my life reflected: every time I was in an airport, for example, I'd be barraged with hotel and rental car ads. There were also families of ads that seemed to make little sense; for weeks I'd see dozens of ads a day for legal training. In the background were the stalwart advertising categories of my internet life as a middle-aged male: watches, flashlights, key chains.

Inspired by a project called Cookie Jar by the digital artist Julia Irwin, I paid ten strangers ten dollars each to tell me, in writing, what kind of a person I was, based only on what they could deduce from my thousands of browser ads. I'm a twenty-six-year-old from Montreal, a twenty-seven-year-old in Vegas, and a retiree with a penchant for photography. Mostly I'm unemployed. I'm a gamer, a fashionista, an occasional beer drinker, and a dog owner. I graduated from a community college, I like to travel, and I wear glasses. Also, I might be Jewish.

My ad-based biographers got a few things right. I do indeed wear glasses, I enjoy perhaps slightly more than the occasional beer, I travel a lot, and I have a dog. The rest, though? These things are detritus from my digital life, signals that advertisers, in their zeal to garner a click, took too seriously. My browser is perhaps more zigzagged than most because I tend to wiggle into strange rabbit holes quite often as I'm researching for artwork or articles. Still, this is a common theme when people are confronted with their web personas, according to advertisers: signals from side roads of browsing activity seem to be taken as seriously as the thoroughfares. A bigger shared response from people who used Floodwatch to get a look at their browser history doppelgängers is that, by and large, they are deeply erroneous. And yet a lot of money is spent on assembling your profile, building a picture of you that can be used to make the purchase of ad space in your web windows a little less of a gamble.

That the government, Facebook, and the Ford Motor Company know things about you seems a given. But the fact is that many of the things they "know" are statistical kludges, pieced together from some combination of data, chance, and guesswork. The pervasive branding message of web-era capitalism is that these tactics are effective; that by collecting great quantities of data and processing it with sophisticated machine learning algorithms, these

surveillant interests can get some precise idea of not only where we are and what we're buying but who we are. That advertisers in particular have an ability to get at our true selves with their computational machinery.

In the last twenty-five years, a ramshackle computational system has been duct-taped together, one that operates in the very briefest slice of time between when you load a web page and when that page is fully rendered in the browser. All of this vast machinery was developed for a simple purpose: to put an ad into your web browser that you are likely to click. In recent years this massive system of trackers and servers and databases designed for placing ads has been turned in other directions—to insurance, to health care, to HR and hiring, to military intelligence. To understand living in data's ubiquitous condition of being collected from, it's important to know how ad targeting was meant to work, how it works differently against different people, and how, at the root of it, it doesn't really work at all.

=

For a few years in the 1980s, I ran a dial-up bulletin board system called the Hawk's Nest. Bulletin board systems (BBSs) were a community-based precursor to the internet; while DARPA and other scientific and military interests were creating the technical backbone for what would one day support the web, BBS system operators (sysops) and users were figuring out how social spaces could exist on phone lines. My own BBS had only two lines, which meant that at most two users could be online at the same time, but a social group of a few hundred hung out on the Nest, leaving messages for one another on boards and sharing software of dubious legality in the file areas.

One of the defining experiences of the BBS era was waiting.

If the dial-in line was busy, you'd have to wait to log in. If you wanted to talk to a friend, you'd have to wait for them to show up. If you wanted to download even the smallest of files, you'd have to wait, the whole time praying that no one else in the house would pick up the phone. Today's web browsers cache an image in your computer's memory, storing the bits and bytes until the image is complete, only then drawing it to the screen. My BBS client would render the image as it loaded; I'd watch as the (black-and-white) picture was painfully assembled one line of pixels at a time.

When I got to college in 1993, I landed a job at the library teaching new students how to use the internet. Actually, the job was first to teach students what the internet was (almost none of them had an email address before coming to the school), and then teaching them how to use it. The first public web browser, Mosaic, had been released earlier in the year, and it was with genuine en-thusiasm that I'd show the students how to load an image from a server across the world. I'd enter in the URL, and then we'd all wait ten seconds for the image to appear—a sixty-four-by-sixty-four-pixel picture of the *Mona Lisa*. It wasn't unusual for there to be applause.

Two years later I moved into newly built university housing and experienced for the first time the joy of broadband. The build-ing was wired up for ADSL, and downloads ran at four megabits per second, a speed that is still pretty respectable today. I'd just built my own web page, and I remember refreshing it again and again, marveling at how fast my carefully photoshopped buttons loaded against the tiled putting-green-grass background. It seemed clear to me that it was a matter of time before pretty much all of the web would appear instantly into a browser.

Indeed, the web as it first existed was fast. *The New York Times* launched its first website in January 1996, and the page was forty-nine kilobytes in total; from my room at the University of British

Columbia I could load it in a tenth of a second, less than half of a blink of an eye. And then, around the turn of the century, the web slowed down. Today a media site's page typically takes around one and a half seconds (four blinks) to load. Part of the reason for this, of course, is that the content has gotten bigger—high-res images, preloaded videos, web fonts, JavaScript libraries. But the main reason for today's delay in serving up nytimes.com or weather.com is due to placement of advertising. Before a web page fully loads, a complicated network of ad sellers and buyers, data brokers, and real-time exchanges activate to "place" web ads into your browser. Ads sold directly to you, or to the person advertisers believe you are.

Here is what happens in the space of a second and a half:

When you arrive at a web page, a request is initiated for one or several advertisements to be placed in a particular spot on the page. In the lingo of online marketing, delivery of an ad is called an impression. An impression request is assembled, which includes information about the page you've arrived on (that it's a news story, that it's in the culture section, that it mentions cheese) and also whatever the publisher of the page already knows about you. This personal information almost certainly includes your IP address (the electronic signature of your device) and data about you that is stored in any number of cookies. Cookies are local files stored on your computer that hold information about your online behavior. Most important, they store unique identifiers for you, such that the next time that cookie is loaded, the owners of the page can know with confidence that it was you who came back. Indeed the first cookie ever deployed, by the Netscape website in 1994, was used only to check to see if the user had already visited the site. Today's cookies are elaborate chocolate-chip-with-shredded-coconut-and-flax-seeds-and-dried-cranberry-affairs; the cookie stored by *The New York Times* contains 177 pieces of

data about you, with strange labels like *fixed_external_8248186 _bucket_map*, *bfp_sn_rf_2a9d14d67e59728e1b5b2c86cb4ac6c4*, and *pickleAdsCampaigns*, each storing an equally cryptic value (*160999873%3A161010639, 1543942676435, [{"c":"4261","e":151872 2674680,"v":1}]*). Advertising partners can also deliver and collect their own cookies; loading nytimes.com today without an ad blocker sees eleven different cookies written or read from your machine, including ones from Facebook, Google, Snapchat, and DoubleClick.

Once a request for an impression is put together from available user data, it's sent off to the publisher's ad server. There, a program checks to see if the request matches any of its presold inventory: whether, for example, a cheese maker had already bought advertisements for stories that mention cheese, or if a real estate developer had bought placements for anyone who comes from a particular zip code (easily gleaned from your IP address). If there's not an ad ready to be placed, the impression request is sent off to one of several ad exchanges. These exchanges are bustling automated marketplaces in which thousands of ad impressions are sold every second.

Prospective ad buyers communicate with other servers to build on the data that they already have about the user. A data broker might think they know a lot about your identity from your IP address—that you live in Chicago, that you have a gym membership, that you drive a Honda, that you have a chronic bowel condition, that you belong to a gay dating site, that you vote Democrat. This data (right or wrong) is sold to the prospective ad buyer all with the intention that they might make a better decision on whether to buy your ad impression.

So far, sixty-five milliseconds (a fifth of a blink) have elapsed. The impression request has been assembled and sent, brokers have been consulted, and a particular data picture of you has been

brought into focus. Now the ad exchange holds a real-time auction to bid on the chance to show you an advertisement. As many as a dozen potential ad sellers might be vying for space in your browser, and depending on who you are and what you're reading, the price for an ad might range from a tenth of a cent to more than a dollar. The auction takes another fifty milliseconds. The highest bidder is granted the chance to place an ad on your page, and the image is delivered, loaded, and rendered. The page is loaded, Cheese of the Month Club waits eagerly for a click, and you, the user, are blissfully unaware of all that has happened.

In the space of a second, we see much of capitalism in miniature. Market research and sales teams and purchase and delivery shrunk down to milliseconds. Google's and Yahoo's ad exchanges use a procedure for auction that traces its roots to nineteenth-century stamp collectors: the second-price sealed-bid auction, also known as the Vickrey auction. In this type of sale, bidders submit bids without knowing what others in the auction are proposing to pay. The party that bids the highest wins, but they win for the second-highest price. Mathematical models have shown that this structure for an auction encourages "truthful bidding"; that is, the parties involved tend to bid around what they believe the actual value is. The shortcomings of the Vickrey auction—namely, the chance that two bidders could collude, lowering their bids collaboratively while ensuring that one party wins—are mitigated by the extraordinarily short auction time. There's not much space for collusion in one two-hundredths of a second.

=

The first banner ads appeared on the top of *Wired* magazine's affiliate *HotWired*'s home page on October 27, 1994. That evening, the publishers held a rave, got drunk on Zima, and celebrated

breaking the internet. "People told us if you put ads online, the internet would throw up on us," said *Wired*'s co-founder Louis Rossetto. "I thought the opposition was ridiculous. There is hardly an area of human activity that isn't commercial. Why should the internet be the exception? So we said, 'Fuck it,' and just went ahead and did it."

One of the first twelve ads was for AT&T. It featured a block of text filled with a confetti of random colors that read, "Have you ever clicked your mouse right HERE?" Beside the text was an arrow pointing to the words "YOU WILL." The combination of bad design and arrogance seems in hindsight very fitting. AT&T had paid ten thousand dollars to place that ad, and it wanted to know if it had worked, so Rossetto's colleagues went line by line through server logs, counting how many people had clicked on the image.

What followed was a decade-long game, played against a backdrop of elevator pitches and VC funding. Advertisers asked for more and more: how many people clicked, and then who clicked, and from where. Developers built systems to track these things, and then other things. Can we place different ads to different people? the corporations asked. Dutifully the web teams built systems just for this, wrangling together a system of cookies and indexed user data. And then came the ad servers and exchanges, the data brokers and the rest, a mudslide of collection and hopeful correlation. No one, it seems, paused to ask whether any of this was a good idea, whether it was legal, whether their targeting tech might be used for more nefarious purposes than selling phone-and-internet packages. Or, it turns out, whether any of it actually worked.

In 2013, Latanya Sweeney, then the chief technologist at the Federal Trade Commission, published research showing disturbing racial discrimination in Google's AdSense product, one of its most popular and pervasive ad placement systems. She showed

that on pages containing personal names—for example, a staff page at a research institute—AdSense was placing particular ads much more often for people with names assigned primarily to Black babies such as DeShawn, Darnell, and Germain. These ads were suggestive of an arrest record in ways that ads placed for white-sounding names (Geoffrey, Jill, Emma) were not.

In 2016, ProPublica set out to buy blocks of web advertisements for rental housing from Facebook and requested they be targeted to a number of very specific user sets: African Americans, wheelchair users, mothers of high school kids, Jews, Spanish speakers. It picked these groups on purpose because they are protected by the federal Fair Housing Act, which prohibits any advertisements that discriminate based on race, color, religion, sex, handicap, familial status, or national origin. "Every single ad," ProPublica wrote, "was approved within minutes." Facebook quickly apologized. "This was a failure in our enforcement," mea-culpa-ed Ami Vora, the company's vice president of project management, "and we're disappointed that we fell short of our commitments." It promised to fix the problem.

In 2017, ProPublica repeated the experiment. It even expanded the groups it attempted to purchase for, adding "soccer moms," people interested in American Sign Language, gay men, and Christians. As in the previous experiment, its ads were approved right away. Facebook again promised to fix the problem, although it took a while: in March 2019, Facebook announced that advertisers could no longer target users by protected categories for housing, employment, and credit offers. Why did it take Facebook so long to close the doors on a practice that was fundamentally illegal? It might have been bureaucratic inefficiency, or a failure to prioritize legal compliance ahead of its more favored metrics of user counts and ad spends. Or, it might have been because Facebook

knew the problem of discriminatory ad targeting went deeper than anyone might have imagined.

Early in the summer of 2019 a group of researchers from Cornell demonstrated that even when ad buyers are deliberately inclusive, the workings of the massive and convoluted delivery machine can exclude particular groups of users. On Facebook, they showed that the company's efforts at financial optimization, combined with its own AI-based systems designed to predict ad "relevance," colluded to show content to wealthy white users, despite neutral settings for targeting. Using clever methodologies designed to isolate market effects from Facebook's own automated systems, the researchers demonstrated results that feel similar to those of Matthew Kenney's word2vec investigations. Housing ads were routed based on race, with certain ads delivered to audiences of more than 85 percent white users and others as little as 35 percent. Employment ads showed high bias to gender, as well as race. Jobs for janitorial work more often appeared in feeds of Black men. Secretarial jobs were more often shown to women. Jobs in the AI industry ended up in front of mostly white men. In all of these cases, no specific choice was made by the buyers to direct ads to a certain demographic; Facebook took care of the discrimination all by itself.

What this study and others like it suggest is that the ad-targeting machine itself is biased, breaking the protections laid out in the federal Fair Housing Act and indeed in the Constitution. There are no check boxes needed to target (or exclude) white people or Black people, trans people or Muslims or the disabled, when the system obediently delivers ads based on its own built-in biases. Facebook and other ad-centered platforms have spent a decade being trained on the reward of per-ad profits, and they have dutifully learned to discriminate.

=

I was traveling in Newcastle in 2010 when I heard two things for the first time: a talking elevator and the phrase "data is the new oil." The talking elevator had a thick French accent; apparently the hotel was invested in convincing visitors that the cold and rainy banks of the river Tyne might be a fair substitute for those of the Seine. Around every corner in the place, there was a Geordie staff member waiting with a cheery "bonjour." The restaurant served madeleines and a croque monsieur and the elevator counted off the floors in a strange mix of French and English: "floor trois," "floor deux," "floor un." I mumbled a jet-lagged "au revoir" to the doorman and crossed the curved footbridge across the river to the Sage Gateshead, a music and events center that was hosting a one-day conference on tech and creativity.

The speaker schedule was heavy with advertising executives and directors of marketing; there was plenty of talk of monetizing and impact and customer conversions. I was there along with a comedian and an origami expert, presumably to add a little bit of levity. I'd become distracted at some point and was checking Twitter when Don Levy, the second speaker that morning, said something that caught me by surprise. It was on his slide, too, for reinforcement, set in white type against a silhouetted image of a drilling rig. The audience seemed to be nodding in agreement. One scribbled a note: "DATA = NEW OIL." The phrase seemed to me as absurd as the talking elevator; I thought for a moment that it might have been a joke. Do we really need a new oil, I wanted to ask, given how well the first one has served us?

As it turned out, Levy wasn't the first to come up with this particular metaphor. Clive Humby, a mathematician-cum-marketer, had coined the phrase four years earlier at Northwestern University's Kellogg School of Management, in Illinois. "Data is just like

crude," Humby had said. "It's valuable, but if unrefined it cannot really be used. It has to be changed into gas, plastic, chemicals, etc. to create a valuable entity that drives profitable activity; so must data be broken down, analyzed for it to have value." It came as no surprise to me that Humby had, in a previous career, launched one of the most popular customer-tracking programs in U.K. history—the Tesco Clubcard.

If we were to come up with a genesis story for marketing's obsession with big data, there'd be a long chapter on customer loyalty programs. Humby and his wife, Edwina Dunn, pitched the Clubcard to Tesco in 1994, but the idea for such a scheme was hatched in the late 1980s by another U.K. entrepreneur, Keith Mills. Mills, who has since graduated to loftier arenas of schemery (he was the chairman of the London Olympic organizing committee), dreamed up a way for his client, British Airways, to track customers in a way that far exceeded what had previously been possible. The idea was to give people a unique ID that they'd use whenever they shopped, not only for airline tickets, but for groceries or gasoline or movie tickets. The program, launched in November 1988, was called Air Miles.

I was seventeen when the Air Miles program launched in Canada in 1992, and as a teenager ready to plunge headlong into the warm waters of consumerism, I found the Air Miles program really appealing. With every purchase I made, I'd earn a small number of miles, which could then be converted into travel. "Do you have an Air Miles card?" was soon a part of most retail transactions in the country. In Canada in particular, the program was phenomenally successful, and still is: as of 2017, more than two-thirds of the nation's households participate in Air Miles.

Mills's scheme was irresistible to marketers for two reasons. First, it allowed for a bridging of data from different corporate systems. Air Miles was a boon to retailers who wanted to join

their databases with those of brands their customers also bought from. Second, Air Miles was fiendishly effective at disguising consumer research as consumer benefit. In the past, most efforts to gather data about consumers were largely undertaken by companies hired by corporations. "Excuse me," they'd ask you in a shopping mall, "I wonder if you might have time for a few questions about your shopping experience?" "Good evening," came the voice over the phone, "you've been selected for a brief survey." In hindsight, the honesty seems quaint. For more than a decade I happily handed my Air Miles card along with my credit card to clerks and cashiers; at no point in any of these transactions did I have even a vague idea that my data was being used for marketing purposes. Even the name "Loyalty Program" is a lie. The point wasn't to keep you coming back but to follow you when you went elsewhere.

At the root of the Air Miles strategy was linking—the connection of a consumer's activity across a number of different corporate terrains. It's the promise of this linking, the "refinement" of data's oil, that squeezes a live auction into your internet page loads.

=

If data about data is called metadata, data between data might be called interdata. Interdata are records or measurements that act as bridges between two data sets. Among the complicated bureaucratic data systems of the U.S. government, a formal piece of interdata is your Social Security number. On the internet the most oft-used interdata are your email address and your machine's IP address. Both of these pieces of information give the data-ers a way to find you in more than one data set, thus being able to know how your Facebook posts intermingle with your Instagrams, how your dating profile might predict what will go into your Amazon

shopping cart, how your mobile calling records might connect to your voting record.

Much of the "innovation" in the surveillance capitalism era has been around finding new kinds of interdata. This is the central promise of facial recognition: that the physiognomy of your face might give a ubiquitous, publicly recordable data bridge that will bring targeted marketing tactics into the real world. The data signature of your face becomes a kind of Social Security number readable by anyone, anywhere, used not just to confirm your identity at the bank but to follow you as you move from the gym to the grocery store, to the public health clinic, to the political rally, to pick up your child from day care.

By bridging two sources of information, interdata are meant to perform an addition—the value to the corporation or the state is to take the one thing that it knows about you and make it into two things, or three things, or one hundred. However, there is also an inherent subtraction. Anything that is missing from the data sets—any of their dark matter—combines. Consider a disaster response system that links census data to cameras equipped with facial recognition. We've already learned that census data undercounts people who live in poverty; as it turns out, facial recognition has its own significant blind spot: Black faces.

In 2018 at MIT's Media Lab, Joy Buolamwini was working on a computer vision project of her own. She was building a project that involved face tracking and had very quickly become frustrated. Although she was sure she'd written the code correctly, the face tracking wasn't working. Puzzled, she called over a colleague to help her debug the program, and as soon as he sat down, the program worked exactly as it should have, finding and following his face in the camera feed. She called over some other lab mates, and the face tracking again worked as it should for them,

but not for Joy. It slowly became clear what was happening: the CV algorithm wouldn't recognize her Blackness. In a kind of perfect piece of tragicomic improvisation, Joy finished her project by using a white theatrical mask, which the system had no problem whatsoever tracking.

Curious as to how facial recognition technology in general might be viewing (or not viewing) Black faces, Buolamwini set out to perform an audit of the leading facial recognition software libraries, with an eye toward how well they performed with Black subjects as opposed to white ones. The results were damning. In her report, titled "Gender Shades," Buolamwini showed that all three of the most popular facial recognition tools—from Microsoft, IBM, and China's Face++—performed worse on Black faces than on white ones. In a task called gender classification, in which the software attempts to "guess" the gender of a face in an image, the three tools performed an average of 14 percent worse on photos of Black people than they did on white. All failed more often with faces of Black women than with faces of Black men. IBM's software performed particularly badly here, correctly classifying only 65.3 percent of Black female faces, compared with 92.9 percent of white female faces and 99.7 percent of white male faces. That what Buolamwini calls "the coded gaze" fails to see Blackness as well as whiteness should come as no surprise. The software industry is predominantly white and male.

In our disaster response example, we saw how technology's failings can be made worse when data is combined, joining together the information but also increasing each data set's systemic incompleteness. The empty areas of missing data overlap, the blind spots of the census and facial recognition combine, and in doing so magnify risk tremendously for one specific group— Black people living in poverty. We see this over and over again in ad tech, where a furious decade of interdata collection has

compounded and re-compounded bias. Job ads are biased toward men, and employment ads toward white people; at the center of the Venn diagram of exclusion are Black women. We see in the Cornell study that this is not so much a mistake as an inevitable result of tweaking the system over a decade to favor the "optimum customer," a tactic that is necessarily racist.

=

By the time we sat down beside the windows on the 7:45 to London, Ashkan Soltani had spent much of a decade investigating how ad placement systems actually work, with a particular focus on how advertisers are getting data about individuals through unconventional means. In 2010, his research showed that mobile apps were sharing location data; in an analysis of 101 then popular iPhone and Android apps, he showed that 47 of them were sending the device's location in some way. In 2012, he showed that Google was tracking users of Apple's Safari web browser, using a cookie-based hack to get location data on users, even though the browser is configured to block this kind of data collection. Soltani also showed how, as early as 2012, advertisers were finding ways to bridge the online world to the brick-and-mortar. He demonstrated that Datanium, a U.S.-based business intelligence company, was collecting the email addresses of people who were browsing automotive websites. These addresses were then used to assemble customer profiles, which were available to car dealers when a prospective buyer walked in to buy a car.

At the end of 2013, Soltani turned his attention to the Snowden leaks, working with the *Post* on the series of articles that would later win him his Pulitzer. Here, the tactics were similar to those he'd seen in his investigations of targeted advertising: the gleaning of data from individuals via their mobile devices and their

web browsers and the use of that data to predict the behaviors of people. However, the actors were different, their intent more ominous, the results more violent. U.S. intelligence had taken the tactics and tools that tech companies had conceived of and built, and weaponized them. The NSA, as Soltani and his colleagues Andrea Peterson and Bart Gellman showed, were using Google cookies to identify targets for their hacking operations. The agency used tactics similar to advertisers' to collect location data on individuals, then combined this with sophisticated statistical correlation techniques to link individuals together. This program, called Fast Follower, could potentially identify foreign actors who might be tailing U.S. agents, by analyzing the pattern of their phone's communication with cell phone towers.

In his investigations, Ashkan has been tracing the ways in which ad tech's computational behemoth has been reaching its dark tentacles into other areas of our lives and the lives of others. It's scary to think how this thing, so fundamentally flawed, might be pointed toward decisions on how we're insured, or whether we get health care, or if we're let into a country on a refugee claim. As we've seen, these systems can't help but discriminate, can't resist in any meaningful way the aims of the men who authored them and those of the capitalist system that, from the beginning, guided their logic.

It's scary also because, as some of us have long suspected, none of this seems to really work. In an analysis of millions of advertising transactions across many big websites, a group from the University of Minnesota's Carlson School of Management showed that revenue from ads where a user's cookie is available is just 4 percent higher than when it isn't. This suggests that all of ad tech's sophisticated targeting and data brokering and auctioning result in an increase in earnings of just 0.00008 cent per ad.

"Relational analysis of an individual's activities," Arthur R.

Miller wrote in 1971, "is clearly the wave of the future in the surveillance field." It would be optimistic to assume that, just because the system is unconstitutional, or that it doesn't seem to turn a profit, this particular wave is over. Companies like Google and Facebook aren't closing shop on data collection from users. They do, however, seem to be chasing different kinds of value from information about your life. Rather than using what they know about you to entice advertisers to pay more for your attention, these companies are using your information as capital, wielding it in aggregate as a bargaining chip for their customers, and munging it with machine learning algorithms to come up with new products to sell.

In 2015, the makers of a now-defunct photo app, Pikinis, sued Facebook, accusing the company of trading access to user data in return for mobile advertising purchases. As early as 2012, Six4Three, the developers of the app, claimed that Facebook had instigated a strategy, withholding access to information until developers bought ads. Facebook eventually won the suit, with the court ordering Six4Three to pay seventy-seven thousand dollars in damages. But in the course of the lawsuit, which lasted more than four years, a series of documents ended up being produced by Facebook as evidence. In a strange turn of events, these documents were made public by a British court.

In one particularly damning email, a Facebook employee talks about suspending "all apps that don't spend at least $250k a year to maintain access to the data." There are also agreements outlining "whitelisting" relationships with Amazon, Nissan, Lyft, Tinder, Netflix, and other companies that receive special access to Facebook's data even after it had been cut off to other partners. What we can see from the Six4Three story is that Facebook's intent was not so much to make money off its user data as to use it as an enticement for developers who would then pay fees to access

the Facebook platform. It's a nice work-around for the Zuckerberg camp, who get to say that they are not in fact selling user data while instead cashing in on selling access to that user data.

If Facebook's game plan here can be understood as a kind of pay-for-play scheme, Google's strategy has been to look further up data's refinery pipeline. It has invested billions in machine learning, developing systems that can consume the huge amounts of user data that the company has collected over the last two decades and turn it into trained computational machines that can solve challenging problems. Most fruitfully, Google has taken its trove of trillions of indexed images (scraped from websites by its automated systems since 2001) and used them to train neural-network-based image classifiers and generators. These tools, in turn, increase the value of other Google offerings: photo captioning and content moderation and self-driving cars.

It's more sophisticated, and easier to wrap in neat PR packaging, but Google's tactic is the same as Facebook's—to sell user data without selling user data, to dance around privacy laws and pesky constitutional barriers. Both companies (and of course many of their big-tech compatriots) have found new ways to use the data they collect about you, by carefully controlling access to it and by refining it to be a cleaner-burning product that creates less obvious harms. Fifteen years later, it seems, "data is the new oil" has made itself into a kind of truth.

LIVING IN DATA

# HOW THINGS ARE FOUND AND LOST, HOW HISTORIES ARE WRITTEN

List of Library of Congress classification subjects, sorted by th length of each record. At the top are subjects with a lot of da associated, at the bottom are ones with very little.

| J. T. | GITHUB.COM/BLPRNT/LID/COMPLETENESS |

Human-alien encounters, Bedouins, Gangsters, Criminal investigation, I-beams, Fathers and daughters, Mothers and sons, Adventure and advent Murder, Shipwreck survival, Sisters, Revenge, Practical jokes, Wives, Man-woman relationships, Avarice, Kidnapping, Supernatural, Detectives, H students, Religious facilities, Spies, Christians, Arabs, Rich people, Scandals, Deception, Fathers and sons, Adultery, Newspaper editors, Bayonets, Knives, Handguns, Tariffs, Princesses, Cupboards, Events, Crime and criminals, Married people, Political platforms, Backdrops, Democratic donke Printing industry, Republican elephant (Symbolic character), Prostitutes, Mayors, Ironwork, Stonework, Silver question, Receptions, Free trade a policy, Civil rights leaders, Americans, Politics & government, Marriage, Courtship, Industrial trusts, Military decorations, Reform, Corruption, En Business & finance, Commerce, Military hospitals, Nobility, Lawyers, Mantels, Working class, Skylights, Mothers and daughters, Visits of state, Pla Families, Cost & standard of living, Journalists, Rest periods, Heroes, Brothers and sisters, Crimean War, 1853-1856, Political persecution, Picnics, officers, Resorts, International relations, Governors, Parties, Soldiers, Autonomy, Terraces, Military facilities, Samurai, Singers, Monetary policy, l Britannia (Symbolic character), Industry, Judges, Employment, Authors, Courtrooms, Porters, Political elections, Troop movements, Railroad train Veterans Memorial (Washington, D.C.), Tigers, Crying, Monuments & memorials, Activists, Ambassadors, National parks & reserves, Gangs, Coal n Dreaming, Porches, Democracy, Space flight, Banquets, Rest stops, Popeye (Fictitious character), Conservation & restoration, Military officers, Str ceremonies, Prostitution, Military parades & ceremonies, Commercial facilities, Taxes, Cavalry, Charity, Servants, People with disabilities, Turkey Military life, Business people, Porcelain enamel, Religious services, National security, Mansions, Gold mines and mining, Jazz, Draft (Military serv headquarters, Indian encampments, Skeletons, Depressions, Upper class, Educational facilities, Supernatural beings, Dancers, Batteries (Weapon: picture industry, Wounds & injuries, Protest movements, Gods, Manners & customs, Peace, Warships, Stained glass, Signs (Notices), Roosters, Que events, Ethics, Violence, Religion, Clergy, Bombardment, Construction workers, Apple computer, Sedan chairs, Boat & ship industry, Magicians, Fc Dreams, Advertisements, Cigars, Fords (Stream crossings), Punishment & torture, Churches, Health care, Scientists, Peasants, Islands, Show wind conferences, Censorship, Missionaries, Prisoners of war, Race discrimination, Shopping, Physicians, Signs, Poets, Buddhist monks, Consumers, An Newspapers, Japanese, Demons, Boys, Spouses, Immigrants, Mosaics, Teenage girls, Housing developments, Fishers, Priests, Political campaigns, speaking, Segregation, Eating & drinking, Domestic life, Pines, War casualties, Nationalism, Looms, Rivers, Fourth of July, Archaeological sites, Ba Salutations, Camps, Anarchism, Eagles, Centennial celebrations, Fraternal organizations, Kings, Scales, Concentration camps, Inventions, Women Lobbies, Office buildings, Pilgrimages, Older people, Military air pilots, Holocaust, Jewish (1939-1945), Explorers, Patriotism, Passes (Landforms) Mining, Journalism, Inventors, Animals in human situations, Document signings, Slums, Fountains, Buddhism, Umbrellas, Merchants, Stores & sh Prime ministers, Fires, Lifting & carrying, Railroads, Tourism, Infantry, Women's rights, Juvenile delinquents, Theatrical productions, Poor person schools, Singing, Grief, War work, Apartment houses, Actresses, Government facilities, Coastlines, Hurricanes, Railroad bridges, Fund raising, Bud Revolutions, Houses, Disabled veterans, Parades & processions, Expeditions & surveys, Neutrality, Human locomotion, Communists, Mules, Nucle Defense industry, Barracks, Circuses & shows, Skulls, Row houses, Hieroglyphics, Snow, Waterfronts, Card games, Circus performers, Warehouses Teenagers, Bays (Bodies of water), Prisoners, Art education, Faces, Clouds, Niches, Lakes & ponds, Mothers, Explosions, Industrial buildings, Tipis Orthodox churches, Pavilions, Banks, Apache Indians, Barracks, Clubhouses, Battleships, Barns, Military bands, Refugees, Gardens, Comedies, Lif armament, Pylons (Gateways), Photographers, Coffins, Dead animals, Exhibitions, Roofs, Caves, Canyons, Supreme Court justices, Courtyards, Roc Starvation, City walls, Capitals (Columns), Korean War, 1950-1953, Fire fighters, Fire, Military education, Gold rushes, Cows, Bazaars, Horseback r Stoves, Stadiums, Running, Business enterprises, Nurses, Dragons, Bands, Military camps, Barges, Architectural decorations & ornaments, Flow Carriages & coaches, Children playing, Metalwork, Tents, Military occupations, Storms, Medals, Pueblo Indians, Puerto Ricans, Bodybuilders, Boo Taverns (Inns), Bahamians, Buildings, Beauty contests, Education, Executive power, Tents, Geese, Students, Restaurants, Young adults, Tombs & Petroleum industry, Horses, Patent medicines, Air travel, Construction, Legislative bodies, Homeless persons, Trails & paths, Cheyenne Indians, Unemployed, Television broadcasting, Dirt roads, Capitols, Environmental policy, Crosses, Blacks, Reflections, Shipping, Drawing, Paintings, Legends, Boo Transportation, Offices, Piers & wharves, Swimming, Petroleum industry and trade, Fences, Poor, Saint Croix, Folk music, Antiques, National parks & Prohibition, Walls, Beauty contestants, Eczema, Medical education, Power plants, Winds, Airships, Dogs, Cartography, Wood, Genre, Farm life, City and town life, Department stores, Bridges, Hills, Press conferences, Nuclear, Baskets, Costumes, Mountains, Interiors, Recruiting & enlistmen Musical instruments, Harvesting, Herb Gardening, Railroad accidents, Monsters, Gray fox, National forests, Radar, Cooks, Schools, House cleanin Orchards, Grooming, Mountain life, Hand tools, Masquerades, Submarines, Plaza, Pueblo, Winters, Gems, Agricultural laborers, Bathing suits, Bapti Submarines, Motion picture theaters, Steamboats,

North America, Tewa

les, Crime, Thieves, Abolition movement, Porky Pig (Fictitious character), Fire-resistive construction, Jealousy, Organized crime, nvestigators, High school students, Civil service reform, Drug traffic, Brothers, Triangles (Interpersonal relations), College ion picture producers and directors, Celebrities, Motion picture actors and actresses, Cornices, Love, Rescues, Customhouses, rchitectural elements, Military art & science, Escapes, Rifles, Military uniforms, Political patronage, Monopolies, Foreign visitors, nanciers, Politicians, Muslims, Superheroes, Poverty, Special interests, Daggers & swords, Presidents & the Congress, Economic Widows, Political parades & rallies, Irish Americans, Presidential elections, Zouaves, Feature films, Nazis, Prosperity, Devil, nting, Slavery, Statesmen, Rulers, Industrial facilities, John Bull (Symbolic character), Historic sites, Organizations' facilities, ud, Pirates, Orphans, Gambling, Justice, Military camps, Tramps, Uncle Sam (Symbolic character), Cross dressing, Cabinet atholicism, Student strikes, Japanese Americans, Travelers, Tourists, Windows, Allegiance, Criminals, Romanies, Imperialism, trians, Courtesans, Big business, Military standards, Suffrage, Ceilings, Terrorism, Stairways, Treaties, Human rights, Vietnam tillery (Weaponry), Swimming pools, Beauty, Wealth, Hunting, National socialism, Shipwrecks, Spanish-American War, 1898, , Medical aspects of war, Warriors, Fighting, Cherry trees, Sick persons, Monasteries, Diplomats, Ferries, Farewells, Rites & ers, Clothing & dress, Military academies, Columbia (Symbolic character), Hair ornaments, Pilgrims, Delegations, Contests, l relations, Vietnam War, 1961-1975, Legislation, Musicians, Historic buildings, Fireplaces, Meetings, Post offices, Military Economic & social conditions, Alcoholic beverages, Relations between the sexes, Political parties, Orphanages, Symbols, Motion ons, Bombings, Seas, Balconies, Weddings, Intoxication, Popular music, Businesspeople, Military training, Anniversaries, Biblical lents, Drums, Balls (Parties), Actors, Parent and child, Pontoon bridges, Boxers (Sports), Mickey Mouse (Fictitious character), Estates, Judicial proceedings, Governmental investigations, Ojibwa Indians, Farming, Admirals, Sailors, Interviews, Peace lay (Recreation), Fighter pilots, Plantations, Naval yards & naval stations, Folk dancing, Jews, Naval warfare, Thanksgiving Day, s, Propaganda, Farmers, Anger, Navies, Ocean travel, Concerts, Police, Furniture, Law enforcement, Ghosts, Ships, Nuns, Public s, Socialism, Wages, African Americans, Homicides, Campaigns & battles, Flags, Knights, Voting, Awards, Castles & palaces, , Inflation, Anti-communism, School integration, Gold miners, Dance, Divorce, Shrines, Presidents' spouses, Artists, Assistance, s & museums, Operas & operettas, Cemeteries, Harbors, Cowboys, Wetlands, Hands, Religious articles, Animal locomotion, Fear, sure, Miners, Frontier & pioneer life, Riots, Couples, Monks, Battlefields, Rain, Rock music, Celebrations, Obelisks, Generals, tudents, Banners, Eggs, Hay, Rock formations, City & town life, Arrivals & departures, Reporters, Sightseers, Armories, Public Shoes, Sleeping, Reviewing stands, Kissing, Fairs, Pedestrian bridges, Bulls, War relief, Russo-Japanese War, 1904-1905, Fish, ace relations, Suicide, Bridges, Cannons, Tribal chiefs, Laborers, Night, Consumer rationing, Magic, Guards, Sunrises & sunsets, Bathing, Correspondence, Silk industry, Traffic accidents, Women, Ranches, Bows (Weapons), Gardening, Horse racing, wns, Shaking hands, Shooting, Waterfalls, Executions, Smoking, Office workers, Universities & colleges, Slaves, War damage, ns, World War, 1914-1918, Recreation, Chinese, Yachts, Elections, Meetings, Pueblos, Ruins, Oglala Indians, Civil rights, Arms & islative hearings, Villages, Toys, Gates, Air pilots, Walking, Cadets, Christmas trees, Athletes, World War, 1939-1945, Architecture, onesty, Poetry, Dakota Indians, Stables, Puppets, Music festivals, Country life, Indigenous peoples, Friendship, Pioneers, Cliffs, (Aircraft), Winter, Postal service, Uniforms, Wooden buildings, Marines, Camels, Ceremonial dancers, Skyscrapers, Canals, iles, Men, Horse teams, Columns, Girls, Shepherds, Windmills, Carts & wagons, Child labor, Sugar industry, Hotels, Donkeys, jons, Covered wagons, Spiders, Official residences, Banquets, Civil rights demonstrations, Military personnel, Snakes, Chairs, rocomputers, Baseball, Firsts, Frontier and pioneer life, Earthquakes, Mexican War, 1846-1848, War, Porticoes (Porches), ration & immigration, Stadiums, Zuni Indians, Stagecoaches, Minarets, Horse farms, Breast feeding, Goats, Lumber industry, Presidential inaugurations, Hides & skins, Elephants, Hairstyles, Dolls, Petroleum industry, Boats, Government employees, es, Food supply, Masks, Communism, Writing, Saloons, War bonds & funds, Kuwait, Chains, Streets, Mothers & children, City ns, Statue of Liberty, New York, N.Y., Stairs, Parks, Fur garments, ... events Iroquois Indians, Aeronautics, Baseball players, ... Housing, ... Railroad stations, ... Indians of Skiing, ...

# 6. Number of Grown Sheep That Were Sheared

> When knowledge passes into code, it changes state; like
> water turned to ice, it becomes a new thing, with new
> properties. We *use* it; but in a human sense we no longer
> *know* it.
>
> —ELLEN ULLMAN

The point of data's collection has been called its genesis moment. This is apt, not so much in a biblical sense as in a biological one: from the point of collection on, there are many messy cleavings and bubbling transformations ahead. By the time we act on a piece of data (or it acts on us), it may be nearly unrecognizable as the modest record we once collected. A large part of this transfiguration will come as a necessity of digitization. As a record of a real-world thing is reformatted and trimmed and parsed to fit into a computer, it changes, often in ways that affect how stories might be told and decisions may be made. Meanwhile, as the record is munged and refactored and set forth into a computational wilderness, the real-world thing itself might have changed, forcing us and our databases to reckon with decisions about accurate (and timely) representation.

Remember that the amount of data that can be conjured from any given thing is almost limitless. Pick up a plain gray rock

from the side of the road, and play the same data-ing game we did with the bird in chapter 2. Very quickly you'll have assembled a set of descriptors and values: size, weight, color, texture, shape, material. If you take that rock to a laboratory, these data can be made greatly more precise, and instrumentation beyond our own human sensorium can add to the list of records: temperature, chemical composition, carbon date. From there comes a kind of fractal unfolding of information that begins to occur, where each of these records in turn manifests its own data. The time at which the measurement was made, the instrument used to record it, the person who performed the task, the place where the analysis was performed. In turn, each of these new metadata records can carry its own data: the age of the person who performed the task, the model of the instrument, the temperature of the room. Data begets data, which begets metadata, repeat, repeat, repeat. It's data all the way down.

This infinity mirror of data and metadata can be exhausting for people who are trying to decide exactly what to record about a thing. Right now, a cataloger at a library holds an old book in their hands that has just arrived as a donation. There are so very many things that they could enter into the catalog about the book, for a book is a thing with a particular penchant for producing data. The number of pages, the type of binding, the typefaces used to set the text, the presence of a dust jacket—all of this before we get to whatever it is that the author might have to say. As a means of sanity for the cataloger and as a defense against bloated databases and overstuffed card catalogs, the library has defined a particular set of things that the cataloger should record about the book: the title, the author, the publisher, the year—all of the things we might expect to find listed in a bibliography. There is simply no means for our cataloger to add more data than what

is allowed: that the book in their hands smells vaguely of camp-fire smoke is of no business at all to the database.

The Library of Congress is, technically, what it says on the package. That is, it is a library whose primary purpose is to serve members of Congress. It holds the world's largest collection of books, fourteen million photographs, five and a half million maps, miles of manuscripts, seven Stradivari, Walt Whitman's walking stick, the contents of Lincoln's pockets when he was assassinated—all there (at least in theory) in case a congressperson requests them. This is something like saying that the purpose of the body is to produce saliva or that Coney Island is a hot dog stand. The Library of Congress is the nation's de facto national library, and the largest chunk of its mighty archival and cataloging and librarian-ing armaments are aimed at the public. For the last 150 years, this public has mostly been academic researchers, who come to read and write (with their quietest pencils) in the library's twenty-one reading rooms. Since 2016, when Dr. Carla Hayden (previously the president of Baltimore's public library system) was appointed to the position of librarian of Congress, the institution has been slowly tacking toward a new course—one aimed away from quiet research and to a louder, more gregarious type of learning.

I spent most of 2017 and 2018 at the library finding things, coming up with new ways to find things, and talking to librarians, archivists, and historians about things they'd already found. I was there as the institution's first innovator in residence (a title they made up), tasked to come up with new ways that the public might engage with the library's vast holdings. I approached the problem in a decidedly un-computational way, by having as many conversations with as many library staff as I could. Under the auspices of recording a podcast called *Artist in the Archive*, I met

with librarians and archivists, conservators and researchers, technologists and administrators.

Somehow all of these conversations kept coming back to this moment of data genesis, when a book or a map or an audio recording produces a catalog record, for it is in this moment when the object's life as a thing that might be found is largely defined. If the cataloger has a bit of time, and if they are thorough, our object might get a record that will serve it well for future searches. An exact date, an accurate place, an extra line of descriptive text: all of these things privilege the object greatly in the context of being found, they increase its chances of being included in research and in the stories that get told about the past. Conversely, many objects are data-fied with a spareness that all but guarantees them a life on the last page of search results.

Sometimes, an object is fortunate enough to be rescued from search obscurity. Consider a lucky newspaper clipping from 1863, which for 156 years was mislabeled as an Arabic translation of Lincoln's Emancipation Proclamation. In 2019, a volunteer transcriber in Kuwait came upon the clipping on the LOC's crowdsourcing platform and sent a note to the library that the text was not in fact in Arabic, but perhaps Armenian. Research by the library staff later determined the text to be Neo-Aramaic, a language spoken by Assyrian and Chaldean Christians in Urmia, Iran. The next day, the clipping's catalog record was changed, and it is now the number one search result for "Neo-Aramaic." A century and a half later, it is just beginning its life as a findable thing.

And then there's the Sheep Census.

When Julie Miller started her job in the Manuscript Division of the Library of Congress, she set out to survey the particular archival terrain of her specialty, early American history. This was a daunting task: the library holds more than sixty million items in its Manuscript Division, stored in more than thirteen thousand

collections. Conservatively assuming it would take ten minutes to review a single document, all of the manuscript collections would take roughly a thousand years to comprehensively explore. Not having more than one lifetime, Miller decided to take a survey approach, using the library's online catalog to peruse the holdings.

One particular document, for whatever reason, caught her eye. It was labeled "Massachusetts Sheep Census, 1787." Apart from that, there was no other information about what it was or where it had come from. Miller went into the archive and found the document, stored in a flat file among miles and miles of Hollinger boxes neatly lined up on metal shelves. It was a stiff piece of paper measuring about sixteen inches square. On the front was a hand-drawn table with thirty columns and thirty rows, a spreadsheet created two centuries before Excel. On the back was a single note, written in an elaborate script: "No. 2 a List taken from the Year 1787."

While many of the column headings were illegible due to physical damage, those that can be read made it clear to Miller that the so-called census was in fact a tax document. Through research into local newspapers and genealogy databases, she found out the names on the document were not from Massachusetts but from a small town called Canterbury, Connecticut. At some point in the summer of 1787, an official had been dispatched to the town to count the inhabitants and to assess what they owned for the purposes of taxation. "There's no income tax at this point," Miller explains, "so they're being taxed on what were called their polls, their heads."

The details the document records about a household are specific: it divides the "polls"—people—into those aged twenty-five to seventy and those aged sixteen to twenty-one, because these age groups were to be taxed at different rates. There are columns for the number of livestock (pigs, oxen, bulls, steer, cows, and heifers) each person owned, as well as acreage and type of land. Only particular possessions are counted: clocks and silver

watches. "Only three of them own clocks," says Miller, "which is interesting because you would think that everyone would own a clock, but in fact in the eighteenth century a clock was a kind of a cutting-edge technological device, and in fact not many people had one, and in reality they didn't have much use for, so it was kind of a status item."

Because there was no income tax in America in 1787, earnings are not listed, but these specific questions about watches and clocks act as proxies for wealth. The questions themselves, as much as the data recorded, give us an insight into the unique politics of the time and place. That sheep, for example, are counted in their own individual column, tells us that there was some specific difference in purpose that tax collectors had for asking about them. As it turns out, sheep were tax deductible in 1787.

"This is a period when New England was beginning to think about how it might participate in the Industrial Revolution," Miller told me. George Washington had visited early textile factories in New England shortly after he became president. He and his Treasury secretary, Alexander Hamilton, saw promise in a burgeoning milling industry. Textile production needed mills, mills needed wool, and wool needed sheep. This kind of manufacturing wouldn't gain a foothold in Connecticut until the 1820s, but we find a sign of its provenance in the last column of this document: "Number of Grown Sheep That Were Sheared." "Sheep ownership," says Miller, "may have signaled a willingness to belong to a woolly vanguard, to be part of something new and potentially profitable."

Miller's investigations into the "Sheep Census" produced a kind of data rescue two in one. Not only is the document itself now findable under the correct headings (Connecticut, tax records, 1787), but some glimpse of the ordinary lives of these Canterburians is now also available to researchers. "Quantitative data is often the only written record of people who never learned to write, such as

slaves, the poor, and, in early America, many women," Miller writes. "In fact, quantitative data is often the only extant information about all kinds of people who went about their daily business making no special mark on history. That is to say, most people."

The proclamation that wasn't in Arabic, the sheep census that was neither: two objects that found their way out of data obscurity. Alongside them in the library's collection are millions of objects that will never be so lucky, items with absent or inaccurate dates or descriptions or subject headings. They are, in a system that prioritizes data, invisible, along with information they contain and the stories they might tell. What's crucial to understand with the sheep census is that both the yes/no binary choice of collecting data or not and the more nuanced decisions of how to store the data have greatly influenced how the data version of Canterbury, Connecticut, in 1787 matches to the real world at that same time and place.

=

In a 2015 essay about this mismatch between data's reality and the actual world, Jacob Harris conjures computer programmers who've been asked to create a database that tracks prisoners in a fictional kingdom called Zenda. These developers approach the problem in exactly the way you or I or anyone else faced with this problem might, by building a data structure—a schema— that fits their estimated version of reality. The programmers' database records the names and birth dates of the Zenda prisoners, along with a true/false value for whether each person is currently incarcerated, the idea being that upon release, captive = true would be changed to captive = false. These true/false values, called Booleans, are extremely convenient for programmers: first, because they take up very little space in a computer's memory; second,

because they can be operated on with ease. Boolean logic—the ways in which these true/false values can be added or multiplied or divided—is central to computer code. Almost any computer program will have instructions in which Booleans are evaluated, choose-your-own-adventure points in which the computer does different things depending on how combinations of these true/false values are evaluated. If captive = true, lock gate. If captive = false, open gate. In most data applications, subsets of information are often retrieved from the database using Boolean matches—SELECT * FROM prisoners WHERE captive = true.

Harris's hypothetical developers quickly realize that while the "captive" Boolean is convenient for the database, it doesn't mesh well with the reality of the prison. What if, for example, a prisoner has been apprehended but not yet imprisoned? On the other hand, what if they've been acquitted but not yet released? The programmers' first instinct is to add more Boolean values: "captured," "captive," "acquitted," "released." The developers lean back in their chairs, confident that reality has been modeled, that the true/false cascade they've built will tell the story of all of the prisoners. And then, to their dismay, a prisoner is acquitted, then released, then captured again. What are the poor Booleans to do?

Harris's essay is about how seemingly inconsequential coding decisions can have an extraordinary impact on data's capacity for communication. Specifically it's about how the precision imposed on data by computers can clash with what Harris called the "murky reality" of the real world. His writing underlines a critical point, often missed: that while computational bias can come from big decisions, it can also come from small ones. While we urgently need to be critical of the way machine learning systems are authored, we also need to pay attention to the impact of procedural minutiae—like whether a data point is being stored as a Boolean or as a number or as a piece of text.

I'd wondered since I read the piece whether Harris's Zenda prison example might be a metaphor for some real-world system, if the Boolean conundrums the hypothetical programmers faced might have come from some actual problem that Harris had worked on in *The New York Times*'s newsroom. Finally, two years after he left the *Times* to wrangle data for the public sector, Harris admitted as much in a tweet. A few months later I sat down with him to speak about Booleans and data structures and the world's most infamous military prison.

In November 2008, *The New York Times* published "The Guantánamo Docket," an interactive database of information about the roughly 780 people who have been (or still are) imprisoned at the Guantánamo Bay detention camp on the south shore of Cuba. This information had, since 9/11, been a missing data set, classified information that had not been released to the public. This changed in February 2010, when Chelsea Manning leaked 750,000 documents to WikiLeaks, including nearly 800 files concerning Guantánamo. The "Gitmo Files" contained assessments, interviews, and internal memos about detainees. Since the Manning leaks, "The Guantánamo Docket" has been updated through journalists' investigations and from documents received through FOIA requests.

The database for "The Guantánamo Docket" was, as Harris explained to me, built in nearly the same way as the fictive Zenda one—starting with a simple structure based on initial assumptions and then rebuilding and retooling from there. In a newsroom, under deadline, developers often need to leap before they learn. "You don't really know that much about the data, because you're about to load it because you just got a big CSV dump or you have a bunch of records you're going to scan. You don't have time to go through them, because you're operating on deadline time.

"You start with the most easily obtained cases first," Harris says. "Then you start hunting down the things that are harder to

find. You might have a record of all the most common prisoners that you know about, the ones that have been listed in press releases or things like that." At this point, the only real option to the developer is to build data structures around the data that they can see. Any cases in which prisoner data doesn't quite fit the structures are going to be, fingers firmly crossed, labeled as edge cases: strange one-offs that don't represent the bulk of the expected data. "Then you start hunting down other names," Harris tells me. "Those are going to be the ones that are usually a lot murkier in terms of what you can get, but also the ones you're going to encounter a lot later. You don't know when you find that, is this going to be the only edge case that's like this or are there going to be tens of them? Hundreds of them? Thousands of them?"

As an example, let's say a record is found for a prisoner from Guantánamo who doesn't have an exact birth date listed, just a year. How does this person fit into the schema that's been written, one which requires a birthday in MM-DD-YYYY format, such as 06-24-1982? "Do you give them the birth date of January 1, as a specific date that year? Or do you rewrite the database, breaking the date down into three parts: a year, a month, and a day?" The first way is easier, of course. But it depends on any future user of the database knowing that January 1 is a proxy for "we don't know." And what about prisoners who were actually New Year's babies? This is the start of a long three-way wrestling match, between the programmer's time, the computer's requirements, and the real world as it actually exists.

"You dream of one day throwing out the database and starting again with the one that will get it all right," Harris says. "But you know you have to maintain this one in the future." And so instead of redrafting code to fit better to reality, more often the data is redrafted to fit the expectations of the computer. In the real world of the newsroom, which in most ways matches the broader world of

programming and data science, this Guantánamo story is playing out every day, with databases and their rigid structures dictating what pieces of the real world are stored as bits and bytes, Booleans and floating point numbers and strings, and which pieces are discarded, trimmings of the computer's "cookie-cutter logic."

=

"I think a lot of computer systems and a lot of data entry systems work," Jacob Harris told me near the end of our interview, "because they train us to think like the computer." Understanding this encourages us to look at "The Guantánamo Docket" with a view for which parts of the story might have been cast to the computation margins by the needs of a database and the decisions of a programmer. Indeed we can ask the question anytime we read a news story or listen to a politician's speech: What is missing from a data story because it found itself outside a computer's uncompromising ways of thinking? Harris points to gender, and how it has often been handled as data by programmers in the past: as a male/female binary. "That's terrible if you're not someone who falls into either of those categories. What you're basically telling those people is you don't matter as a person."

We learned in the last chapters that data can bestow privilege and that its absence can push a thing out toward the margins. Here we see that the processes in which a thing is data-fied and the constraints of the structures made to hold that information can also have a profound effect on how that thing can participate in the databases and search engines, newspaper articles and court hearings, in the record of history.

This effect—where data is trimmed or transfigured to match the expectations of the machine—can be called schematic bias. For those involved in building data systems, a schema is a kind

of blueprint, a map of which types of information will be stored, in what form, and which types of information will be rejected. In cognitive science, a schema is a pattern of thought, a framework of preconceived ideas that directs how a person sees the world: if you observe something that fits neatly into your schema, it gets filed easily and efficiently into your memory. On the other hand, schema-foreign things will often not be noticed or remembered, or they will be modified to fit into what you expect based on the frameworks you've constructed. The many machines that order our data lives are working the same way, paying more attention to the things that fit neatly into their schema and ignoring things that don't—or changing them to fit.

It's particularly important to understand how schematic biases are amplified. How a decision made by a developer in a newsroom affects how a data point is stored, how a visualization is made, how a story is told, how a public understands. The structures built to store data affect how things are found and lost, how histories are written and who is included in them. Algorithms, with their expansionary tendencies, can loop these omissions upon themselves until they become wide sinkholes, affecting the ways in which people live (and lose) their data lives.

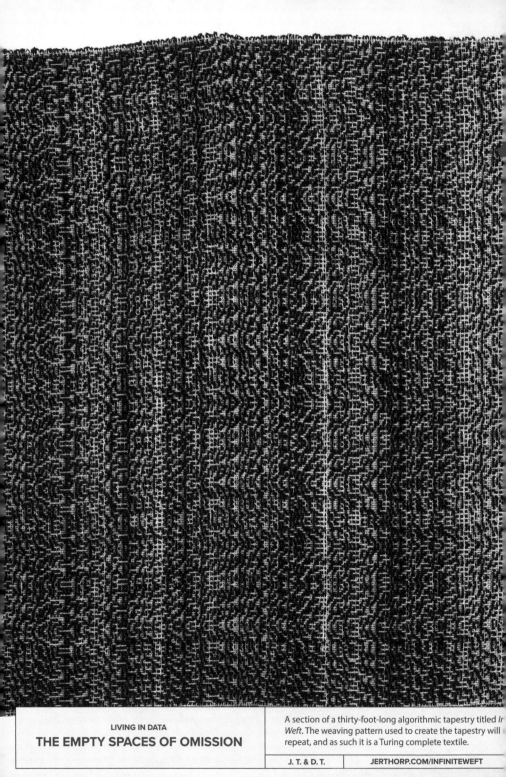

LIVING IN DATA

## THE EMPTY SPACES OF OMISSION

A section of a thirty-foot-long algorithmic tapestry titled *Infinite Weft*. The weaving pattern used to create the tapestry will repeat, and as such it is a Turing complete textile.

J. T. & D. T. | JERTHORP.COM/INFINITEWEFT

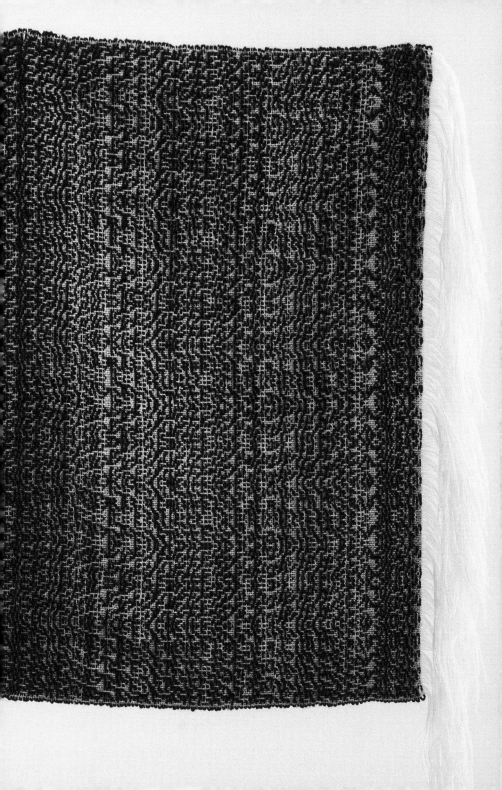

# 7. do/until

Algorithms hold a pivotal and particularly mysterious place in our public discussions around data. We speak of Google's and Facebook's algorithms as wizards' spells, cryptic things that we couldn't possibly understand. Algorithmic bias is raised in almost every data discussion, in classrooms and congressional hearings, as if all of us have some kind of shared definition of what an algorithm is and just exactly how it might be biased.

Computers run by executing sets of instructions. An algorithm is such a set of instructions, in which a series of tasks are repeated until some particular condition is matched. There are all kinds of algorithms, written for all kinds of purposes, but they are most commonly used for programming tasks like sorting and classification. These tasks are well suited to the algorithm's do/until mentality: Sort these numbers until they are in ascending order. Classify these photographs until they fall neatly into categories. Sort these prisoners by risk of re-offense. Classify these job applicants as "hire" or "do not hire."

This is not to say that an algorithm is a specifically computational thing. We use algorithmic approaches in our everyday

lives when we are faced with do/until problems. Take, for example, a classic task of grade school: how to divide a gym class into two teams. My second-grade gym teacher, Mr. Williams, took a particularly egalitarian approach. He'd line us all up against the wall; then he'd count down the line: one, two, one, two, one, two, one, two.

This is a reasonable algorithm, but it has two big problems. First, it's fairly easily gameable. The first few times Mr. Williams did this, the teams were most likely close to random, but by the third time the line set itself up against the wall in a decidedly non-random way. Mark and Brad always made sure that there was an odd number of people between them, guaranteeing they'd end up on the same team. Second, random selection is just that: random. There's just as good a chance that all of the talented soccer players would end up on the same team as there was that the teams would be evenly balanced.

By grade five, almost every team-picking session in my gym classes was built around four words that still haunt me to this day: "second captain, first pick." This algorithm is nearly as simple as the one/two alternation we saw a moment ago: the gym teacher picks two captains, and then they alternate picking players for their teams until there's no one left. This algorithm seems to have the advantage that it tends to pick more balanced teams. Mr. Adams would pick the two best players to be captains—by giving the second captain (that is, the second-best player in the class) first pick, he was ensuring the two best players wouldn't be on the same team. Assuming the captains then pick players in order of talent, the resulting two teams should be well matched.

The problem with this algorithm is that it magnifies existing social biases. Brad will of course choose Dave and Scott, his two best friends, in his first and second picks. Mark will always choose Chris and Peter. The two resulting teams might end up

being roughly equal in terms of student popularity, but there's no guarantee they'll be well matched on the field. Anyone who was the skinny kid, or the asthmatic kid, or the Black kid, or the queer kid in school will also understand something else that's built into this particular algorithmic system: a performative cruelty.

A modern gym teacher might consider a more sophisticated approach. Aggregating data of students' performance over the year, they might write a program that generates every possible combination of teams and then select the one that is most statistically balanced. This seems to solve both of the main problems of the previous approaches: Because it's not random, the teams should end up equally balanced. Because humans aren't involved in the team selection, social pressures shouldn't play into how the teams are constructed. The gym teacher also gets a bonus: they remove themselves from the construction of the teams and thus can't be blamed for any choices that are made. This solution, though, depends on data that is unbiased—specifically data that hasn't already been fouled by the poor team-picking methods the teacher (and teachers before them) have already used. How much of Mark's statistical sports skills had come from his benefiting from being able to load a team with friends who'd always pass him the ball? How many disabled students were ever picked to be second captain, first pick?

The gym teacher could, I suppose, run a first series of games with randomly picked teams and then use the stats from *those* games as a basis to pick properly fair squads. But by that time the kids would already be on summer vacation.

=

It might be hard to put these gym class sortings in your brain alongside today's algorithms—computational monsters that

generate deep fakes and automatically caption your vacation images and give us hallucinogenic images of puppy slugs. It's certainly true that these algorithms, together with their accompanying computational constructs, operate at a different scale. Google's BigGAN, for example, can synthesize "shockingly real" images from text: give it the phrase "three kids at a picnic table," and you'll get back an image as described, albeit three kids who never existed sitting at a picnic table fashioned straight out of a computer's woodworking imagination. One of the most successful BigGAN experiments was trained on hundreds of millions of images from all over the web (conveniently aggregated by Google's search engines); it took 512 top-of-the-line computers with 512 graphics processors forty-eight hours each. All this computation takes a lot of electricity: nearly five thousand kilowatt-hours, roughly the same amount of power an average American household uses in six months.

BigGAN's image imaginary is composed of artificial neural networks, a kind of mathematical model that traces its roots back to the 1940s, when logicians and neuroscientists and cyberneticians were trying to explain how the human brain learns. Taking a page from how actual neuron cells work, neural net pioneers conceived of a system of nodes, each a kind of simplified neuron. These nodes hold a number, called an activation potential, above which a node will "fire," sending a signal to one or more other nodes, or, if there is no node to talk to, spitting out a result. Stitched together into collections (networks), these nodes showed the ability to recognize pattern; that is, to take a specific set of numeric inputs and to turn it, consistently, into an expected result.

Imagine a group of thirteen children in a classroom, sitting in three neat rows of four, with one sitting alone in the back row. Each child can be given either a cookie or a nap. A cookie increases the kid's energy level by one; a nap reduces it by one. If a child's

energy goes above a level ten, they have a tantrum, exhausting their excitement but also passing some of it on to any kids they may be connected to. Neural networks tend to be "feed-forward," meaning that signal can go in only one direction from node to node. In our classroom, we can take this to mean that kids can pass energy back only to those sitting behind them.

If we feed a plate of cookies to the kids in the front row, we can expect a wave of hysterics to pass from the front to the back of the class, ending with our lonely back-row student in tears. If every child in the front row got the same amount of sugar, and if they all had the same tolerance for it, this wave would be uniform, starting and ending with crying kids. Neural networks function the way they do, though, because the nodes aren't uniform; they are weighted. This means every kid in our classroom has a different tolerance for cookies, a different level at which they'll break into a conniption. The wave of tears won't flow evenly from front to back, and the signal that we pass into the front won't be the same as the one that comes out the back.

Assuming the kids in the class are randomly weighted, each with a unique combination of patience and metabolism, feeding different amounts of cookies to the four kids in the front row would result in times when the back-row student loses their temper and times when they don't. Importantly, feeding the same pattern of cookies to the front of the class will always result in the same outcome in the back. This means that the classroom acts together as a pattern-recognition machine. Anything we might be able to translate into "cookie language," a set of four numbers, can be fed into the machine to get a tantrum-based yes or no.

If the teacher wanted to make sure they got a specific reaction from a specific piece of cookie code, they could reseat or replace the students, feeding the cookies to the front until the teacher saw the answer they wanted from the back. The teacher might

train the class to recognize their birth year—2015—or the first four notes in "Baby Shark," or a binary representation for the number twelve. In a school assembly, with many more students, this same system could be arranged to recognize bigger sets of numbers, digitized words, or pixelated faces. More than that, a large network might be trained to recognize signals that are similar: faces that are smiling or words that rhyme with "cheese." A crucial point here is that the kids in the network don't need to know anything about the signal or the desired output. They just eat cookies, cry, nap, and compute.

Training a kids-and-cookies neural network would be laborious. That's a lot of baking, and a lot of Kleenex. Computational neural networks, of course, operate inside a computer, where things are faster and a lot less messy. Advances in neural network construction and processing power have meant that gigantic networks can be made and trained quickly. A modern neural network might have several hundred nodes and might be trained over several billion generations.

=

A neural network is not an algorithm itself, because, when activated, it runs only once. It has the "do" but not the "until." Neural nets are almost always, though, paired with algorithms that train the network, improving its performance over millions or billions of generations. To do this, the algorithm uses a training set—a group of data for which the programmer knows how the neural network should behave—and at each generation of training the network gets a score for how well it's doing. The algorithm trains and retrains the network, rolling down a gradient of success, until the network passes a threshold, after which training

is finished and the network can be used for whatever classification task it was designed for.

Neural networks excel at classifying things that have a lot of data attached to them. What's more, they're particularly good at classifying things in which the reasons for classifying correctly are hard to describe. Take, for example, a task in which a neural network is asked to decide whether a set of images contains birds: the images are labeled either "bird" or "no bird." This is a problem that most humans are quite good at but one that computers have, in the past, had a really hard time with. This is because it's actually quite tricky to describe what a photograph of a bird looks like. Your brain and mine might be able to look at a photo with a white cockatoo on a perch and another with a flock of starlings against a sunset and think "bird." But where does the "birdiness" of these photos lie, exactly? It's both beautiful and a little terrifying that we can avoid the stickiness of this question by training a big enough neural network, for enough generations, with a sufficient number of input images, to define "birdiness" on its own. By later feeding the network some "bird adjacent" images (other, similar animals, patterns that resemble feathers), its programmer might be able to reverse engineer exactly what part of the input signal the network has latched onto, but more often programmers are content with the result, a bird-finding machine built on nodes and weights and chance.

There's an important difference between the way neural networks work and the way a standard computer program does. With a run-of-the-mill program like a decision tree, we push a set of *data* and a list of *rules* into our code-based machine, and out comes an *answer*. With neural networks, we push in a set of *data* and *answers*, and out comes a *rule*. Where we were once drafting our own rules for what is and what isn't a bird, or which prisoners

may or may not re-offend, the computer now constructs those rules itself, reverse engineering them from whatever training sets it is given to consume.

Training sets, we've come to learn, are too often incomplete and ill-fitted to the nuances of the real world. When Matthew Kenney ran his experiments with word2vec, the algorithm didn't decide to link "black" to "criminal" because it found some pattern in the real world; it did it because its training set of news articles, largely from the United States, commonly placed those words together. Joy Buolamwini's computer vision program didn't fail to see her face because of some mistake in its code; it failed because the image set it was trained on contained a hugely overweighted majority of white faces.

=

Sam Sinyangwe described how, after he and his collaborators launched Mapping Police Violence, *The Washington Post* released a similar project, collating various citizen-driven collection efforts into a single database. That *The Washington Post*'s database and MPV's are quite similar isn't surprising, given they started with the same goal. However, the two teams made different decisions about how the real-world stories of police killings would be translated into data. The *Post*, crucially, decided that it would classify incidents in which kids were brandishing toy guns as cases where the victim was "armed." "So they did not classify Tamir Rice as unarmed," Sinyangwe explains. Mapping Police Violence, on the other hand, does list Rice as unarmed. "That's a choice that needed to be made, and there isn't a clear-cut answer," Sinyangwe says. "But it is a political decision."

Here is a real thing that happened, a real and painful and tragic thing, which became data in two very different ways. Consider a

future in which every law enforcement officer wears a body camera (a particular solution much recommended to curtail police violence). To get around the messy judgment of fallible humans, a neural network is used to analyze footage on the fly, to decide whether a situation requires an armed response. To get to the shoot or don't shoot *rule* that is at the center of the logic, the system is fed with *data*—images from crime scenes, video from bystanders, historical footage from body cams. But that's not enough. The system also needs *answers*, to be taught in which scenarios officers might be justified in firing and in which scenarios they aren't. Where do these answers come from?

A body-cam analysis system trained with the *Post*'s data might, thanks to a decision made by the people who made the database, recognize Tamir Rice—and boys with toy guns like him—as armed. Meanwhile, another network, relying on a different data set built on different human decisions, makes the opposite choice. What might have begun as a way to remove certain biases from policing decisions ends up entrenching different ones, often harder to trace back or understand.

Algorithms can, in themselves, be biased. They can be coded to weight certain values over others, to reject conditions their authors have defined, to adhere to specific ideas of failure and success. But more often, and perhaps more dangerously, they act as magnifiers, metastasizing existing schematic biases and further darkening the empty spaces of omission. These effects move forward as the spit-out products of algorithms are passed into visualizations and company reports, or as they're used as inputs for other computational processes, each with its own particular amplifications and specific harms.

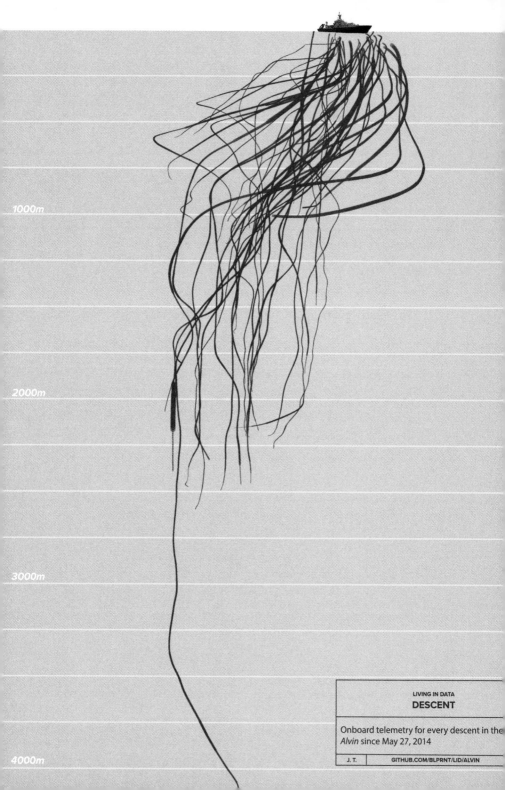

1000m

2000m

3000m

4000m

LIVING IN DATA
**DESCENT**

Onboard telemetry for every descent in the
*Alvin* since May 27, 2014

| J. T. | GITHUB.COM/BLPRNT/LID/ALVIN |

# Interlude

Only a thin layer of the world's seas is lit by the sun, a brief segment from the surface to 650 feet or so, after which the dark of the water is a true dark, an inky blackness in which photosynthesis becomes impossible. The oceans' average depth is twelve thousand feet, which means that 95 percent of the 70 percent of the earth that is ocean lives permanently in blackness.

Even in the slow descent of our titanium sphere, this illuminated section of the ocean was fleeting. *Alvin*'s tiny portholes painted a gradient from a blinding turquoise through all the crayon colors of blue. Robin's-egg blue, Pacific blue, blue green, cerulean blue, navy blue, denim. In the last meters there was a five-minute fast-forward of the long hours of twilight. And then darkness. The portholes seemed painted over with some kind of perfect black, an illusion that held until the occasional silvery shape flitted past.

At two hundred meters the pilot killed the lights inside the sub, and as my eyes adjusted, I realized that what I'd seen as such a sheer black wasn't really dark at all; out there in the deep water there were tiny lights, rising up as we sank past them. Blinking

motes of white, darting lines of fluorescent blue. Long chains of red and orange, oscillating rainbow rings. The sun can't bring light down this deep, so the animals have brought the light themselves. The deeper *Alvin* sank, the more lights appeared, a menagerie of twinkling, shining, living things. At one point a curious flashlight fish hung for a moment in the window, and the light from the shining organ underneath its eye was enough to reveal its shape, to remind me that these lights in the darkness were just traces of the real animals; that if I were somehow possessed of eyes that could see into this near-perfect dark, all of their strange anatomies might be revealed.

For ninety minutes I watched the lights rise past the tiny window beside me. There were regime changes as we descended. Schools of lantern fish gave way to long colonial siphonophores, like strings of Christmas lights. At one point we passed through a layer that was like an arm of the Milky Way in the night sky, dense with tiny points of light, each of them blinking in and out.

"We're going to touch down here in a minute," the pilot said, breaking the spell of silence. "I'm going to turn on the floodlights."

And suddenly there it was, the ocean floor. A gray expanse of smooth silty sand extending off to the edges of *Alvin*'s light in all directions. The water was so perfectly clear, and the sub was so completely still, that it was hard to convince my brain that we weren't floating in the air. Out in front of me a chimaera, an ancient ancestor of the shark, swam in from the darkness. It paused for a moment to look at us with its great reflective eyes, before it darted off again into the deep.

The pilot radioed up to the surface, confirming that we'd made it to the seafloor. He reported the depth—eleven hundred

meters—and confirmed the mission plan. We'd be down here, in this strange world, for an hour and a half. We were looking for methane cold seeps, places where gas bubbles up through the seafloor, oases that would be marked by tall stands of tube worms and beds of giant mussels that had learned to live without the sun.

Three days before, I'd taken a small boat from Chauvin, Louisiana, out into the Gulf of Mexico. Hours later, long after land had disappeared over the horizon, we rendezvoused with the RV *Atlantis*, a three-hundred-foot research vessel operated by the Woods Hill Oceanographic Institution. The *Atlantis* was just beginning a three-month mission to explore a series of strange deepwater ecosystems in the Gulf, and I'd been invited along by the mission's head scientist, Dr. Cindy Lee Van Dover, as a kind of artist in residence at sea. The chance to spend two weeks aboard the ship with some of the world's leading deep-sea scientists had been enough for me to respond with an enthusiastic yes; it was only when we were arranging the details that I'd learned that my residency would include two dives in *Alvin*, down more than a thousand meters to the bottom of the sea.

Dr. Van Dover—Cindy, as she tends to insist—is a person deeply connected to the oceans' depths. As well as being one of the world's leading deep-sea oceanographers, she was *Alvin's* first female pilot and has taken more than a hundred dives to the ocean floor. She and her collaborators have described dozens of new species, and she has done more than perhaps any other individual to explain how deep-sea ecosystems function.

"One of our biggest problems is imagination," she told me in our first phone call. "We have these amazing, tremendously important ecosystems, which are critical to our understanding of life on this planet, and maybe two hundred people have ever seen

them." One thing that has always been crucial to conservation movements, Cindy told me, was an emotive connection. A person might not have ever set foot in a Brazilian rain forest, but we can convince ourselves that we or our children someday might. How can we persuade someone to care about a place that they will almost certainly never visit?

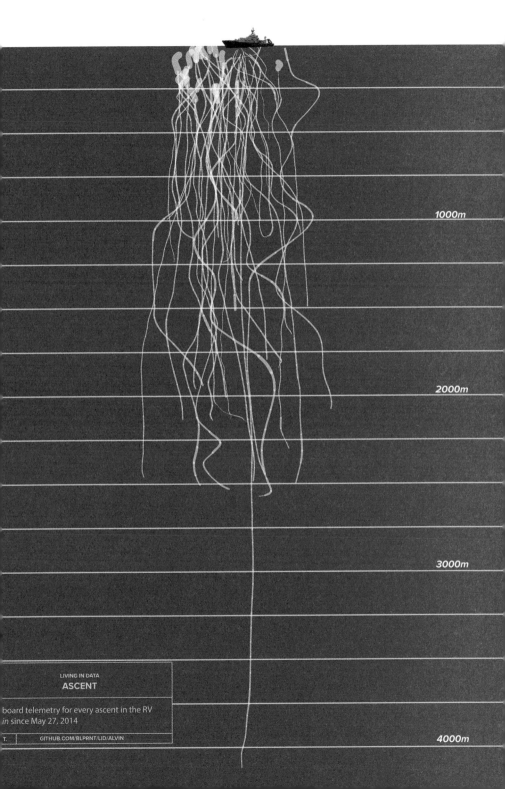

1000m

2000m

3000m

LIVING IN DATA
ASCENT

board telemetry for every ascent in the RV
*in* since May 27, 2014

T.     GITHUB.COM/BLPRNT/LID/ALVIN

4000m

"The first image of Mars," made on July 15, 1965. This image is made up of a series of hand-colored printer strips, and was sh by hand with crayons.

# 8. A Lossy Kind of Alchemy

We were taught that the world could be described, and even
explained, by means of simple answers to intelligent ques-
tions. That in its essence the world was inert and dead,
governed by fairly simple laws that needed to be explained
and made public—if possible with the aid of diagrams. We
were required to do experiments. To formulate hypotheses.
To verify. We were inducted into the mysteries of statistics,
taught to believe that equipped with such a tool we would
be able to perfectly describe all the workings of the world—
that ninety percent is more significant than five.

—OLGA TOKARCZUK

On July 15, 1965, NASA's *Mariner 4* spacecraft swooped past Mars,
traveling at a speed of seven kilometers per second. As it flew
by, its onboard television camera shot twenty-one images of
the planet's surface from 9,968 kilometers up, the closest that
anything human-made had ever come to the red planet. Then
the spacecraft looped toward the back of Mars, and it was out of
communication, messages blocked by a planet's worth of rock. The
images, humankind's first look at the surface of an alien world,
sat on the spacecraft's tape drives for three hours. In the control
room, 216 million kilometers away, the NASA scientists waited
anxiously. Just after 7:00 p.m. in Pasadena, *Mariner* found a signal
again and began to transmit the images back to Earth.

On board the satellite, a small device called a slow-scan vidicon tube had translated the optical signal from the TV camera into numbers. These numbers were then streamed back to Earth, a kind of pixel-by-pixel reading of the image that took twelve minutes to get from the spacecraft to the control center. Back in Pasadena, these numbers would again be written to tape and would be loaded into a computer for processing and display. Given the slow computational speeds of the mid-1960s, each image would take hours to process. The scientists did not want to wait. So they came up with a surprisingly analog work-around that would get them an image of Mars—the first image of Mars created by human beings—before the computer had time to spit the official one out.

First, they printed out the numbers—130,000 of them from the first image—into a long strip. Then they cut the strip into pieces that were 360 numbers high (this was the vertical resolution of the images). They lined the newly cut slices of paper up next to one another and ended up with a grid of numbers, each of them representing a "pixel" of the image. The numbers ranged from 000 to 100, where 100 was a very dark pixel and 000 was a very light one. The plan was to shade the block containing each number on the paper, to convert the whole collaged thing into an image. For this they'd need a set of markers, or pencils, or something that had an even range of colors. NASA, as it turned out, was not a place where art supplies were easily found, so a runner was sent to gather whatever they could from the offices and laboratories around the building. The runner came back with a set of pastel crayons. Digging through the box, the scientists found a range of shades that would be good enough for what they wanted to do: yellow to red to brown to black. After an hour of coloring, a group of three NASA scientists stood up to see Mars for the first time. Television crews, also too eager to wait for the computer-rendered image,

Living in Data

broadcast the map. It was the crayon drawing seen around the world.

At the core of data visualization is this hands-and-knees-and-crayon thing: to take a number and turn it into a visual element. To take a measure and make it into something that is differently understood. We do this to better comprehend a record (often a number), to grant it some kind of new significance, and to share it with other people. This is a habit we get used to early: we teach kids to count using real-world things as proxies for numbers (say, a basket of apples), and we show them that numbers have significance by marking their heights on a door frame. It's quite possible there was a data visualization at your second-birthday party, when a parent lit two small wax candles and set them into a frosted cake. Two whole years of your life, two years full of learning to talk and saying your first words, two years falling and learning not to fall and learning to walk and learning to run. All of that in two candles, in a cake. *Blow them out, dear.*

I'm starting this chapter with crayons and birthday cake to underline one of the most important things I've come to understand about visualization as a form of telling: that it is a simple thing. Any burdens we've placed on it—requirements for objectivity or truthfulness—come more from our own politics than from some innate character of the act itself. These simple examples also help to illustrate that data representation of any kind is a human act, full of human choices. As we've seen, the processes of making data and changing it with computers are rampant with decision points, each of which can greatly increase or greatly limit the ways in which our data systems function. When we reach the showing stage, where we decide how our data might tell its story to humans, possibility space goes critical. Each time a data designer picks a chart type or a color palette or a line weight or an axis label, they're trimming the prospects for communication. Even before

**A Lossy Kind of Alchemy**

that, the choice of a medium for representation has already had a predestinatory effect. A web page, a gatefold print, a bronze parapet, a birthday cake—each of these media is embedded with its own special opportunities and its own unavoidable constraints.

=

Search for a definition of "data visualization," online and in books, glue the pieces together, and you'll end up with a chimera. *Data visualization is a process. It is a set of technologies. It is a graphical representation. It is a practice. It is a situation. It is the use of visual effects for communication. It is mapping, it is displaying, it is transforming and translating. It enables communication and supports decision-making. It amplifies human cognition. It is looking at the world from a data point of view. It is a form of knowledge compression, an emerging market space, a software feature, and a discipline.*

You may glean from this that data viz is not, as much as some may try to make it so, a neat process. There are no correct instructions to follow, no best practices. Some readers might bristle at this suggestion (provided they've made it this far, past the hippos and the sheep and the lazy attitude toward pluralization). They'll point to fifty years of graphics semiology, take their copy of *The Visual Display of Quantitative Information* off the shelf, gesture wildly at an entire subdiscipline of cognitive science. They'll send me a link to a blog post by Stephen Few. "Rigor," they'll say, a little more loudly than they'd meant to.

I've learned over the last twelve years on Twitter not to put a lot of energy into arguing. Data viz fanatics are a lot like hippos: territorial and quick to anger. It's best to wait until they've exhausted their bluster, then continue on your way. And so I stay quiet and think of the hundreds of conversations I've had over

the years with people who are in the business of making data visualizations. Graphic editors at *The New York Times* and *The Guardian* and *La Lettura*, designers in small studios and large corporations, epidemiologists and network scientists and statisticians. Students who've just finished their first visualizations and professionals working on their thousandth. Very nearly all of them speak of something inexact.

My own data viz process is defiantly nonlinear. I fail. I rewrite the code. I fail. I try a new type of chart. I fail. I munge the data. I fail. I do this all over again, until eventually my tall stack of failure carries itself well enough that it can pass convincingly as a success. There are folders all over my computer, on backup drives in drawers and closets, with files labeled by day and time, scrolling lists of tangents and backtracks. For each project a termite mound of castaway ideas, buggy commands, and crossed-out sketches.

Near the end of the summer of 2011, I was asked by the publishers of *Popular Science* magazine to produce a piece that explored the archive of their publication—140 years of homemade telegraph machines, crystal radios, mail-order ads, hovercrafts, and floppy disks. I asked my friend Mark Hansen, a statistician and artist, to help out, and together we sorted and analyzed the data set and figured out how to show it on a printed page. The result was a graphic that combined a color history of the magazine's cover photographs with a linguistic analysis that showed how different terms in the magazine came and went over the decades. The visualization stretches across two pages, a stylized time line in the form of a molecular chain. At the hub of the molecules are decades; branching off from these are bubbles that hold issues for every year, rendered as circles colored to match the covers of the magazine. From 1872 until the early 1920s, these circles are gray. By 1930 they're all color, though constrained in color by printing

processes and by in-house style guides. From 1948 until 2000, the *Popular Science* logo was orange, so this color appears in every circle for every issue for almost half the graphic.

Across the whole spread, filling the space around the color chain, are seventy-seven little graphs, each showing the frequency of a specific word during a particular stretch of the magazine's history. I specifically chose words that come in and out of usage. "Telegraph" appears in 1878 and holds on until 1943. "Datsun" occupies two decades, starting in 1966. There is "celluloid" (1880–1946), "dirigible" (1902–1947), "Bakelite" (1918–1957), "H-bomb" (1950–1968), and "cassette" (1962–2000). There is of course "hovercraft" (1963–1997). History can be read in the transitions: "Nazi" to "IBM," "ultraviolet" to "microwave," "hobbyist" to "geek."

In the folder for the *PopSci* project is an image for every major change I made to the code, from early attempts at structure to tiny tweaks in color or typeface. There are more than three hundred images, rendered over two weeks (all for $250 and three free copies of the magazine). When read together, these images are, like the visualization, a time line. They hold a history of the choices I made as the graphic came to be. Adding things, in the beginning, and then removing them. Removing more. Trimming out ideas. Excising information, sanding it down, sweeping away the dust. Data visualization is a lossy kind of alchemy.

Visualization favors cleanly drawn lines and neatly printed dots. It wants the edge of bars and borders on maps to be cut with a sharp blade. Some of this neatness is a result of the tool, the computer's cookie-cutter logic exposed again as things are taken out of a database and put onto the screen or the page. Some is a result of visualization's fundamental distaste for uncertainty and ambiguity. But much of the cutting away is deliberate, done to fit the graphic to the shape that it holds in the designer's mind.

One way to avoid the onus of omission is to give the people

who are reading the visualization some control as to what they see and from which angles. While static visualizations hand viewers a carefully framed postcard of the data, exploratory visualizations give users a vehicle, where they are (to some extent) free to roam the full terrain of the data, snapping photos as they go. Almost all of my visualization work has taken the form of exploratory tools. Even in the case where the result is a static image (like the *PopSci* piece), I build my own vehicles, to make it easy for me to range widely across a data set's terrain. More often, I let others drive.

At *The New York Times*, working again with Mark, I built a tool to model how the newspaper's content was shared online and how people talked about it. It was a complicated system. To explain it on the first day, Mark drew a diagram of how people might read a news story on the internet and go on to share it with their network. Then he added to what he'd drawn, showing a second generation of sharing, and a third. From this, he explained the project we'd undertake in the lab: using data from a URL-shortening company called Bitly, we'd be able to take these sharing structures, which had until then been largely hypothetical, and construct statistically sound data sets of the actual sharing activity. This was possible because the URL shortener bridged two previously separate worlds: the *New York Times* site and the Twitter feed.

Consider a news story with a hypothetical URL: http://nytimes .com/bignewsevent. Before the work that Mark had started, there was no way to see how someone had found that particular URL when it appeared in their tweet. They might have seen it on one of their friends' feeds, they might have found it on the website, they might have read it in an email newsletter. But Twitter and Bitly had set up a system where every time a *New York Times* URL was shortened by a user, it created a unique URL—http://nytim.es/sdq889s

when I shared it, http://nytim.es/kuk2xa when you did. By following how these URLs appeared and how they propagated through Twitter, Mark would, in theory, be able to construct a clear data picture of exactly when and how everyone on Twitter was sharing a *New York Times* story and what they were saying about it.

First, the Bitly data needed to be processed and run through a statistical model that "filled in the blanks," assigning a probability for each link in the sharing trees that we were generating. If I posted a *New York Times* story in my time line, and one of my followers posted the same story, the model assigned a chance whether the two postings were related. This ranged from a 100 percent chance (in the case of a retweet) to a near-zero chance (in the case where the two postings were many hours or days apart). The model created a data set that contained the sharing structures and these various probabilities. The visualization tool that I built was meant to take these data and show them to the user as expanding tree diagrams, back over time.

It didn't work right away. By a month in we still hadn't seen a "real" sharing tree rendered in the tool. Mark's model was outputting something, and my tool was working well with prebaked test data, but thus far we hadn't managed to get the two systems playing well together. And then one morning, all at once, it worked. Mark sent me a file, I loaded it into my system, and I watched as a perfect animation of a thousand people sharing a story built itself in front of my eyes. It was a wonderful moment, containing all of the joy that I mentioned in the beginning of this book. There, in front of me, was something that existed in the real world, a thing that had happened but that no one had ever seen before.

Exhilarated, we generated data set after data set for story after story and watched the "sharing trees" for each one of them grow on-screen. What we saw right away was that each tree was different—sometimes radically different. Some looked like tall

Christmas trees, others like low and rangy shrubbery. Some were lopsided, others were split in two, but each one was different. We'd discovered a method to make visual fingerprints of conversations, and with this method came a whole new set of language. Whereas before we'd had only the most limited terms to describe conversations—they might be short or long, big or small—now we could describe a sharing system as bushy, or bivariate, or lopsided. There were the *Charlie Brown Christmas* stories, thin, teetering trees, which of course Mark and I found endearing.

The project—which we code-named Cascade—became an extraordinarily productive question farm. Armed with our new vocabulary, we quickly stacked them up. Did certain writers cultivate certain types of sharing trees? (Yes.) Can we say anything about a person's influence by their position, whether they are in the root or the trunk or the branches? (Yes.) Can we predict what kind of shape a tree will have in the early moments of its growth? (Maybe.) We installed Cascade on a five-screen video wall in the hallway outside the lab and made an app for anyone to control it. In groups or alone, staff from the R&D group and elsewhere at the *Times* could view every sharing structure in detail, see everyone who tweeted, and watch the trees grow in real time.

At the time, *The New York Times* was publishing more than six thousand pieces of content a month; while our data vehicle couldn't cover all of that terrain, it exposed all kinds of interesting vistas. Some were sprawling, memes bursting across social media like time-lapsed weeds. Others were more intimate. One day, I stumbled upon a tiny sprout of a conversation about an article from the city desk. It was a civilized, quiet exchange, atypical of Twitter. All five participants were rabbis.

While Cascade was meant to be purely a research project, various people at the *Times* followed the fresh smell of monetization potential to our lab. They carried in their own questions. Can we

figure out which stories are going to go viral? (Probably not.) Can we find out what brands the people who are sharing our content are interested in by looking at their feeds? (I guess?)

Can we sell this thing? (Uh-oh.)

Cascade ended up being moved to its own new department, where a small team of designers and developers took it far beyond our prototype. I went on to other projects at the *Times*. A tool to visualize home power usage. A browser plug-in to see the semantic network behind web pages. I did more work for magazines, too. A visualization of the U.K.'s National DNA Database, a mapping of shipping traffic in the world's biggest ports, an exposé on what patterns could be gleaned from cell phone data. When I left the *Times* and started the Office for Creative Research, exploratory tools defined our practice. We made them for researchers analyzing botnets, for scientists indexing exoplanets, and for ambulance dispatchers in rural India. In our last project as a studio, we made a real-time interactive visualization of the entirety of Twitter.

At some point along the line, I got tired. Tired in part because to make data visualizations is to be constantly answering to data visualization's critics, to be forced to answer, again and again, "What would Edward Tufte say?" Tired because all my roads seemed to lead inevitably to marketing, to branding, to the placement of ads in browsers. Tired as well because I knew at some deep level that there was more to be done. That charts and graphs and maps, even exploratory tools, touched only some puddle-shallow part of the creative potential of data.

Reading descriptions from its canonical texts, you might be forgiven for assuming that data visualization describes a moral outlook as well as an act. In the opening chapter of *The Visual Display of Quantitative Information*, Tufte, the grand old man of

data viz, lists nine things that graphical displays of data should do, among them a list of acceptable purposes for data viz: description, exploration, tabulation, or (we get the sense grudgingly) decoration. Stephen Few invokes the Buddha on page 9 of *Show Me the Numbers*, suggesting that practicing the good, conservative kind of data viz is to find a "right livelihood." Thou shalt not "entertain," he writes, nor "indulge in self-expression." "We *must*," he tells us (emphasis my own), "lead readers on a journey of discovery, making sure that what's important is clearly seen and understood." In the introduction to *The Truthful Art*, Alberto Cairo writes that the purpose of data visualization is to "enlighten people—not to entertain them." Quite the responsibility has been placed in this simple thing of turning numbers into dots, shapes, and colors. There are echoes of Clive Humby's data-as-oil idea here, too. *It has to be changed into gas. It must be broken down. It must be analyzed to have value.*

To be a practitioner of a "truthful art" is, after all, to name yourself as a truth teller, to self-ascribe authority to your own perspectives and ways of knowing. To follow Tufte and Few is to walk the path of an ascetic, signposted by objectivity and reductionism. In a quest to avoid the daunting specter of bias, data visualization practitioners too often adhere rigidly to best practice, scrubbing and scraping at the excesses of "decoration" until, they hope, there's nothing but the clean white bone of truth. The result of all this is that there's a kind of meal-replacement logic at work—a conviction that a story might be blended down into a neat, easily consumed slurry, with all the essential vitamins and absent the pesky nuance. That none of us should miss the crisp snap of an apple's skin.

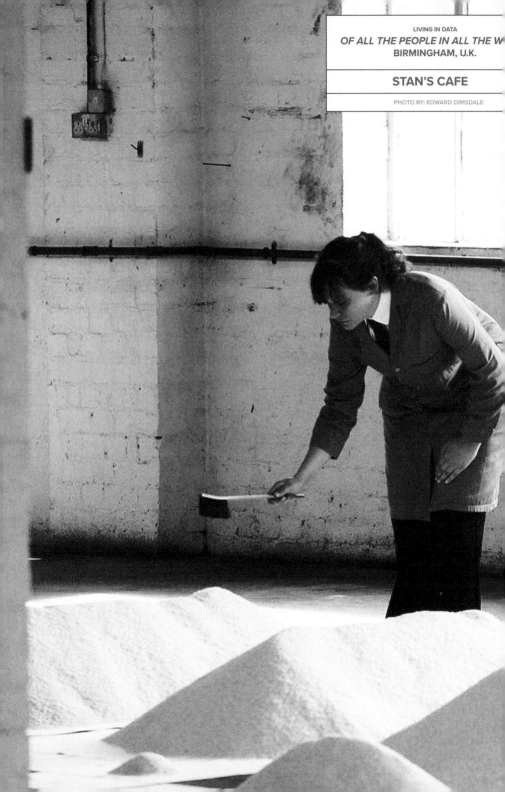

LIVING IN DATA
*OF ALL THE PEOPLE IN ALL THE W*
BIRMINGHAM, U.K.

STAN'S CAFE

PHOTO BY: EDWARD DIMSDALE

## 9. The Rice Show

At any given point in time, there are more than a million people in the air. This number fluctuates. For a few hours every day you'll see a dip in airborne humans when the wide expanse of the Pacific Ocean (which hosts very few airports) takes up much of the waking population. In a week you'll see boosts as long-range commuters leave their homes on Monday morning and return on Friday afternoon. In a year you'll see punctuated drops in the number of people in the air (Christmas Day) along with longer seasonal trends (summer vacations). But the variance is smaller than you might think, and that number remains fairly constant. One million people, aloft.

The human brain is not particularly good at comprehending large numbers; we begin to fail somewhere in the low hundreds. As an example, you could probably give a fairly good estimate as to how many words are in this sentence, without having to go back and count the words one by one (there are 35). Likewise, you might be able to give a reasonable guess as to how many words are in this paragraph (93) or are on this page (208). But what about how many words are in this whole book (79,752)?

If I ask you to close your eyes and imagine a million people, the best your brain can do is offer a kind of aggregate crowd shot, a mental placeholder for "a lot."

Visualization can do something to persuade our brains to estimate numbers with a little bit more accuracy. One useful approach is to space out individual units on the page or the screen such that our brain can do a better job of estimating and then multiplying. We can guess fairly well how much space is occupied by about a hundred things, and then we can guess again how many hundreds of things might be on a page. Likewise, we can introduce aggregate symbols. If I can teach a person that one dot equals one hundred people, then use the exact approach that I outlined above, a person might be able to start to get a sense of higher numbers. But we're losing something to abstraction, moving from the brain's ability to count to its ability to place-hold. When the numbers we're counting are people, we also lose a sense of the individuals in the groups when we clump them together into a visual unit.

Representing big numbers has been one of my biggest puzzles as a data visualizer, one that I've never quite solved. In 2009, I made a graphic for *Wired* U.K. showing the 4,457,195 people in the country's National DNA Database. Not content to batch these people into groups of a hundred or a thousand, I wrote a program to patiently draw each person as a dot, connected into a long, winding skein. It's a neat visualization, still one of my favorites, but I question whether anyone, given the small size of the magazine page, really understood the scale of it all. Who cares about a dot?

In June 2019, *The New York Times* offered a clever interactive solution to show the scale of the crowds in Hong Kong's street protests while maintaining a sense of humanity: the designers tiled a series of thirty-two images together into a scrolling page, starting first with seven detailed images and then zooming out to

the full set. The graphic, made by Jin Wu, Anjali Singhvi, and Jason Kao, scrolls for 25,639 pixels (about ten screens' worth) and is marked with a series of useful comparisons. "The roadway here is about 66 feet (20 meters) wide," reads one annotation, giving the reader a sense of scale. It's a wonderful piece, using photography in a way that is likely more effective than any drawn or generated diagram might be. But it's still difficult, for me at least, to find a meaningful relation to the numbers: two million people, by organizers' estimates.

Living in data, we are required day by day to think about these large numbers, to put them into our minds and give them weight and meaning as if they were something that actually made sense. There were 147.9 million Americans whose consumer records were exposed in 2017's Equifax breach. Bredolab, a botnet that spent much of 2009 sending out spam emails, infected more than 30 million computers. Facebook, at the time of this writing, has 2.19 billion active users. XKeyscore, the vast digital surveillance machine exposed by Edward Snowden, collects an estimated 14.5 trillion records every day. Each of these numbers is intractable to our brains. The digits are swapped out for a placeholder. A lot of people. A lot of users. A lot of records.

How might we get a little closer to these kinds of multitudes?

=

In the summer of 2019, James Yarker and I sat in a cafe around the corner from his studio in Birmingham's jewelry district. If you're like me, it's possible that the word "cafe" (unaccented, note) is deceiving you in a couple of ways. First, in local parlance it's pronounced "kaff," like the sound Bill the Cat makes. Second, the English cafe bears little resemblance to its continental cousins; you'll find no

tablecloths, no sophisticated smoking of cigarettes, no delicious canapés, and no refreshing Aperol spritz. Instead, these establishments are closer to American diners, with Formica tables and a vestigial smell of ashtrays. We'd chosen this particular one because it was nearby and because it made sense to start our conversation at just such a place. "Come to Stan's Cafe, we have to take you to a cafe," Yarker said, as we tucked into our plates of beans and sausage.

Yarker and his co-founder, Graeme Rose, named their theater company after a now defunct establishment in London. The name and its pronunciation are at the same time quotidian and challenging, much in the style of the work they'd become famous for. Stan's Cafe's first success, *It's Your Film*, was a production for an audience of one. Using a Victorian theater trick called Pepper's Ghost, the show took the performances of a real cast and made it look as if it were being viewed as a film. Conceived as a one-off for a Friday-night performance art revue, *It's Your Film* went on to tour across the world and has been called the "godfather of one-on-one theater."

Yarker grew up in Eastbourne, a seaside resort town on England's south coast, composed of stately hotels and white chalk cliffs. As a child he remembers looking out across the gray Atlantic. "I was very aware of the boundaries of the country," he told me, "but not the scale of the world." Having never been outside the country he was born in, he found touring *It's Your Film* across several continents a revelatory experience. "We'd dive in and out of these capital cities, and I had this real sense of agoraphobia," he said. "Just think, if you're brought up in Britain, that's the limits of your world. I mean, it's small, isn't it? Suddenly you're on mainland Europe, and that landmass actually goes a hell of a long way in every direction."

Back home in England, Yarker looked up the population of the world, which at that time was just over six billion. "See-

ing that number, written down, didn't help very much," he told me, between forkfuls. "It's just an unknowable number." Yarker wondered, would the number be any more knowable if it were represented in real, tangible objects? He assigned this idea as a challenge to his students at Manchester Metropolitan University, where he was teaching theater. They came back frustrated. The number was just too big. Anything small enough to represent such a big number in a small space—sand, sugar, salt—wasn't actually discrete; the grains varied in size from chunks to powder. It was impossible, they told him.

"I was really annoyed," Yarker said. "I really couldn't let go of the idea. And so I said, well, okay, I'll do it then, if you can't do it, I'll sort it out." Yarker's persistence came mostly from the fact that he himself had no idea what a number like six billion really was. It was, to be sure, a really big number. But what did it look like? How was it possible that we had no way to understand such an important number? A trip to the local grocery gave him the idea of using rice to represent the population of the world. He bought a bag and used a kitchen scale to do some quick calculations. Six point two billion grains of rice worked out to be just over 120 metric tons; at the price he'd paid at the grocery, a pile of rice the size of the world's population would cost just over eighty-two thousand pounds (then about a hundred and eighty thousand U.S. dollars). Yarker's big number would have to wait.

A year later, Stan's Cafe received its first grant that wasn't for a specific project; it was, instead, for "development," a term that was loose enough that it could be spent on anything from salary to staging to costumes. Or, Yarker surmised, on three thousand kilograms of rice. The budget wouldn't allow them to get into the billions, but it would, as his arithmetic assured him, get them to the population of Britain. And so he cashed the grant check and drove his truck to the local food wholesaler.

**The Rice Show**                                                                 175.

Yarker soon realized that along with the physical piles of rice, there was a human act of counting, which was very much a performative thing. He also figured out that that gigantic pile of sixty million grains of rice could be subdivided into as many different smaller piles as they might imagine, each in its own way as captivating as the whole. They started to invent groupings: The population of the Isle of Bute. People per kilometer in China. Gun makers in Birmingham. King Henry VIII and his wives. Lawyers working for Squire Sanders. The population of Birmingham, Kentucky, before the construction of the Kentucky Lake and Dam submerged the town. People living with undiagnosed HIV in the U.K. People attacked by sharks in the world each year.

The first performance of *Of All the People in All the World*, which came to be known as "the rice show," happened in 2003. The entire population of the U.K. was there as rice, sixty million grains, give or take. The biggest pile, six feet across, stood in for every person in London (nine million). In front of the big heap were many smaller ones, neat cones of rice on clean white paper, bearing simple labels of what each pile represented. In the space, Yarker and other members of his company were dressed in vaguely bureaucratic uniforms—beige overcoats, white shirts, maroon ties—counting and measuring rice into new piles. The overall effect to visitors was of finding a strange city office that you hadn't realized existed, one entirely concerned with counting.

Counting and comparing. Because the unit of measure is so uniform, it's easy to compare one number with another. Yarker and his team have choreographed these comparisons to some extent, placing one pile next to another to provoke visitors to think about the difference. One mound of rice shows the number of people who auditioned for the reality show *The X Factor*'s fifth season. Beside it is a pile counting the number of people who applied to train as

teachers in the U.K. Two small hills beside each other show casualty counts from the bombing of Dresden in 1945 and the Coventry Blitz. Occasionally, two mounds of rice will show the same number, from different "official accounts," such as the number of people killed at Chernobyl, as counted by the Russian government and by the UN.

In the years since that first show, the Stan's Cafe crew has staged *Of All the People* eighty-two times in cities across the globe. Outside an old tram warehouse in Stuttgart in 2005, Yarker waited for four delivery trucks to arrive, each of them full with sacks of rice. Two weeks of scooping and weighing and piling later, he finally had the answer to his question: *this is what six and a half billion looks like.*

The rice show is a masterwork of what Amanda Cox calls the "kooky comparison": when a piece of information is held against another that purposely contrasts, forcing a viewer to think about *both* data in different ways. A clever piece of stage setting makes sure everyone is ready for this contextual framing: at the entrance to the venue each person is given a grain of rice representing themselves.

=

When I visited James in his studio, Birmingham was getting its first breaths of spring. Stan's Cafe had, since 2009, occupied a corner of a metalworks, A. E. Harris. Behind a tall metal mesh gate was an office, a ramshackle storage area, and a performance space, where the company developed its shows and touring groups from around the country occasionally performed. To tour the space was to get some look into Stan's Cafe's constant disciplinary wriggling. Beside a box of wooden cutouts of cardinals, there were three

rewired exercise bikes, designed for a show about the oil industry in which the performers powered all of the stage lighting. There's a long coatrack hung with costumes for a children's performance about the Cuban missile crisis. "The girls played the Americans," Yarker says, holding up a small, neatly tailored pin-striped suit, "and the boys played the Soviets."

But everywhere, among the disarray, is rice. There are bags of it, taped up, leaning against the wall. A whole shelf is dedicated to measuring devices: scoops and a set of the kind of bucket-on-top scales you might expect to find at a dry goods wholesaler. There are small packets of rice on a table, prototypes for a show in which the leftovers from *Of All the People* were distributed to the audience. We walk past a steel box, two meters cubed. "Rice," Yarker says, before I can ask.

A question I kept coming back to is, why rice? There's the serendipity of finding it at the corner grocery; there's the ubiquitousness of it as a product. It's familiar to almost everyone, no matter what part of the world you're from or what kind of culture you grew up in. Yarker has another theory. "I think it's the shape," he tells me, a non sequitur as we're walking up to his office. "The grains are oblong, so they're like little humans." Later, he describes a strange piece of magic particular to the project, one that I experienced myself when I saw *Of All the People* in person. Within minutes, he tells me, nearly every audience member starts to see the grains of rice as actual people. He explains how a visitor will approach him, cradling a single stray piece of rice found over by a wall or just outside the door. "This one is lost," the visitor tells him. "Where do they belong?"

Yarker tells me about one particular experience that continues to perplex him. He and the team had set up a version of the show at the Vancouver East Cultural Center. On one of the pieces of paper on the floor, there were just two grains of rice—"Andrew

Lloyd Webber and Tim Rice," the label read. On the second day of the show, a woman approached him as he was hunched over the two rice grain playwrights. "Is that really them?" she asked. "Is that really them?" Yarker repeats to me, unable to contain a laugh. "What does that even mean?"

# 10. Paradox Walnuts

Data can be mapped to almost anything, to things so creative and bizarre that they make even the most radical paper- and screen-based visualizations (or gigantic piles of rice) seem downright staid. Perhaps my favorite example of this is *Rose of Jericho*, an installation by the German media artist Martin Kim Luge. The rose of Jericho, *Anastatica hierochuntica*, is a plant with incredible powers of resurrection. When water is scarce, the plant curls up upon itself and resembles an apple-sized brown hair ball. Dried up, it releases its roots and tumbles with the wind until it finds itself (sometimes years later) somewhere that water is again available. It then comes back to life, unfurling its tightly curled leaves and spreading itself out until it looks like a verdant, textured lily pad. *Anastatica* can repeat this process over and over again. Scientists have attributed this remarkable ability to a peculiar sugar called trehalose, which is most often found in bacteria and fungi and which seems to facilitate cryptobiosis—what sci-fi enthusiasts might call stasis.

In Luge's installation, three *Anastatica* are placed on top of pedestals. They sit in shallow dishes, into which run thin plastic

tubes. Below the pedestals, water pumps are placed that, when activated, feed water up to the plants, drip by drip. When the water flows, the plants do their thing; they come to life, unfurling and turning green. If the water flow stops, they reverse the process, reverting back to their tumbleweed forms.

As a biological magic trick, it's impressive enough. In the gallery these three plants live and die and live again. What makes the project particularly delightful, though, is that the flow of the water is mapped to data: specifically, to a word analysis performed on one of Luge's friends' Myspace pages. Using a super-simple sentiment analysis database, a program maps adjectives found in posts to an emotional score. When the friend is using "happier or more wholesome" words, the plants are given more water; sad words cut off the water supply altogether.

It's a remarkable installation on many levels. It takes an inert number, a measure of word usage, and literally brings it to life. For years, *Rose of Jericho* has sat in my brain as a persistent reminder that we've only crept into the very edge of the possibility space for representing data, for communicating its value and its flux. It also speaks to the possibility that data, presented in new ways, might act at a critical time as a tether between our own human lives and the natural world around us.

=

The Bow Glacier, some 750 meters of ice sticking out like a tongue from the Wapta Icefield, is the last stub of a great river of ice that once flowed far to the east, carving out the wide valley that bears the same name. The ice, at its peak, measured more than a kilometer in depth. Twenty-two thousand years ago it stretched itself east out of the Rockies, into the foothills, briefly touching the great plains on which the city of Calgary now sits.

If you're reading this in the spring, meltwater is beginning to flow from the ice and down to the lake, tumbling down a series of waterfalls. The water carries with it dust, tiny motes of rock scraped from the rock bed, evidence of the glacier's heavy movement. In streams, this "rock flour" gives the water the appearance of diluted milk. Down in the lake, the particulate collects to color the water a brilliant, unforgettable turquoise. To the southeast, water drains into the Bow River, which elbows through Lake Louise and Banff and Canmore and Cochrane and Calgary, on its way to Hudson Bay. If you drink a glass of water today in Calgary there's about a fifty-fifty chance you're tasting some of the glacier. If you've lived in the city your whole life, your body is infused with the blue limestone molecules. The mountains are, quite literally, in your bones.

It takes some time for the water from the glacier to make it to the city. If you dropped a small toy boat into Bow Lake on a Sunday morning, and if it was lucky enough not to get caught up or sunk along the way, you could step out onto the Peace Bridge in Calgary early Wednesday evening and watch it drift below you. If you're not that patient, put the boat in your car, pull off the gravel shoulder and onto the Icefields Parkway, and drive southeast from the lake to the city. It would take you two and a half hours, if the traffic wasn't too bad.

I have a print of a black-and-white photograph of the Bow Glacier taken almost a hundred years ago. In it, a man stands, hands in pockets, gazing over the lake and up to the ice. Beside him is a large teepee, pitched on a gravel island. In the foreground, both the teepee and a piece of the mountain are reflected in still water. It's a gorgeous image. In it, the Bow Glacier is massive. It spills hardly held back by the peaks to its right and left, and it pours in three great channels into the valley below ... the line, everything is scraped clean.

If you're reading this in the spring, meltwater is beginning to flow from the ice and down to the lake, tumbling down a series of waterfalls. The water carries with it dust, tiny motes of rock scraped from the rock bed, evidence of the glacier's heavy movement. In streams, this "rock flour" gives the water the appearance of diluted milk. Down in the lake, the particulate collects to color the water a brilliant, unforgettable turquoise. To the southeast, water drains into the Bow River, which elbows through Lake Louise and Banff and Canmore and Cochrane and Calgary, on its way to Hudson Bay. If you drink a glass of water today in Calgary, there's about a fifty-fifty chance you're tasting some of the glacier. If you've lived in the city your whole life, your body is infused with those blue limestone molecules. The mountains are, quite literally, in your bones.

It takes some time for the water from the glacier to make it to the city. If you dropped a small toy boat into Bow Lake on a Sunday morning, and if it was lucky enough not to get caught up or sunk along the way, you could step out onto the Peace Bridge in Calgary early Wednesday evening and watch it drift by below you. If you're not that patient, put the boat in your car, pull off the gravel shoulder and onto the Icefields Parkway, and drive southeast from the lake to the city. It would take you two and a half hours, if the traffic wasn't too bad.

I have a print of a black-and-white photograph of the Bow Glacier taken almost a hundred years ago. In it, a man stands, hands in pockets, gazing over the lake and up to the ice. Beside him is a large teepee, pitched on a gravel island. In the foreground, both the teepee and a piece of the mountain are reflected in still water. It's a gorgeous image. In it, the Bow Glacier is massive. It seems hardly held back by the peaks to its right and left, and it pours in three great channels into the valley below. Above the tree line, everything is scraped clean, scoured by thousands of years of ice.

The photo is staged, typical of nature photography of the era and routine for Byron Harmon, the photographer. He and his expedition team—seven horses, three guides, and a *National Geographic* writer and former war correspondent named Lewis Freeman—had arrived at the lake late the previous afternoon. Finding no suitable forage for the horses, they'd been forced to push forward through deep snow, finally finding some grass and a workable campsite just before dark. The next morning they back-tracked, pitched the teepee on damp gravel, and waited. Weather in the Rockies is tempestuous and unpredictable. Often Harmon would wait for a whole day for the light and snow and frigid fog to cooperate; it wasn't uncommon for him to leave without exposing a single plate. On this particular morning, the clouds cleared for thirty minutes, and Harmon got the shot.

Byron Harmon had arrived in Banff from Oregon in 1903 and had, for the previous two decades, operated a successful studio, producing tourist postcards and portraits of the town's wealthy residents. Over the years, he'd dreamed up a project to shoot every one of the dozens of glaciers attached to the Wapta Icefield, and in Freeman he found a willing collaborator. Fresh off a trip by boat between Chicago and New York City by way of the Great Lakes, Freeman arrived in Banff in the late summer of 1924, and after a few days of preparation they set out. It was tough going. On the second night, three of their horses—which had been fed and rested for months to prepare for the trip—wandered off. The replacements, ill-suited to the rigors of daylong hikes through deep snow, were constantly exhausted and hungry. Two days later, they lost a third of their supplies and another horse in an ill-fated river crossing.

Two boxes that weren't lost in the crossing give us perhaps the best picture of the character of Freeman and Harmon and of the

general disposition of the expedition. In one was a radio, a then very novel device weighing more than a hundred pounds. The other box held eight carrier pigeons. Freeman wanted to prove that the Rockies were not, as experts had predicted, a "dead zone" for radio, and Harmon wanted to see how the pigeons' vaunted navigational skills would fare against the area's tall peaks and winding valleys. The radio worked. Weeks later, they'd get warning of an early storm and decide to end the expedition early, having been in the mountains for seventy days and having traveled more than five hundred miles. Harmon had shot four hundred stills and more than seven thousand feet of film. The pigeons, banded with messages typed onto oiled paper (Freeman had packed his typewriter for this specific task), never made it back to Banff.

In May 2017 a helicopter dropped me with a small team on a snowy patch visible in Harmon's photograph, just beside the peak on the glacier's south edge. We spent much of the morning moving several hundred pounds of batteries and other equipment up to a rocky limestone ridge that we'd scouted a year before. After a quick lunch leaning against the rock to get shelter from the wind, we managed to drill some deep anchor holes and get the frame of our sensor station built.

And then the storm rolled in.

As Harmon and Freeman had well learned, alpine weather can change in an instant, and what was once a clear, windy day quickly became an inclement one. Wind turned to rain, and rain turned to snow. The clouds that rolled over the glacier's clean white ridge were the same dark gray as the rock. Any sort of heavy snowfall would put us in avalanche danger, and bad visibility would make it difficult and dangerous to work. So we stowed our equipment

as quickly as we could under tarps and in Pelican cases, and we made the ninety-minute snowshoe hike to an empty alpine hut. Just as the building came into sight, the blizzard engulfed us.

We spent the next two days indoors. I watched out the window as the snow piled high onto a stack of firewood. The wind howled. We played Yahtzee and tried to ration the regrettably small amount of whiskey that we'd packed with us. With every passing hour, I became more and more nervous. It'd taken us almost a year to get the permit that we needed to install our equipment in the park, and there was no flexibility in that document at all. In a day and a half, the helicopter would come to get us, functional sensor station or not. Anytime the storm abated even just a little, I pinged out frantic messages to my team in New York on our little red satellite tracker. No messages came back.

I barely slept that night, my mind stuck on the worst-case scenario, that the snow would keep falling and that we'd be stuck in the hut for another day. We'd miss our window for the helicopter; the hike back to the ridge by the glacier would be too dangerous in the fresh snow. Our station would be a much more expensive version of Harmon's pigeons, failing in the face of the unforgiving geography. Just as I thought I might never get to sleep, I woke up. Sunlight was streaming through the windows.

We ate breakfast and gathered our gear; after two slow and careful hours of snowshoeing, we were back at our site. The wind on the ridge had kept the snow away, and everything was just as we'd left it. We worked quickly, soldering and connecting and mounting and testing, trying to fit three days of work into one. Early the next morning we sent our first piece of data via radio bridge to a second station we'd built below the mountain, six kilometers away. I used the red tracker to text my team back in New York City, and in minutes I had a reply. The data from the glacier was up in the cloud, streaming through our API. I copied and

pasted a chunk of the data from the station, and I wrote a bit of code to draw it onto my laptop screen. It wasn't much to look at, just a long bar chart, but there was no doubt that there was signal there. Not the TV snow of random numbers, but something more structured, something that felt . . . well, it felt as if it were alive. Up on the mountain, when the wind wasn't blowing, there was an eerie, complete silence. Watching the data scroll by on the screen, though, I could see that the ice was not as it appeared; that its stillness belied a quick and constant movement. Two hours later the helicopter came and picked us up.

The station we built beside the glacier holds three sensors called geophones, which measure the movement of the rock bed along different axes (north/south, east/west, up/down). Shifts in the limestone move a tiny magnetic mass suspended in a wire coil inside each device; this movement is converted into electricity and in turn to a digital signal. Data from the station is beamed four kilometers via radio bridge to the Num-Ti-Jah Lodge at the edge of Bow Lake, then uploaded via satellite. Within five minutes the cracks and shifts of the ice are translated into sound and sent out into the plaza in front of Brookfield Place, a shiny fifty-six-story office building that headquarters Cenovus, one of Canada's biggest oil and gas companies. In the building's entrance, a tall set of seven LED arrays translate the glacial data into distortions in a field of colored lines. At night the light casts out onto the stone in the plaza, some seven thousand unique pieces of granite, cut to depict the geological forces of the glacier's ice field. In the winter the sound and light are muted by freshly fallen snow.

Ben Rubin, a longtime collaborator of mine and co-artist on the project, wrote the audio software for *Herald/Harbinger*— transforming the stream of seismic signals from the glacier into sound, a twenty-four-hour-a-day broadcast from the ice. Played in sixteen channels of surround sound, signals from the glacier

sweep across the plaza. The ice burbles and cracks and pops. Calgary responds with the sounds of the eastbound CTrain passing by on Seventh Avenue, with the rumble of a full garbage truck, with the clattering steps of the well-heeled shoes of a commuter crossing the pavement. On the LED arrays, traffic patterns from around the city and pedestrian paths through the plaza share space with data from the glacier, in a conversation that never quite stops. Often while we were working, the glacier would fall quiet for long stretches, its whispered signal barely heard behind the noise of rush hour. Other times, late at night, when the city was quiet, the plaza would come suddenly alive, an icefall 180 kilometers away echoing out into the street.

Ben and I spent long days installing the piece in Calgary, sitting at a makeshift desk in the center of the plaza at First and Seventh. Heads down, listening to the sounds of the ice, we were somewhere that shouldn't exist, a somewhere that was at the same time 2,450 meters up in a sixty-million-year-old mountain range and in the center of Canada's fastest-growing city. We were sitting in a kind of rift in public space, at once at the edge of the ice of the Bow Glacier and in the midst of glassy skyscrapers, filled with eager oil and gas executives and mining engineers. We had one foot in the Pleistocene, the other in the Anthropocene.

There's an earlier image than Byron Harmon's of the Bow Glacier, taken in 1902 by an amateur photographer and climber from Philadelphia named George Vaux while on vacation. It's a more casual shot, with nothing in the foreground, but the vantage point is almost the same as Harmon's. There's the lake, the tree line, the two peaks on either side of the glacier, and there's that monumental mass of ice. Where in 1924 the glacier stopped just above the trees, here it pours forward, carving low through the valley. At the bottom right of the image you can see a thin slice of white, the ice reaching almost to the lake even on a warm summer day.

Almost exactly a hundred years after this photo was taken, George's grandson Henry walked to the edge of the lake and took another photo, doing his best to match the angle and framing of the earlier image. The images are so similar that they can be over- laid on top of each other in Photoshop and difference-blended—a technique that hides every part of the two images that is the same, showing only what has changed over a century. In the ghost pixels that remain is a slow, irreversible retreat.

In the time between Henry's photo and now, the Bow's ice has backed up farther, and in the time between when I write these words and when you read them, it will have withdrawn farther still. Perhaps by now it has fallen back past those two peaks, and perhaps our sensors are sitting far from any ice at all, recording nothing but the occasional rockfall. Perhaps the plaza in Calgary is dark and quiet. That is the inevitable end of our project, and its underlying purpose. To witness, in data, the death of the Bow Glacier. To play out its last testament not in low, hidden frequen- cies but aloud, in public, for everyone to hear.

=

Almost two decades before we flew up to the Bow, the artist and design provocateur Natalie Jeremijenko stretched her own improb- able space across the city of San Francisco. Working with plant propagation experts, Jeremijenko grew a thousand clones of the same tree, a common nursery hybrid of the English and Califor- nia walnut called the Paradox walnut. The "Xerox copy" saplings were then planted across the Bay Area, on the premise that the varied success of the trees would reflect the particular environ- mental and social conditions of that particular locale. The trees were living environmental sensors, recording data about pollution and water through the growth of their trunks and branches and

leaves. Jeremijenko called the trees "conductors of information." She was particularly interested in the idea that the trees could, unlike most scientific charts, be read by the layperson, by the casual passerby. Of the thousand saplings grown, only about forty were planted in public: there were eight pairs planted in San Francisco, eight in Palo Alto, and one pair each in Montara, Pacifica, and Livermore. Thiry-eight trees. I wondered, how are they doing two decades after planting?

In the summer of 2019, I booked the closest hotel I could find to a OneTrees planting, a Marriott near Fisherman's Wharf. I spent the evening in the hotel bar plotting a course that would take me, on foot, twenty kilometers across San Francisco in search of Jeremijenko's leafy "social registers." My map, based on whatever information I could scrape from the project's neglected 1999 website, would take me first to a pair of the walnuts that were planted a few blocks from where I was, in North Beach. Then I'd hunt for trees in the Marina, in Sunnyside, in Bernal Heights, and in the Mission, before ending the day at Warm Water Cove on the city's eastern shore, looking out over the bay to Oakland.

The North Beach trees were on the grounds of San Francisco Art Institute, planted in a happily messy corner garden that was tended by the school's resident students. The walnuts here were easily identifiable as twins; though their bows sloped in slightly different directions, they were most definitely the same species and were, within a meter or two, the same height. Which is to say they were both tall, much taller than I'd expected. The trees bore little resemblance to the scrawny saplings I'd squinted at on the OneTrees site's seventy-five-by-seventy-five-pixel images. They'd become big, shade-making trees, lie-on-the-grass-and-read trees, come-weary-traveler-and-take-a-moment-to-rest trees. Conveniently, some art student gardener had left a small wooden bench between them.

My search for the Marina trees was less fruitful. All I knew about this "pair site" came from a terse description: "Elementary School, North Point St." After I walked the length of North Point, which exists in three unconnected sections, it seemed that the most likely site would have been Claire Lilienthal Elementary, a big alternative school housed in the much-renovated shell of what had once been Winfield Scott Elementary. The school was in the midst of another facelift when I visited, and much of the North Point side was enclosed in scaffolding and white plastic sheeting. It's possible that the OneTrees pair were somewhere on the grounds, weathering the construction, but I didn't see them. I did, however, spot some neatly stacked rounds of wood that might have been walnut, sitting in the school's flower gardens.

The rest of my long day of walking held mixed fortunes. I spotted the crowns of two walnuts in Sunnyside and found nothing in Bernal Heights. One of the Mission's two pairs was, like the art institute's, tall and verdant, shading three of Twenty-Second Street's multimillion-dollar houses. The other Mission walnuts, planted around the corner at Twentieth and Valencia, were nowhere to be found. A new apartment building sat beside where their planting photo had been taken. Finally, I walked down to Warm Water Cove, a reclaimed industrial site that is now a city park. There were feral cats hunting among the concrete rubble, and in the distance the port's brontosaur cranes were loading containers off a ship. I almost didn't spot the OneTrees walnuts, because they were so big—much bigger than any of the others I'd found. Planted away from other trees or any buildings, they must have seemed stranded back in 1999. Now they were giants.

Jeremijenko describes the walnuts as "social registers," living records that allow people to read subtle changes in the world around them. They also train people to see trees—all trees—as indicators of well-being, encoding both environmental conditions

and financial ones. "Trees take on a value as a symbol of private wealth," she said in an interview in 2004. She points out that the wealthiest neighborhoods in the Bay Area are the most treed, whereas underserved areas are under-planted. "The poor bear the burden of degraded environments."

Reading Jeremijenko's data project had taken me just over twelve hours. I'd walked 13.8 kilometers, had traveled through a dozen neighborhoods, down a hundred streets, past thousands of unique street addresses. Sunburned and exhausted, I thought about how OneTrees spoke to me so differently than the data tellings I've grown used to, all of the infographics and interactives and charts and maps. How strange, to feel data in my legs. In my lungs.

I took a bus and then a streetcar back to the Marriott. As we wound our way around the edge of the city, some of my exhilaration turned to lament. I was probably the only person in years who'd paid attention to the walnuts. Natalie Jeremijenko, an artist whose practice has always been bound tightly to publicity, moved on to other projects. The website slowly decayed. The last thing written online about OneTrees is a blog post by an arborist from 2014: "The Forgotten Tree Art Project."

Meanwhile, the trees have been quietly doing what was asked of them. Each pair has stored in their leaves and their trunks and their roots a unique story of twenty years of time and twenty years of place. Together, the Paradox walnuts have much to tell about San Francisco, if we find the time to listen. A story of a changing climate and changing demographics, of a city riven along a class divide. Of rolling fog and Google buses, of nesting birds and zoning changes, gentrification and decomposition.

=

The walnuts, the crack and ping of the glacier, the piles of rice—all offer revisions on how data might be told, how it might connect people to place and to space. These projects are radical. They're radical because of their media: not charts and graphs, screens and paper, but sculpture and sound and performance and landscape. They're radical because they don't depend on literacies in mathematics or statistics. They are, to borrow from Julietta Singh, "new performances of humanity," centered on data.

I'm captivated by how *Of All the People in All the World* happens, always, in public spaces. It acts as a foil to the ubiquitous, invisible counting that is performed by the state. Counting, and telling stories of scale, somehow become intimate, hilarious, dramatic, political, and approachable. "It's about numbers," Yarker told me, "but it's also not about numbers at all. It is about finding your place in the world." Too often civic data is posted online in cryptic format, accessible through some obscure URL, both obstacles to legibility, understanding, ownership. The rice show knocks those barriers down for everyone—the young, the elderly, the disabled, the non–internet savvy.

OneTrees (or at least my sentimental version of it) exists at vast scales of space-time. It soundly denies the attention economy; to read it takes travel and time. In a car you might be able to see all of the surviving trees in an hour or two, but to see change in the trees you'd have to visit them again, in a year or a decade. Jeremijenko was particularly invested in one of her trees' core traits: longevity. "The best database standards last eight years," she told a reporter from the *San Francisco Chronicle*. "But trees such as redwoods accrue differences over 100 years. We ignore slow environmental changes unless they are crisis-driven such as hurricanes in Florida. It is more important to read and understand that slow change is recorded by trees."

Eventually, *Herald/Harbinger*'s sounds of the living ice will fade, and the plaza will again ring only with our footsteps and the thrum of our vehicles. Until then, the piece is a living wake. It's a reminder for Calgarians that although their view of the mountains might be blocked by fifty-six stories of gleaming glass, their every action connects them to the rock and the ice through the water they drink and the air they breathe. The word "advocate" comes from the Latin "advocare": to call for help. *Herald/Harbinger* advocates for the glacier, as futile as it seems, and in turn imagines how data put into public space might advocate on behalf of places and animals and plants that might not otherwise have such a persistent voice.

Each of these projects extends the time we spend with data, stretches out our ideas of where and with whom we might hear data's voices. Is it possible that by letting data speak across larger scales and by listening together, we might better understand and address today's urgent issues? Climate change, financial inequalities, post-capitalism—all happen across measures of time and space that defy the bounds of our screens if not the limits of our imaginations. Perhaps what we need more than one-off arguments are long, persistent reminders.

# 11. St. Silicon's Hospital and the Map Room

When I finished my first year of university in 1994, I moved back in with my parents for the summer. After a year of living on my own, being back with my family felt like being anesthetized. My parents had moved a few weeks before I'd graduated from high school, and I knew no one in the quiet Vancouver Island suburb of a town they'd relocated to. I spent the first few weeks mostly sleeping. Eventually my mother, as mothers are wont to do, found me a job through a family friend at a hardware store an hour's drive away. I worked half the time there as a cashier, learning the codes for quarter-inch stove bolts and lock washers and Robertson-head screwdrivers. The other half I spent transcribing their customer database from four-by-six index cards into a database program. It was my first (and maybe only) real data job. This work was numbing in a different way. There were meters and meters of cards, and with each four-hour session in the stuffy upstairs office I seemed to make only scant finger widths of progress.

One of my first priorities when I moved back home was to get online. Thanks to my part-time job teaching internet classes

at the library, I'd gradually started to spend more of my life in IRC channels, on Usenet forums, and in elaborately constructed MUDs based on fantasy books. In 1994, telecom companies had yet to get into the internet business, and unless you were on a university campus, dial-up access came through small businesses or, more rarely, through some kind of community organization. As it happened, Victoria was home to Canada's second Free-Net, a node of a short-lived but ambitious global movement that aimed to make internet access a kind of public utility, in the same category as public television and public radio.

The Free-Net movement was born in Cleveland, Ohio, in 1986. It began as a medical service—called St. Silicon's Hospital and Information Dispensary, a one-line dial-up bulletin board system that provided free health information and consultation. St. Silicon's was set up by Tom Grundner, a professor of family medicine at Case Western Reserve University. People could connect to the system from their home, or business, or school, or library, and leave medical questions that would be answered by physicians within a day. St. Silicon's was such a success that a larger "community computer system" was launched in 1986, with support from AT&T and Ohio Bell. With ten incoming phone lines, the Cleveland Free-Net amassed more than 7,000 users in its first two years of operation, taking around five hundred modem calls every day from people seeking local information and looking to jump off into the wilds of the nascent internet. Between 1988 and 1994, the unique user count for the Free-Net jumped to 160,000, many of whom logged in on a daily basis. The Free-Net became a kind of community-center-cum-public-square for its users, who would log on both for information and just to chat. At its peak, the Cleveland project supported 406 simultaneous users; even then there'd often be an hour or more wait to get online.

After using the Victoria Free-Net for a couple of weeks, I an-

swered a call posted on the main message board looking for volunteers. In an old utilities building downtown, I met Mae Shearman, who had founded the Free-Net together with her husband, Gareth, in 1992. As Mae led me downstairs, she spoke of the mission of the Free-Net, and it was quickly clear that she and her husband saw their work as more than providing free internet access. According to the mission of the Victoria Free-Net Association (ViFA), a major part of the Free-Net's purpose was to provide access to those who "find themselves excluded from full participation in the digital economy." For Mae and Gareth this meant people with low incomes, the elderly, and First Nations (indigenous) communities. ViFA and the Cleveland Free-Net drew a very wide circle around those they wanted to serve.

=

"Public" is a word that has, in the last decade, become bound tightly to data. Loosely defined, any data that is available in the public domain falls into this category, but the term is most often used to describe data that might serve some kind of civic purpose: census data or environmental data or health data, along with transparency-focused data like government budgets and reports. Often sidled up to "public" is the word "open." Although the Venn diagram between the two words has ample overlap (public data is often open, and vice versa), the word "open" typically refers to if and how the data is accessible, rather than toward what ends it might be put to use.

Both words—"public" and "open"—invite a question: For whom? Despite the efforts of Mae and Gareth, and Tom Grundner and many others, the internet as it exists is hardly a public space. Many people still find themselves excluded from full participation. Access to anything posted on a city web page or on a .gov domain is

restricted by barriers of cost and technical ability. Getting this data can be particularly hard for communities that are already marginalized, and both barriers—financial and technical—can be nearly impassable in places with limited resources and literacies. Data.gov, the United States' "open data portal," lists nearly 250,000 data sets, an apparent bounty of free information. Spend some time on data.gov and other portals, though, and you'll find out that public data as it exists is messy and often confusing. Many hosted "data sets" are links to URLs that are no longer active. Trying to access data about Native American communities from the American Community Survey on data.gov brought me first to a census site with an unlabeled list of file folders. Downloading a zip file and unpacking it resulted in 64,086 cryptically named text files each containing zero kilobytes of data. As someone who has spent much of the last decade working with these kinds of data, I can tell you that this is not an uncommon experience. All too often, working with public data feels like assembling particularly complicated Ikea furniture with no tools, no instructions, and an unknown number of missing pieces.

Today's public data serves a particular type of person and a specific type of purpose. Mostly, it supports technically adept entrepreneurs. Civic data initiatives haven't been shy about this; on data.gov's impact page you'll find a kind of hall-of-fame list of companies that are "public data success stories": Kayak, Trulia, Foursquare, LinkedIn, Realtor.com, Zillow, Zocdoc, AccuWeather, Carfax. All of these corporations have, in some fashion, built profit models around public data, often charging for access to the very information that the state touts as "accessible, discoverable, and usable."

On an 1842 visit to Washington, D.C., Charles Dickens wrote of "public buildings that need but a public to be complete." While he was speaking of the capital's wide but underpopulated streets,

he might as well have been speaking of today's information publics, sparsely populated places with data piled high on the curbs.

=

Over the last decade, I've attended many open data events: for scientists working with satellites, for librarians and archivists, for city planners, for software developers, for policy makers. As I've sat in the audience at these events, it's occurred to me again and again that we're not all talking about the same thing when we say "open data."

Indeed there seemed to be a kind of fractal misunderstanding about what the word "open" means, or more specifically whom the "open" is for. Earth observers had a different idea from librarians: while scientists seemed to be focused on making their projects open to other scientists, the library people were mostly considering humanities researchers. But even within those groups there didn't seem to be common ground. Everyone who worked at the Library of Congress didn't agree about who the audience for "open data" was, nor did everyone in one department at the European Space Agency. Honestly, I'd be surprised if any two people at any of the events I went to could agree on whom they were meant to be making their data open to.

I'm still Canadian enough to believe that open means *open*. I'm with the Open Knowledge Foundation when it says that "open means anyone can freely access, use, modify, and share for any purpose." Under this definition I'd argue that very few of the so-called open data projects from the last decade are actually open, unless we manufacture a definition for "anyone" that includes only people who look and think a lot like ourselves.

Let's try an experiment. Pick an open data project, your own or someone else's, and give it a score of zero. Because we're feeling

charitable, let's give the project one point just for the word "open," assuming the data is accessible in some way, through an API or a file download or a carrier pigeon service. Next, give your project one additional point for each of these questions you can answer yes to:

1. Does the project have comprehensible documentation, examples, and tutorials?
2. Are there materials (teaching curricula, blog posts, videos, and so on) that offer context around the data so that someone unfamiliar with the project can understand why it might be important?
3. Can a nonprogrammer access the data?
4. Is there documentation available in more than one language (for example, English and Spanish)?
5. Is your documentation and the site it is hosted on compatible with screen readers? Have you tested it?

How did you do? Data.gov scores a 2, if we're being generous. New York City's Open Data portal gets a 3.

Turning the red pen back on myself, I find I didn't do much better. The three open data projects that I built with the Office for Creative Research—Floodwatch, Into the Okavango, and the Elephant Atlas—scored 2 points, 2 points, and 3 points, respectively.

I think it should be a minimum goal for every data project that wants to legitimately use the term "open" to score at least a 3 on this test. But scoring a 3 is like scoring a C; it's the minimum viable open, just enough so your parents can't ground you. Even with a score of 5, you've arrived at *open-ish* data, *open-esque* data at best. How might we do better?

A lot of the answers are encoded in the questions above. Write understandable documentation, examples, and tutorials, and

write them for an audience that isn't you. Post interviews with good communicators who can give context and narrative. Provide easy-to-use visualization tools to foster comprehension. Think about making your data human-readable as well as machine-readable.

Early in 2014, a group of scientists began a series of closely spaced transects in single-engine planes, flying low across wide swaths of savanna in twenty-one African countries. The planes were equipped with laser altimeters, and the pilots worked meticulously to keep flight speed constant. Out of the rear windows, an observer on each side of the plane counted elephants. Over the next two years, they'd fly thousands of kilometers and count 352,271 elephants, in the first pan-continental survey since the early 1970s.

At the Office for Creative Research, we built the Elephant Atlas in 2016, a public front end to the enormous data set that had come from all of those hours in flight. The task of making the data public was tricky. Each of the countries where data had been collected had agreed to its own specific terms about how (and if) the data could be released. For some flights, no geospatial data could be released. For others, the path of the plane could be made public, but not the location of the elephants. Even the high-level country-by-country counts were complicated. To really understand the numbers, and how they'd changed over four decades, is to track a set of parallel narratives: conservation policies, ivory demand, food scarcity, habitat loss, human conflict.

We knew there would be a handful of researchers and policy wonks who'd want to dive deep into the data. For them, we built an API that would spit out detailed JSON files (a common format meant to be read by machines), time-stamped records of every flight and every elephant counted. These files could be computed upon, analyzed, mapped, charted, placed neatly into scientific

papers. The point of the census, though, wasn't to generate more scholarship; it was to effect policy change, particularly in the countries where the elephants lived. So we programmed the project API to return printable PDF reports, with maps and charts that were generated on the fly in response to the user's request. Reports that could be printed on paper, stapled together, dropped on a politician's desk. Real, tangible things that could be mailed or stuck with a thumbtack into a corkboard.

To get to the outer reaches of open, where our data is really and truly serving the public, we need to consider exclusion and accessibility. Put more directly, we have to think about people who aren't us. Who is being excluded by the technologies that we are using and by the ways in which we are communicating? I spent four years working on data-focused conservation efforts along the Okavango River, which spans three countries with three official languages. We offered API documentation only in English. All three of the OCR's supposedly public data projects are tedious (or impossible) to access with a screen reader, making all of our open data very much closed to people with visual impairments.

To make a data project truly open to anyone, we need to think about outreach, past the computer. There is a technocentricity to our platforms that is excluding huge groups of people—the elderly, the young, people in poverty. How do we make our data open to those with low levels (or no levels) of digital access or literacy? One tactic might be to ensure that our data and documentation are friendly not just to researchers but also to propagators. Write tutorials specifically for journalists. Work with teachers to develop curricula around your data, even if your target audience isn't the classroom. Print postcards and send them out in the mail.

A final, necessary answer is to take our data actually into the open, into the wild spaces of community.

=

On September 30, 1999, users who dialed into the Cleveland Free-Net were shown this message: "The Cleveland Freenet has discontinued operation. The project has concluded. Thank you for your participation." Just below were listed some alternatives: "Community users of Free-Net should explore alternate ways of receiving e-mail and using Internet resources. Public libraries, various continuing education programs, city recreation boards, and community users' groups are excellent sources of information."

With a straight-line view of progress, it's easy to swallow the story that the Free-Net movement is a "concluded project," a failed experiment inevitably overwritten, first by the internet and telecoms and then by social networks. "CFN fell victim to the slow decay of time," reads a memorial posting on the Free-Net's old website. A slow decay, perhaps, but also a ruthless excising. In the decades between then and now, Silicon Valley has pushed a particular libertarian agenda in which public spaces have little value. "It is the message that underlies all the mythologizing about the web," Ellen Ullman writes, "the idea that the civic space is dead, useless, dangerous, and the only place of pleasure and satisfaction is your home." Google and Facebook and Twitter have little interest in your spending time in a park, nor do they want you spending your online hours on some community site, free from banner ads and cookies.

"Dominant history," Jack Halberstam teaches us, "teems with the remnants of alternative possibilities." If the Free-Net project was a failure, it was, as Halberstam might call it, a potent one. We can choose to not believe that the Free-Net project really concluded. Let's believe instead that it has lain dormant, waiting. That we might revitalize its ideas of some new type of public, inheriting from libraries and television, centered on data and togetherness.

St. Silicon's Hospital and the Map Room                    205.

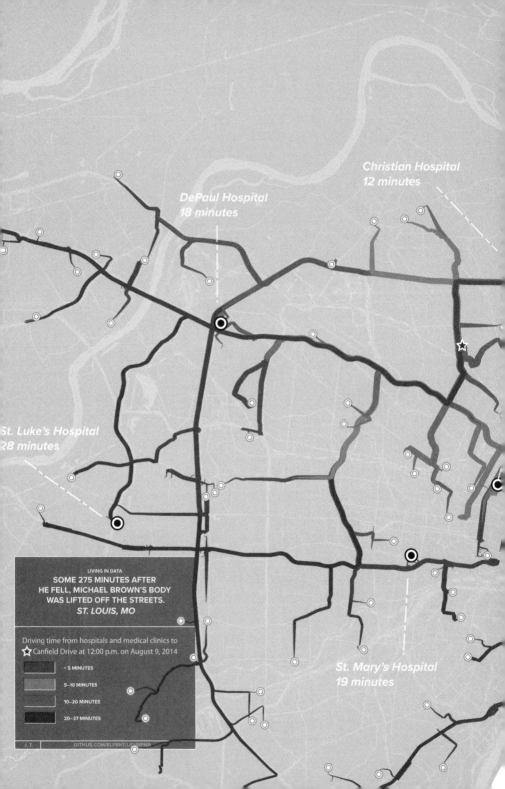

Christian Hospital
12 minutes

DePaul Hospital
18 minutes

St. Luke's Hospital
28 minutes

LIVING IN DATA
**SOME 275 MINUTES AFTER
HE FELL, MICHAEL BROWN'S BODY
WAS LIFTED OFF THE STREETS.**
*ST. LOUIS, MO*

Driving time from hospitals and medical clinics to
☆ Canfield Drive at 12:00 p.m. on August 9, 2014

| | < 5 MINUTES |
| | 5–10 MINUTES |
| | 10–20 MINUTES |
| | 20–37 MINUTES |

St. Mary's Hospital
19 minutes

Free data spaces where information is truly open, where new ways of data-telling speak to whole communities. Places where people come not only to read data but to write it. To convene around it, to discuss it, to critique it, to rewrite and rerelease it in forms that adhere more closely to their own lived experience.

In 2017, in a deserted old high school five hundred miles to the southwest of Cleveland, I had the chance with a group of collaborators to put some of these ideas into action.

=

To understand what St. Louis is today, you need to keep many different story lines together in your head.

There is the bustle of the city at the turn of the nineteenth century and its many decades of industrial boom. Between 1900 and 1950, the population of St. Louis nearly doubled, to just over a million. In 1951, it was the eighth-biggest city in the United States.

There is the city of St. Louis's separation from St. Louis County in 1876, which provided a neat loophole for its suburbs to incorporate. While the state's constitution prevented cities and towns from incorporating within two miles of another city or town in the same county, St. Louis was no longer in a county. So suburbs like Kirkwood and Clayton and Richmond Heights and Ferguson could incorporate right up against the city's edges. These places, with easy access to the business core and lower taxes, drew thousands of city residents (mostly white) to move to its peripheries.

There is redlining, the drawing of maps that defined which

residents of the city would and would not receive financial assistance in the wake of the Great Depression.

There is the construction of the Interstate Highway System, one node of the nationwide plan for elevated highways and turnpikes and off-ramps, for routes that would give (mostly white) travelers quick thruways past (mostly Black) inner cities across the country. Years of demolitions left wide swaths of neighborhoods erased to make way for the I-44, the I-55, and the I-64/40.

There is a Chinatown, established in 1869, home to a thousand people by the turn of the century. A Chinatown demolished in 1966 to make way for Busch Memorial Stadium, home of the Cardinals and for a while the Rams.

There is a mostly Black city that has had mostly white mayors, mostly white city councillors, mostly white DAs and judges, and a mostly white police force.

My own St. Louis story line changed course on Canfield Drive, where it curves a bit north to become Windward Court. On August 9, 2014, Michael Brown, amateur musician, recent high school graduate, brother to two sisters, was shot dead here by Darren Wilson, an officer in the Ferguson Police Department. It was a warm day, and a little bit of wind came from the southeast. Michael's unarmed body fell to the ground just after noon, shot at least seven times. The first ambulance arrived on the scene at 2:30. The medical examiner began his work an hour later. At 4:37 p.m., some 275 minutes after he fell, Michael Brown's body was lifted off the streets.

By that day in August, I had spent two years in and out of the city, working with a community arts organization called Center of Creative Arts (COCA) on a collaboration that had had a hard time finding a shared idea. COCA was most interested in my exploring the data that it held around its engagements with the community; for decades it'd run programs, mostly for kids, teaching arts with a focus on dance and performance. By 2013, I was just getting

into my thinking about data in public space, and I'd been draft-
ing ideas for a grand sculpture in the city's Loop neighborhood,
where the lower-income neighborhoods of the City of St. Louis
shifted in a patchwork gradient into the affluent, gated streets of
University City.

I'd been made to feel welcome in St. Louis by everyone: by the
staff at COCA, by taxi drivers and bartenders, by the students I'd
met at Washington University, and by the journalists and activ-
ists I'd sat down with to find ideas for a project. But there was
also a guardedness, something that I'd come to identify later as
more of a wariness. A wariness that I, a Canadian white guy from
New York, was trying to do a project about a city that I didn't un-
derstand. A wariness that any single engagement with the city's
blunt divisions around race would ignore decades of nuance. A
wariness that a complicated story might be sanded down into
something too smooth and perfect.

By the evening of Michael Brown's shooting, a makeshift me-
morial had taken form on Canfield, candles and flowers on the as-
phalt. The next day, a public vigil was met in the streets by 150
police officers in full riot gear. Thirty people were arrested on
charges of assault, burglary, and theft. On August 12, several hun-
dred protested in nearby Clayton, the county seat, some holding
signs, others raising their arms and shouting, "Don't shoot." Police
fired tear gas canisters and rubber bullets to disperse the crowd.

The next morning in Botswana, I read coverage of these be-
ginnings of the "Ferguson unrest," using the last minutes of cell
phone signal I'd have for seventeen days. In the airport on the way
back to New York, I read of three weeks of protest, three weeks of
escalating state reactions. I read of officers firing on journalists,
throwing them to the ground, dismantling camera equipment, and
destroying footage. I read of protest after protest, of lootings
and car fires, of curfews and a state of emergency. I read of Michael

**St. Silicon's Hospital and the Map Room**                    209.

Brown's funeral service, attended by nearly five thousand people. I knew then that there would be no sculpture to be made, no grand gesture anchored into the concrete with a plaque.

Instead, I set out to foster the construction of a new kind of public space, one where the people of the city could come to tell their stories, to examine the stories that were being told about them, and to listen to the stories of others.

=

March 9, 2017, is one of the first mild days of the year in St. Louis, and the doors to the gymnasium at Stevens Middle School are open to let the sun stream in. Stevens is one of thirty-two schools in the city that have closed in recent years, but over the last few weeks it has found a new life; inside the gym, a class of ninth graders are on their hands and knees atop a wide platform made from reclaimed brick, drawing with fat Sharpie markers. They are making a map. They'd decided, over the last few weeks in class, that their map would be about the places in their neighborhood where they felt safe. And so they draw their school, Brittany Woods, at the middle left. Beside it someone adds a Jack in the Box, and they write in a rough scribble, "I like to eat here." Many of the kids draw their own houses. "I like my house because I can be myself there," one student writes. "I like my house because it's a sign of love," reads another note. "No matter what troubles I have my family loves me anyway."

The students mark some of the locations with an *X* in a circle, indicating that these places are not safe. Right at the middle of the map, someone draws Jackson Park and marks it with an *X*. "I have shed many a tear here," they write beside it. While all of the different places are being added to the map, a small group

is drawing a key. The key tells us that the places on the map are outlined depending on whom they feel safe (or unsafe) for. Male in green, female in red, gender neutral in purple. African Americans in brown, Caucasians in pink, biracial in blue. Reading the map with the key, we can see that some places are specifically coded as safe for certain people. Jackson Park, ringed in brown and pink and blue, seems to be unsafe for everyone.

When the students are nearly done with their map, a group of four of them draw a rainbow, right in the center. "LOVE IS LOVE," someone writes on top of the rainbow. "LGBT," they add, below. "Love is love, no matter what."

A different spring day, eight decades in the past. Another map is being drawn. With a straight edge, the mapmaker marks out a kind of geometric jigsaw puzzle onto the city, and then he fills each piece, one by one, with a color. Green, blue, yellow, red. First Grade, Second Grade, Third Grade, Fourth Grade. This rainbow-ed map of St. Louis is one of hundreds of similar maps of cities that are being made across the nation, in the wake of the Great Depression, with the support of the Home Owners' Loan Corporation (HOLC). The HOLC, recently born of the New Deal, has a remit to refinance mortgages that are currently in default, in an effort to avoid foreclosure and thus to offer a lifeline to failing cities. Maps like the one being drawn are to act as guides to HOLC officials, showing in which areas of the city they should offer support and in which ones they shouldn't.

As we watch, this 1937 mapmaker colors in a polygon with green, just to the north of the city's sprawling Forest Park. The people who are lucky enough to live in this First Grade polygon will very likely get government money. They'll keep their homes. A few minutes later, the mapmaker shades in another region with red. Fourth Grade. Under the shade of these red lines, the people will

get no money from HOLC, no support in the face of their mounting debts. At worst, they'll lose their homes; at best, they'll become more deeply entrenched in financial despair.

We know now that the HOLC's maps were racist instruments, halfheartedly hidden under ideas of renewal and "residential security." Redlined areas were almost always African American neighborhoods, and these maps became tools to deny Black people property rights, to force them out of home ownership, to remove them from real-estate-based capital systems and thus from civic discourse. Those mapmakers, on that May day in 1937, were setting out a vision for the future of their city—their own white future, on a new map of their own white city.

Back in the gymnasium at Stevens, the students are gathered around the edge of their finished map. The Map Room's facilitator, Emmett Catedral, is showing them how they can use an iPad interface to project dozens of data layers on top of the map they've drawn. He walks them through some data gathered and scraped from census records and city data repositories—employment rates, property values, and annual income. Traffic, and pollution. The number of no-car households. Distance to primary care facilities. The students notice quickly that although each of these map layers shows a different thing, they have a similar visual pattern, a kind of houndstooth shape that shows up in every map.

Then Catedral taps the iPad and projects the redlining map from 1937 on top of the map they've made today. The students see their own neighborhood as those mapmakers saw it eighty years ago. It takes a few minutes for them to decipher the key, and then they find it: there is that same shape! Indeed, they realize, this redlining map was still present in almost every map they've looked at. Sometimes its edges were faded a little bit, but there it was, again and again.

"The historical map that showed home loan ratings was very

powerful because kids understand that the A neighborhoods are still filled with big, beautiful houses—and white people," said the teacher, Anne Cummings. "The D ratings I could identify as historically Black neighborhoods." Cummings learned that many properties in these neighborhoods were condemned by the city and then gentrified. "The one near my home was considered blight and claimed through eminent domain. There's a Menards there now that my family and others have boycotted."

This connection between the current conditions of their neighborhood and the racist policies of the 1930s wasn't the only one the students found during their time in the Map Room. "We used the bus route overlay and the one about households that own cars to talk about the lack of crosswalks on one of our major thoroughfares," Cummings told me. "It's just south of our district's poorest elementary school, and people are often hit or nearly hit." The students also spent time comparing maps showing healthcare enrollment and asthma prevalence, once again overlaying this information on top of their own map to help find themselves and their daily lives in the data.

Over the course of five weeks, thirty other groups made ten-by-ten-foot maps in the gymnasium. The maps were big for a reason; people could gather around them as they might a dinner table; they could walk on them or kneel in groups to get close to a particular area.

Forward Through Ferguson, an organization that is looking to promote avenues for lasting change out of *The Ferguson Report*, made a map showing the drastic difference in life expectancy between Black and white communities in the city. Gateway Greening mapped out every community garden within the City of St. Louis. Team TIF compared the city's Land Reutilization Authority properties with tax abatements, challenging the commonly heard assertion that these abatements are being used to incentivize

development in "blighted" areas. Many of the mappers chose to render their personal stories onto their maps, marking places that held meaning to them, offering anecdote and emotion to go alongside statistic. A map showing Christian churches is densely annotated. "I am the first in my family to graduate college," someone has written beside the Ministerio Apostolico Plantio del Señor. "I NEVER thought I could get a Master's degree, let alone a Doctorate."

"Those large sheets structure collaboration and conversation," Shannon Mattern wrote about the project's big maps. "They represent civic intelligence—a mix of official data and 'indigenous' knowledge—writ large." This mix is crucial; the Map Room's denizens can use personal narratives as a lens to read civic data, tracing a kid's path to school through traffic or air quality data. The same is true in reverse: city data, often so hard to find meaning in, is now marked with the real stories of real people. Projections of single-car households or median employment or life expectancy show not only numbers but words, stories, lives.

Dickson Beall, a reporter and art critic from the city's *South County Times*, came perhaps closest to capturing the intent of the project in a review that he published shortly after the space opened. "The Map Room," he wrote, "is an instrument for re-visioning how urban societal change can happen."

=

I came to think of the Map Room, over the four years it took to develop and the five weeks when it was open, as a machine for changing perspective. It was a place to come and not only tell stories about your city through mapmaking but also understand it through the eyes of others. When you look at a map of your own city, showing property values or lead levels or density of greenery,

it's easy enough to find your story in that map. What is harder is to find the stories of others. The Map Room let the citizens of St. Louis see their city through the eyes of ninth graders, the homeless, bike commuters, city workers, activists, and artists. It's a space to listen to data, but also to be critical of it, to hold up the things data says about people and places against the things those people and places actually *know*. It shifts civic data from being a resource for urban planners and academics to being an exploratory medium for everyday citizens.

The project was a culmination of a decade of thinking; many of the ideas you've read so far in these pages were built into that room. Into the technology, into the teaching and learning, into the ways people spoke with data and let data speak to them. For nine spring weeks, the school gym in St. Louis offered me a clear look at a new free data space, and what I saw *worked*.

Underlying the Map Room is an easy idea: that a particular group of people, living in a specific place, have their own unique experience of living in data. That given the right tools and re-sources, that group might work together, collecting data and critiquing and telling data in ways that respect their *here*s and *now*s. As Yanni Loukissas writes, all data are local. Local to streets and schools and neighborhoods, to forests and river basins, to cultures and languages and ways of knowing. Local, most important, to people.

In the years since St. Louis, Loukissas and I have worked to build the Map Room into something that can be spread widely to cities, towns, and other sites of human habitation like prisons and refugee camps. I wake up some mornings having dreamed of thousands of Map Rooms in thousands of places, each fit to the con-cerns and to the lives of different communities. In understanding how this might work, I've searched for examples in which data

might meaningfully *belong* to people, in legal ways but also in practical and physical ones. I've found these examples, wrought most concisely, from indigenous scholars and activists and technologists and elders who are right now finding ways to live in data that reinforce their own sovereignty while upending data's top-heavy hierarchies.

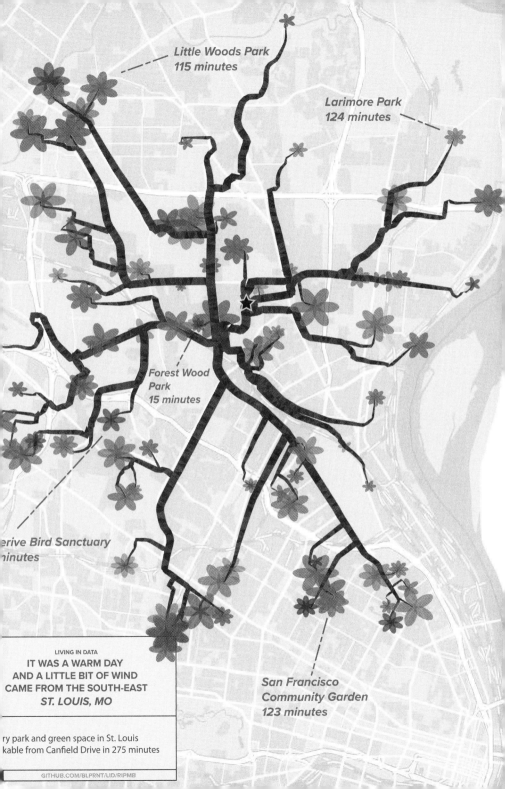

Little Woods Park
115 minutes

Larimore Park
124 minutes

Forest Wood
Park
15 minutes

erive Bird Sanctuary
inutes

San Francisco
Community Garden
123 minutes

LIVING IN DATA

# BY THE LAWS OF THE NATION

Publicly known data centers in the USA,
grouped by the territorial land they occupy.

J. T.    GITHUB.COM/BLPRNT/LID/SOVEREIGNTY

APPLE    FACEBOOK

AMAZON    GOOGLE

= 50,000 SQFT
=~1,000,000 Terabytes

PISCATAWAY CONOY

NORTHERN PAIUTE

HULUNIIXSUWAAKAN

IOWA

PIMA

HOPEWELL

UTE

CATAWBA

OSAGE

POWHATAN

UMATILLA

MUSCOGEE

CHEMEHUEVI

KITIKITI'SH

OHLONE

TIWA

WAŠIŠIW

CHINOOK

CUSABO

SHAWNEE

KOASATI

# 12. Te Mana Raraunga

When I meet Maui Hudson in the lobby of the airport hotel in Auckland, he's in the middle of a conference call with his iwi. He puts the call on mute and shakes my hand. "Tribal politics," he says, with a broad smile. "This might take another ten minutes or so."

Twenty-five minutes later I drift into the restaurant and introduce myself to Maui's colleagues, with whom he's spent the day talking about Māori genomics. They're setting out to build an ambitious database of genetic information, both about the people who make up the Māori nation and about the environment that surrounds them, the plants and animals that have long been connected to their lives. The meeting, I learn, has covered a broad range of topics: what kinds of data might be collected, how it will be stored, who will be granted access to it, and under what conditions.

Maui is tall and handsome, the kind of person you might expect to be carrying a surfboard and/or featured in a commercial for retirement insurance. In the two days we spend together, I rarely see him doing only one thing at a time. While he's driving, he's

answering phone calls; while we sit and talk, he's sending emails. When I later mention this constant multitasking to his wife, she reacts with a laugh that seems to bear equal parts amusement and exasperation. "Maui doesn't know how to rest," she says. "He sees these things that need to be done, and he knows that there's no one else who's going to jump in and do them. So he jumps in."

Māori interest in data is both new and very old. On February 6, 1840, a group of chiefs from New Zealand's North Island gathered in a large tent pitched on the lawn of James Busby's house in the Bay of Islands. They were there to sign the Treaty of Waitangi, a document that would sit at the center of a contentious relationship between the Māori and the government of New Zealand, a long course of wars and betrayals and renegotiations and settlements. The treaty itself is in three parts. The first is a ceding of rights and sovereignty to the crown, the last a granting of full rights to the Māori as British subjects. The second article grants to the Māori "chieftainship over their lands, villages and all their treasures." In the Māori version of the treaty, the version that was signed by the chiefs, the word "treasures" is written as "tāonga," which means not only valued possessions but also culturally valuable resources, phenomena, ideas, and techniques.

In the mid-1980s, the Māori successfully argued that the concept of tāonga could be applied to radio waves. The government was in the process of auctioning off parts of the frequency spectrum (then used for radio and TV, and now home to all of our cellular phone communications), and the Māori rightly believed that to exclude their claims to radio and television channels would be to breach the Treaty of Waitangi. In 1996, members of Te Roroa, an iwi from northern New Zealand, filed a successful claim of treaty violations around spiritual places of special significance, which were again agreed to be tāonga. Five years later, the Waitangi Tribunal, a commission of inquiry that hears Māori claims of treaty breaches, con-

sidered traditional knowledge about flora and fauna and whether consent to its use was required by the terms of the treaty.

Today the concept of data as tāonga is central to the arguments for Māori data sovereignty. According to the Māori, data, alongside language and artifacts and spiritual beliefs and natural resources, are culturally important things. Data are to be treasured. Taken in this context, the Māori relationship to data is necessarily protected by the Treaty of Waitangi, offering legal grounds for stewardship and oversight.

The concept of data sovereignty is not a new one. It has arisen over the last decades as various parties have debated how data should be regulated and by which laws. Should data be governed by the laws of the country where the physical data is located? Or by the laws of the nation where the company or organization that collects the data is based? Or by the laws of the place where the data is collected? If I'm a Microsoft user living in Helsinki, and data is collected about me in Finland, by an American company, and stored in Ireland. Whose laws should prevail?

While it might be common to think of data as living in "the cloud," all information is of course stored in an actual physical location. Twitter, for example, stores most of its data in a nearly one-million-square-foot complex of buildings outside Atlanta. Google operates fifteen data centers around the world, the largest of which is in Pryor Creek, Oklahoma (population: 9,539). Apple's Mesa, Arizona, data center measures a staggering 1.3 million square feet. Data sovereignty is the idea that the information stored in each of these data centers is governed not by the laws of the nation in which it is stored but by the laws of the nation in which it is collected. So, while user data collected by Apple about a user living in Tulsa would be governed by U.S. law, the data of a user in Toronto would be subject to Canadian terms and restrictions.

In the world of the cloud, this opens up complicated questions. A database located in Taiwan might host data that is legal to collect in one nation but not in another. Copies of a data record might exist in more than one data center, in more than one nation. What happens when data is collected on a citizen who is living or traveling abroad?

The political ramifications of data sovereignty are perhaps even more complicated. In the wake of the Snowden revelations in 2013, it became clear that the U.S. government was collecting huge amounts of data, not only about its own citizens, but about people from all around the world. Under the Patriot Act, any of this information was accessible to U.S. officials as long as it was physically located in the United States. This meant that information in any of the enormous data centers listed above was free to access by operatives of the U.S. state. In a 2019 white paper, the Canadian government outlined its strategy to assure data sovereignty through data residency; that is, to guarantee control over data by making sure the physical servers are on Canadian soil.

The indigenous data sovereignty movement sets out a clear framework for ownership of data related to indigenous people. Data collected by or about indigenous people is necessarily controlled by those people, as is data that is related to land, property, and artifacts of indigenous importance. All of these data are then governed under indigenous law. In the case of the Māori, this means having rangatiratanga—chieftainship or authority—over all this information.

Tahu Kukutai is a key member of the Māori data sovereignty movement and a professor of sociology at the University of Waikato in Hamilton. Her previous career as a journalist is manifest in her keenly honed interrogative stare and a habit of bringing a conversation to a point a minute or two before it might be comfortable. Tahu and Maui are part of the core working group of

Te Mana Raraunga, a group tasked with enabling Māori data sovereignty through advocacy and capacity building. I met with both of them in Tahu's office, and we discussed how Te Mana Raraunga came to be, how Māori ways of knowing might provide models for data stewardship and use, and how these approaches might offer a glimpse of what a more equitable data future might look like.

For Tahu, a focus on data is built into the Māori worldview. "Indigenous peoples have long been data gatherers, in whakapapa, in genealogies, and carvings and waiata in chants, in ceremony. We think about data differently," Tahu says, gesturing to encompass the whole of the Māori people. "All the bad stuff aside, our institutions have endured thanks to a sense of peoplehood. The typical way of approaching data is individualistic, whereas we are used to being in a collective structure." Over centuries, iwi have developed their own systems for managing the rights and responsibilities around community-held information. "Knowledge belonged to the collective," Tahu explains, "not to the individual." This information was—and is—a key part of Māori identity and survival. "It's how we've been able to hold together in a colonized context."

Te Mana Raraunga's work is built around three very specific ideals. First, that data is a "living tāonga" and is of strategic value to Māori. Second, that any data produced by Māori or about Māori and the environments they have relationships with is Māori data. Third, that this data is subject to the rights articulated in the Treaty of Waitangi. Taken together, these ideals give the Māori people a road map for defining their own relationship to data and for making the precepts of data sovereignty legally binding.

That Māori data includes data collected about Māori people is particularly important to Tahu and Maui, given the ways in which data has historically been used to marginalize their people. "Māori are underrepresented in data and over-surveilled," Tahu

says. Te Mana Raraunga's work is grounded not only in ideals and policy. It also supports a number of projects that put the ideals of Māori data sovereignty to work. These endeavors act as prototypes while also building capacity, spawning Māori data scientists and visualizers and theorists.

=

One such project, led by Tahu Kukutai, focuses on measuring and understanding the impacts of colonization on the Māori people in the last two hundred years. To that end, a team of historians and archaeologists have worked to reconstruct whakapapa of nineteenth-century ancestors, to create a demographic database anchored in the Māori traditions. The concept of "whakapapa" has deep importance to the Māori. In a 2007 paper on genetic research, Hudson describes its multiple meanings:

> The word "whakapapa" is both complex and interesting. It can refer to ancestry, genealogy or family tree, describing the layers of generations built one upon another. In te Ao Māori (the Māori world) whakapapa is a familiar term and as the "ultimate catalogue" it defines not only the relationships between people but with all other things.

"Whakapapa" is derived from the words "papa," a word for ground or solid foundation, and "whaka," which refers to the transitional process of "becoming." Therefore whakapapa can be thought of as "creating a foundation."

The foundation of Kukutai's research includes census documents from the mid-nineteenth century and other data sources such as birth, death, and marriage registrations, maps and sur-

veys, and information on headstones. More important, the database has been populated with oral histories. "We've been visiting the iwi," Tahu says, "talking to them about some of the stories that had been passed down through the generations, asking them questions like who were the important tīpuna [ancestors] that you recall, and why were they significant? What were the traits of these Māori?" From the aggregated data, statistical models are built and answers are found about how the Māori population changed during this tumultuous historical period. The project is the first attempt at full population reconstruction in Aotearoa New Zealand, and it's one that has inverted what Tahu calls "the usual top-down focus of indigenous demography." It is Māori dataing Māori.

Throughout the process, the research team has brought their findings back to the places where the whakapapa is grounded. "The data belongs to the community," Tahu says, "so we take it back to them." These discussions cover not only what the research team learns but also how the information is protected and shared and how it might be held safely for future generations. For Tahu this is crucial. "We need to create infrastructure that's sustainable, that lasts beyond the duration of a three-year research project."

Meanwhile, Maui Hudson has been working on another project, concerned with a particularly sticky part of data sovereignty: permissions. "Ninety-nine percent of the analysis of indigenous data is by nonindigenous data scientists," Maui told me, "and yet Māori disproportionately carry the risk." He points to genetic testing and screening as an area with particularly sticky ethical concerns, grounded in the Māori worldview and in 180 years of often destructive colonial histories. While Māori recognize that these technologies might hold potential benefits, particularly in regard to therapies for diseases that have high incidence among their people, they are also wary of risks that might come from the

identification of specific genetic traits. "Māori are acutely aware of the potential for genetic information to be used to discriminate, stigmatize and blame the victim," Hudson and his colleagues write, "and population-based genomic research indeed has the potential to reinforce stereotypes about 'race' and ethnic differences."

In media, "Māori genes" have been used to explain disparities in health among New Zealanders, putting blame not on social inequities but on traits that are "biologically ordained." Built-up distrust, Hudson argues, means that access to Māori genetic data must respect the principles of whakapapa. Sovereignty of genetic information must be maintained through a clear system of permissions in which researchers are required to ask for access to Māori data and explain in accountable ways how they intend to use it.

If human DNA data can clearly be understood as whakapapa, so too can genetic data about animals and plants that play important roles in the Māori worldview. Animals like the longfin eel, whitebait, freshwater crawfish, and freshwater mussel are mahinga kai species: they are culturally, nutritionally, and economically significant and make up an integral part of the whakapapa foundation. Each of these species is extensively studied by scientists in New Zealand and abroad, often with the goal of establishing aquaculture projects, which can impact Māori livelihoods and often have deleterious environmental effects. In some ways this nonhuman data is more complicated, because it can be collected without the involvement of Māori people. In considering these data about fish and crustaceans and mollusks comes one of Te Mana Raraunga's stickiest questions, one that came up more than once in my conversations with Maui. "How do we find the sweet spot," he asked me, "where we exercise control over data that other people own?"

Again, we come back to permission. How can access to data

be managed in a way that protects sovereignty and respects the Māori worldview? We know that terms of service, the typical unwieldy solution, are mostly ignored. They are also perched upon colonial ideas of ownership and property that have little resonance with Māori beliefs. There is only a narrow edge of overlap between Māori values and a system where pieces of human genetic code can be copyrighted by pharmaceutical companies. An answer, Hudson thinks, can be found in some work that has recently been done around indigenous objects held by museums and archives around the world.

When I was at the Library of Congress, I spent a lot of my time waist-deep in catalog data. For the first months, I did my best to become fluent in MARC, a set of standards for digital cataloging that is used pretty much ubiquitously in libraries around the world. Developed at the Library of Congress by Henriette Avram in the mid-1960s, MARC became the international standard for library data exchange in 1973. In a MARC record, numbered codes point to information about an item such as the title (245a), the author (100), the date published (045), and the topic, along with metadata like when the record was created and the Library of Congress Control Number (010). Because MARC is used to catalog audiovisual materials, photographs, and plenty of other strange items, the number of possible numeric codes is vast, covering things like production credits (508), physical dimensions (300c), and a whole user-defined section (9xx) for information that doesn't fit neatly into the other available fields.

Search for "Passamaquoddy songs" on the LOC home page, and you'll find a series of objects that carry a particularly interesting and very recent addition to the library's data definitions. The songs—"Song of Salutation," "War Song," "Election Song," "Song of

the Snake Dance"—exist in the holdings as wax cylinder recordings, made near the end of the nineteenth century on the coast of Maine by an anthropologist and inventor named Jesse Walter Fewkes. Wax cylinders were a precursor to the vinyl record. They worked similarly, using a stylus that ran along grooves in the material's surface, translating texture into sound. The cylinders played like a barber's pole, the stylus moving from bottom to top as the cylinder turned. Fewkes's cylinders had room for about two hundred seconds of sound. The same machine was used to inscribe and to play back the cylinders, a bulky device about the size of a steamer trunk, which Fewkes carted into a Passamaquoddy village on March 15, 1890.

Fewkes's intent that day was threefold. First, he wanted to get some cylinder recordings that would demonstrate the fidelity of the wax mixture he used, a recipe he developed himself, which he was hoping to sell to Thomas Edison. Second, he wanted to test out his recording rig in advance of a trip to the American Southwest, where he was planning to record the songs of the Hopi people. Finally, in line with many anthropologists of the time, Fewkes felt he was doing the important duty of documenting the last words of a disappearing culture, a language and a society that seemed to be heading toward inevitable assimilation.

The cylinders that Fewkes recorded on that spring day ended up in the collection of Harvard University, where they remained for more than half a century. In 1972, as part of an initiative to bolster the Library of Congress's Native American holdings, they were transferred to Washington. While they were considered important items, the cylinders' delicacy meant that they were rarely played back. One of the drawbacks of wax cylinders is that playback is destructive; every time the stylus runs over the grooves, some of the audio information that is encoded is worn down and lost. Another problem is that the wax itself dries and cracks. Tape

recordings made from the cylinders in the late 1970s are muddy, saturated with pops and crackles. Listening to them is like hearing voices through a beehive.

Some forty years later, new technologies emerged that made those voices much clearer. High-res scanners could be used to create three-dimensional images of the cylinders, which could then be played back virtually with no damage to the wax. Specially designed software could remove much of the noise that had come from decades of degradation. "It was very powerful for me to hear [these voices] from one hundred and twenty-eight to twenty-nine years ago," Donald Soctomah told me. Soctomah, a Passamaquoddy elder, historian, and preservationist, has been deeply involved in bringing the recordings back to the community. "It's like hearing your great-great-grandfather telling you a story, and you're sitting down and just amazed at being able to hear something from that far back." Soctomah described how, working with a group of elders, he was able to transcribe the words of the songs for the first time since they were recorded: "We'd go around. We'd play one sentence of the song, and everybody would say what they heard and write it down, translate it. Then we'd play the next one, and we'd do this, and we'd continue on through the song, and then we'd combine all the information, and wherever there was a difference on one of the words, we'd go back and just focus on that one word and play it over and over until everybody agrees to the word. It was a long process."

The wax cylinders contained only two or three minutes of songs that traditionally lasted ten or fifteen minutes. Soctomah and the elders had to fill out the rest. "We had the singers sing the new recordings," he said, "and we start talking to people about the history of, say, the 'Trading Song,' and how the customs of trading were really important within the Passamaquoddy tribe and other tribes." Once the songs had been coaxed back into their

full forms, they were performed for and taught to the rest of the community. I watched a video of a group of children, three- and four- and five-year-olds, seated in a circle, listening to the songs. In the background one of the teachers, an elderly woman, starts singing along. The kids are visibly excited to hear her voice, and they start singing too, quietly at first and then with more enthusiasm. "I heard that song when I was a child," the teacher told Soctomah later. "I'd completely forgotten about it."

The story of the cylinders' restoration and of the songs' return to the Passamaquoddy is an important one. But improving sound recordings did nothing to address an issue that had persisted since 1890: that the Passamaquoddy themselves had no ownership of the cylinders or the songs encoded on them, and that they as a people had no say in how these important cultural artifacts were described, or how they were used by mostly non-Passamaquoddy, mostly nonindigenous researchers. Until 2018, curious people who came upon the songs would know nothing of whose voices they were hearing, of the words in the songs, or of the meanings they held to the Passamaquoddy. The only name in the MARC field for authorship was Jesse Walter Fewkes.

Download the MARC file for the "Song of Salutation" today, and you'll find its singer, Noel Joseph, listed in field 245a. Scroll down to field 540, and you'll find something even more unusual for a library holding: a set of permissions guidelines called "Traditional Knowledge (TK) Labels," which indicate how this particular recording should be used. Written by the Passamaquoddy, the section covers attribution, permissions for researchers, and restrictions for commercial use. Each of these is labeled with a Passamaquoddy term: "Elihtasik," "Ekehkimkewey," "Ma yut monuwasiw." Details of the terms are written to be specific to the cultural values of the Passamaquoddy. For example, Ma yut monuwasiw:

This material should not be used in any commercial ways, including ways that derive profit from sale or production for non-Passamaquoddy people. The name of this Label, Ma yut monuwasiw, means "this is not to be purchased."

Traditional Knowledge Labels are in use in museums across the world. In each context in which they are used, permissions for attribution and usage of objects are defined by the people from whom the objects were taken (in many cases stolen). As Jane Anderson explained to me, the idea of the TK Label rules being authored by indigenous communities is crucial. "Every community needed to have the right to self-determine and self-define what those rules are, because the rules aren't the same across communities." Anderson, a lawyer and anthropologist at NYU, helped to conceive of and implement the labels. Unlike similar efforts such as Creative Commons and open-source software licensing, the TK Label doesn't presume that there's a universality to how people might want artifacts and data used. "Each group that uses the labels," Anderson emphasizes, "defines them in their own language and also through their own cultural terms."

Maui Hudson and Jane Anderson are now working to map the fundamentals of the TK Labels to biocultural data. They're building a system for communities to define permissions in their own language, permissions which encode the things that are important to the community. The new labels are at the same time prohibitive and permissive. They clearly lay out contexts in which such data cannot be used or shared, but they also encourage respectful use by outside researchers who take the time to understand what the data mean to the Māori. "Our ancestors were always innovators," Maui told me. The goal of the Biocultural Label Initiative and of Te Mana Raraunga more broadly is not to wall off Māori

data but to ensure it is treated with respect and that any benefit which comes from it is shared. "If you are taking data and want to say something about people," Maui says, "you need to bring it back to those people."

Which only makes sense. After all, blood and DNA samples and historical artifacts and information on the breeding habits of eels are all tāonga. They are precious things.

I flew to New Zealand because I'd realized, six months into writing this book, that I had precious few examples of what living in data *should* look like. I had pieces of my own work and ideas from others that, given a fair amount of duct tape and metal wire, might be coaxed into a cohesive form, but my real world of data, replete with meaning and agency and equality, seemed to be very much a speculative future. In Te Mana Raraunga and in Maui and Tahu's projects, I found work that resonated with so much of what I'd been thinking, nascent but very much in-the-present examples of that data future that for the last decade I've been trying to draft.

It's impossible to separate these indigenous solutions from people and place, but there is real value in considering how the core ideas of Te Mana Raraunga and other indigenous data projects might be applied to data thinking more broadly. How, as Maui says, we might indigenize data and the processes that drive it. For their part, Maui and Tahu seem keen to see the ideas of Māori data sovereignty pollinate to other communities and contexts. "Other people gravitate to these ideas," Maui says, "because they are concerned about data rights but they don't get the chance to voice it." Both of them stress that these ideas stem from a fundamental collectivity that is tikanga—the Māori way of doing things. "We can provide a way of thinking

**Living in Data**

about data differently," Tahu tells me as we're heading out of her office.

Tahu and Maui's work speaks of essential futures. Futures where indigenous sovereignty is strengthened by data, where tribes and nations are better equipped to defend (and reclaim) their territories and their traditional ways of knowing. Ways of knowing that in the face of compounding environmental disasters all of us need to be working together to strengthen. The projects speak of more universal futures, too, in which groups of people with shared interests might build and own data systems end to end, from collection to computation to storytelling. In which the people at the roots of data might have meaningful control over how information is shared, with whom, and under what conditions. In which old definitions of data are not accepted as truths but are redefined, remolded, and retooled to open new avenues of thinking, conversation, and governance. They are crucial waypoints along a new path, one that heads, in Tahu's words, "from a state of data dependency back to one of autonomy."

The principles of Te Mana Raraunga, crucially, were defined not in English but in Māori. "There has been a strong message from the tētēkura," Tahu says, "to use the Māori language to express the concepts of data sovereignty." To speak of data not in terms defined by Stanford engineers and Silicon Valley marketers, but to bind it with tikanga. "Tāonga. Whakapapa. Mahinga kai." Cultural treasures, connected genealogies, gardens. These are terms that seem to live far away from data, but in the work that Maui and Tahu are engaged in, they feel very much at home.

In a 2012 paper, Ocean Ripeka Mercier, Nathan Stevens, and Anaru Toia deconstruct the Data → Information → Knowledge → Wisdom pyramid, considering how the classic hierarchy of data thinking might be adapted to fit with non-Western knowledge systems. Their answer is to turn the pyramid on end, to reimagine

the flow through it being not distillation and simplification but expansion. "A key concept of whakapapa is that all things are derived from the union of two or more things," they write, and so the un-branching flow from data to wisdom in the Western structure needs to be rethought. Placed into the Māori worldview, the DIKW pyramid becomes a "prism that privileges wisdom," in which wisdom occupies the widest piece of the triangle (where in the Western version wisdom is tucked into the pyramid's sharp point). Perhaps most vitally, Mercier, Stevens, and Toia propose that the Māori DIKW prism is meant not to replace the Western one but to sit alongside it, with a bevy of other, culturally specific prisms, each as useful and as unique as the next. "Different cultural perceptions of reality," they write, define the "refractive index" of each prism. Each of these glinting lenses encodes a different way of making meaning between data, information, knowledge, and wisdom.

In my conversations in New Zealand, one thing kept coming up, a footnote to almost every piece of thinking about what real, working data sovereignty might look like: that the infrastructures of data are expensive and controlled almost entirely by large corporations and governments. In writing this book, I've been aware of a specific irony: that almost every project I've described has been, in some way, dependent on big tech's machinery. Floodwatch, a tool we described as a "watchdog for big tech," was hosted on Amazon's cloud. Linguistic analyses for this book were coded with Google's libraries and run on its high-powered servers. The Map Room, for all of its intimacy and focus on the local, didn't work when our Verizon hot spot was down.

If we are going to achieve full agency in our data lives, we'll need to find ways to detach ourselves from data machinery owned and operated by companies that prioritize stockholders over citizens. We'll need to peel off the waxy layers of monetization

that have accreted over decades around our data lives. We need to imagine new infrastructures, software, and hardware that decentralize power and chisel away at tall barriers of cost and literacy. We need to reenvision the way data is stored and told, to imagine farm-to-table data systems that are within the financial and technical reach of those communities that need them the most. This is a huge and difficult problem, with only the vaguest sketches of solutions.

LIVING IN DATA

# LITTLE TRICKLED BACK

Academic papers published about the
Cameroonian rain forest, sized by citation count.

Red leaves are papers where the primary author's
affiliation is a Cameroonian institution.

EUROPE   N. AMERICA

ASIA   S. AMERICA

AFRICA

CAMEROON

From 1995 to 2005, 16.8% of papers came out of Cameroon.

From 2010 to 2020, 24.7% of papers came out of Cameroon.

# 13. An Internet of What

Gunshots, just after 2:00 a.m.

One. Two. A long echo through the trees. Three. And then, for ten minutes, silence.

Quiet is not a natural state of the Congo. At night there is the constant drone of cicadas, the trill of frogs, the chirp of crickets. The escalating screams of the hyrax, the strange birdlike calls of mustache monkeys, the weird electronic beeps of fruit bats. The low hoots of owls, the looping whistle of pigeons, the *woop, woop, woop* of a coucal, the *kok, kok, kok, kok, kok* of the great blue turaco. I spent the first nights at Bouamir awake, listening, parsing, cataloging.

It's hard to gauge distance of sounds in a jungle, because everything bounces from tree to tree and weather affects the way things ring and carry. On a clear night it seems as if the whole forest has crowded into your tent. In thick fog the sounds all stretch out, muffled, into the distance.

The gunshots might have been a mile away, or five. But they were close.

The only way into Bouamir Camp is a thirty-kilometer hike, from Somalomo on the bank of the Dja River, deep into the heart of the forest. We'd walked first through a series of villages, along a narrow road of red soil, past small houses and one-room stores and rusted motorcycles. And then through secondary forest, with wide spaces between trees. Plenty of room to spot the hornbills as they squawked from canopy to canopy. Two hours in, the trail closed in around us, gaps between trees filled with lianas and epiphytes, green and more green. The trees grew taller, and then taller still. Overhead, the leaves and branches filled the space until there were only scattered puzzle pieces of sky. We'd been a loud group at the start, trading jokes and stories of past expeditions and making plans for the week ahead. By halfway, the conversation had dwindled to comparisons of our exhaustion and the occasional warning to avoid the streams of biting ants that marched across the path. Near the end there was just the sound of our labored breath. We let the ants bite. In all, the hike in took us nine hours, and we arrived just before nightfall, blistered, muddy, spent.

There was skepticism in the air as we settled into camp and went about the work of climbing trees and stringing cables. We were working with Cameroonian scientists and staff, but we walked with the same hiking boot stride as the dozens of other researchers who've arrived at Bouamir in the last fifty years. People who were always keen to study the forest and its inhabitants, always keen to record and measure and quantify, often keen to go home. Field science, as much as any form of data collection, is almost always one-way. Expeditions like ours make for good features on *National Geographic*, but they tend to do little for indigenous scientists and for local economies. Places like Borneo and Brazil, after too many decades of snatch-and-grab science, have largely banned research work in their countries if it doesn't meaning-

fully include local stakeholders. Cameroon, though, has no such rules. Staff at the camp spoke of scientists who spent months in the forest, leaning on local knowledge to navigate the winding trails and to track wildlife. They filled their notebooks and laptops with data, and then one day they disappeared. Papers were published, doctorates earned, but little trickled back to the Dja.

The Dja reserve is big. Stretching over five thousand square kilometers, it's one of the largest expanses of protected forest in Africa. The Baka, a seminomadic people, have existed in the land that is now the reserve for centuries. Their lives are tightly bound to the forest, and it is at the foundation of their cosmologies. The linguist and researcher Robert Brisson summarizes this relationship neatly: "In the beginning, before everything, there was the forest." I spent much of my time at Bouamir wondering how the ideas in these pages might fit to this place and these people.

There are plenty of obstacles in front of communities like those in the Dja who want to build their own information infrastructures, who want to have meaningful control over data that is collected, who want to be able to be the ones doing the collecting. There are financial barriers. Servers and routers and sensors and radios cost money to buy, to power, and to maintain. In places like the Dja, far from cell phone service, networks often have to rely on satellite internet, with hefty subscription fees and hard limits on upload and download. There are literacy barriers. Most data tools, software and hardware, are documented only in English and are laden with technical jargon. So much of the data-speak is in the language of the physical sciences. Its timbre is that of the lecture hall, of desks in neat rows, of leather soles on hardwood floors, of privilege.

Obstacles, and pathways too. Often poorly signed, occasionally overgrown, and almost always lightly trodden, these routes loop around new infrastructures. Systems real and virtual, in which

data's favorite adjective—"big"—might be swapped with "small."
With "intimate" and "understandable," "sovereign," "cooperative,"
and "fair."

=

The internet doesn't care what anything is.

It doesn't care that the file you are requesting is a photo of your
dog, or a short story by N. K. Jemisin, or a record of your heart-
beat. What the internet cares about is where everything is. The
central TLA (three-letter acronym) of the modern web is URL,
which stands for "universal resource locator"; in the words we find
reinforcement for this idea. A URL is an address; it is a path to a
place on a server, a file path somewhere where our photo or our
story or our heartbeats can be found. The internet doesn't care if
I switch the photo that currently lives at http://www.myserver
.com/photos/mydog.jpg with another. That a handsome golden re-
triever was just replaced with a scruffy Norwich terrier means
nothing to the browser in which I've typed the URL, nothing to
the DNS servers that route the request to its destination, nothing
to the web server that packs up the file into chunks and sends it
across the network, nothing to my browser again as it renders the
image onto the screen.

This idea that the internet cares about where and not what is
central to the way that the whole system has grown over the last
thirty years. Its dependence on servers—machines that are giant
collections of wheres—has defined how the internet works, how
we use it, and how people have made money from it. As Matt Zum-
walt writes, "The dominant business model in Silicon Valley has
been to accumulate large networks of users, hold their data cap-
tive, and then find ways to make money off that captive web of
data." Four centuries later, data is still "a thing given, a gift de-

livered or sent." The receivers of these gifts have built enormous fortunes while the givers have remained mostly unaware of their generosities.

Zumwalt and many others have come to believe over recent years that the internet's obsession with location is a flaw. They believe that the way the URL system was designed was a mistake, that the internet as we know it right now is broken in a way that has denied it its birthright as an open, participatory space. They believe that the internet took a wrong turn very near the moment it came to life and that if we want to harness the true power of the thing, we need to more or less start again. As I write this, many teams big and small are trying to develop a "new web," a system that will replace the one we have now, one that will dispose of the where-centric machinery of URLs and servers and put in their place a web that cares about *what*.

=

Central to the concept of a what-centric web is the idea of hashing. Hashing is the process of reducing data of variable size down to data of a fixed size. A perfect hashing algorithm can take any kind of data—this sentence, or a photograph, or a video, or the East Berlin phone book from 1982—and reduce it to a string of characters of uniform length which will be unique to that particular piece of content. A simple but silly hashing method is the "add the numbers" algorithm, which reduces a number of any size to a number that is just one digit long. Here's how it works: take any number, and add all of its digits together. If that new number is longer than one digit long, do the same thing again until the result is just one number:

1,798,356

= (1 + 7 + 9 + 8 + 3 + 5 + 6)

= 39

= (3 + 9)

= 12

= (1 + 2)

= 3

2,345,330,107

= (2 + 3 + 4 + 5 + 3 + 3 + 0 + 1 + 0 + 7)

= 28

= 10

= 1

419

= (4 + 1 + 9)

= 14

= (1 + 4)

= 5

Even though this particular method is too rudimentary to be useful, we do see in it some of the things that make hashing so important. First, it always produces the same result for a given input number. This means that, as silly as this method is, it can be useful. If I wanted to tell a friend to memorize my banking PIN, I could then write down the "add the numbers" hash of that PIN so that my friend could confirm they were remembering it correctly, a confirmation of the authenticity of the number in their head.

Second, although the hash can be used to "check" the number, we can't start with 3 and go backward to 1,798,356. There's little danger that the slip of paper I give my friend with a 7 on it could be "hacked" to get my PIN. Even with this comically simple algo-

rithm, it's functionally impossible to go backward. However, if you try this method with some other numbers, you'll quickly find out its biggest weakness: it's very common (a one-in-ten chance) that two "seed" numbers will result in the same hashed number.

In part to avoid this problem—called a hash collision—modern hashing algorithms take data and spit out a long series of characters. For example, here is the result of hashing the paragraph starting with "Central to the concept," from a hashing algorithm called SHA-256, which mathematically churns the text and spits out a sixty-four-character string:

bd2d4f1acee634da813ad8bbb972e0a1ea8491ff0b590df6fddf0c238606d2c6

It would be very, very, very hard to work backward and find the original text from this string of characters. Even if I knew the exact length of the paragraph (remember, these algorithms don't care how much data they're hashing), I'd have to run every possible combination of characters through the same hashing algorithm until I found the paragraph that gave the same hash as I see above. Hashing algorithms like SHA-256 are so effective because they are like computational waterfalls, very easy to drift down but functionally impossible to paddle up. I can easily calculate the hash above on a cell phone, but to decrypt it with brute force I'd need to try $2^6064$ combinations, a number comfortably larger than the count of atoms in the universe in the same way that the sun is comfortably larger than the tip of a pencil.

The second thing to understand is that the hash is sensitive to even the smallest changes in the input data. If I were, for example, to change "East Berlin" to "West Berlin" in my paragraph above, I get a completely different hash:

f748d64a3c00042bb429d7be454a021b0b7aec21643424d51eda84a5abdc21ac

This fidelity to data is what makes hashes so useful. If I wanted to send you an important message, and I wanted to make sure that you knew it was authentic, I could send you the hash as a kind of guarantee. You could hash the contents of my message and check that it matched the string of characters that I sent you. If you wanted to make sure that my editor didn't sneak in any last-minute changes to this book, you could check that the hash of the text matches this one, which I made just before we went to print:

2ca2e85300748bc055383b4a3d7351bf52babcda683356be34999b716d595187

At the core of the whole concept of modern cryptography—cryptocurrency, crypto real estate, crypto farming, crypto toothpaste—is this fundamental ability of a hashing algorithm to guarantee the authority of a piece of data.

Hashing is also in the middle of most designs for the new web. Rather than trusting that http://www.myserver.com/photos /mydog.jpg will bring me to the particular photograph of a golden retriever that I expect it to, new distributed web architectures allow me to request the exact file I'm looking for by asking for it by its cryptographic fingerprint. Using Beaker, a browser for the so-called distributed web, the classic location bar at the top of each page is now an identity bar, the URL replaced by a hash. Hidden from the user—who no longer needs to know—is where the file is living, on a university's server or on my laptop or on your phone.

Whereas the old web might be imagined as something like a vast postal system, in which packets of information are being delivered busily from address to address, these models of the new web are something more like a stock market trading floor. When a machine requests a file from the network, it is effectively calling out to the crowd, announcing what it is looking for. Clever math-

ematical search routines ensure that files can be found quickly across even very large networks.

In this model of file exchange, no central server needs to be involved; data passes directly from one "peer" to another. To understand why this is important, consider how files are typically shared today. If I had a data file, say of records from a heart monitor, and I wanted to send it to a physician, I have a small number of options: I could email it, or I could use a service like Dropbox or Google Drive. In either of these cases, I am not actually sending the file to my doctor directly; I'm uploading the file to an intermediary server, which my doctor then downloads the file from. In the case of email, there are at least two servers involved: my own mail server and the doctor's. This is inefficient; computational resources are used to make copies of the data file, and the routing between my server and my doctor's is almost certainly indirect, meaning that several or even dozens of machines could be involved in a simple file transfer. The transfer is also shockingly insecure. Even if I am careful to encrypt my file, there is still a record of that file being transmitted between every server along the chain. If I wanted to make sure that no one knows about my communications with my doctor, my best bet is to put the data on a USB key and drive it over to the office.

The kind of peer-to-peer transfer that the distributed web facilitates solves both the efficiency and the security problems. Provided my doctor and I have the right software installed, I could send the data from my heart monitor to the office, directly and securely, with no third-party server anywhere having touched a copy of the data. Cutting out this information middleman can be particularly crucial when internet infrastructures are controlled by authoritarian states. At 8:00 a.m. local time on April 29, 2017, the Turkish government implemented a statewide IP ban on Wikipedia. This meant that any internet service provider

in the country was mandated to block its users from accessing any content on Wikipedia's servers. By May 5, the team behind the InterPlanetary File System (IPFS), one of the most promising distributed web protocols, had put the entire Turkish-language Wikipedia up on its platform. Disseminated to thousands of machines, this copy of Wikipedia is very close to unblockable, because the content could be hosted on anyone's machine, anywhere. Even in the event that the *entire* internet were to come down in Turkey, the IPFS version of Wikipedia would still be available on any local network that hosted at least one "node" of the files. As the IPFS developers wrote on their blog, this meant that the content could, if necessary, be moved by "sneakernet"—copied from network to network by physically moving USB flash drives or hard drives.

Another distributed web protocol, Dat, offers particular promise in the creation of sovereign data systems. It was designed to do a very simple thing very well: to enable one scientist to send data to another scientist without having to involve any other servers. This is incredibly useful for practical and privacy reasons. An epidemiologist, for example, would be able to exchange large DNA sequences with a colleague, without having to rely on a shaky wireless network. Even if the connection were broken, they could be confident that Dat could pick up where it left off in their next attempt. The epidemiologist could also be sure that no one was listening in to the data exchange, that the telecom or the satellite internet provider wasn't keeping a copy somewhere on its servers. Entire data systems can be authored in Dat that never touch the internet. Tahu Kukutai's genealogy project could reside, in a meaningful way, in the hapū (subtribe or clan) from which the data came. A Map Room could run entirely apart from Amazon and Google, its participants safe in the knowledge that the maps they were making and the data they were collecting would be theirs. Or, they could choose to share their data,

with the city or with other Map Rooms or with the general public, under conditions that they themselves could devise.

Dat and protocols like it fit well with concepts of data sovereignty and with the ideas of self-defined permissions that we saw in the last chapter. They provide functional ways for data to be held close to a community's chest. However, they don't on their own offer any distance from the physical machineries of data, from the monopolistic telecoms and per-month fees. If we're to imagine an end-to-end system that is truly autonomous, to sketch out a life in data that offers some amount of agency and control, we need also to look at the wires and signals by which data is moved from place to place.

=

After the gunshots, the sounds of the jungle slowly returned. First the insects, and then the birds and the bats, and then, after nearly an hour, the hyrax and the monkeys. They were satisfied, it seemed, that the poachers were done for the night. If I'd been able to somehow tune my hearing, to expand its range, the raucous audio landscape of the forest would have filled up even more. Down in the subaudible range I'd hear the rumbles of the forest elephants, low-pitched conversations between giants, stretching over tens of miles. Up in the ultrasonic would be the social chatter of cane rats, the quiet courtship songs of moths, and the radar ping of hunting bats. Somewhere around forty-five thousand times the upward frequency limit of human ears, three thousand times higher than the highest-known range of animal hearing (the greater wax moth), I'd find a brand-new addition to the jungle soundscape: the chirp, chirp, chirp of data.

These signals are coming from weather stations, installed on two of the Dja's peculiar inselbergs—rocky islands that rise above

the dense rain forest. The stations are measuring data about the inselbergs' unique microclimates and are sending the information to radio gateways we installed high up in the branches of nearby trees. By later this year, there will be four LoRa (long-range) radio gateways in the reserve, which will allow local researchers to easily instrument the forest, tracking its wildlife and learning more about the ecosystem in general. Because the radio network is self-contained, access to data collected can be carefully controlled, permissions granted (or denied) on a case-by-case basis.

Radio has deep roots in conservation technology. In 1894, Alexander Stepanovich Popov demonstrated a device that could detect lightning from more than thirty kilometers away by picking up the radio waves generated by the strike. Recorded on paper rolls, the data points about lightning activity could be used to help the forest service investigate potential fires. As early as the 1950s, scientists began attaching radio transmitters to animals, with the intent of tracking their movement. These radio "tags" emit brief pulses, which are then picked up by radio direction finding (RDF) receivers, which triangulate the location of the signal.

One of the main challenges in using these technologies for conservation has been a fundamental limit of radio: the relationship between range and power. One of the inherent properties of radio signals is that signal strength is proportional to the inverse square of distance. Moving a receiver twice the distance from a transmitter reduces the signal strength by one-fourth. Moving it ten times farther from the transmitter reduces the signal strength by one-tenth. Put more simply, broadcasting a signal across a wide geographic range requires a lot of power. This relationship will be familiar to anyone who has tried to tune in to a community radio station: unlike big corporate stations with high-powered broadcasters, smaller stations typically use less expensive, lower-power setups, which means their signals are broadcast

across smaller areas. When I was growing up outside Vancouver, I could pick up the college radio station (CiTR) . . . only if I parked my car at the edge of a north-facing bluff.

The radio gateways that we hoisted up into trees in the Dja and the weather stations on the inselbergs take advantage of a clever innovation in radio that allows for something that seems to go against the rules I just told you: they can transmit over long distances with very little power. LoRa radio manages this trick by compressing information into short-frequency modulated sinusoidal chirps (yes, that's actually the technical term) that can be reliably picked up by receivers up to about ten kilometers away. Both the weather stations and the LoRa gateways we deployed in the Dja are solar powered; thanks to the small amount of energy needed to send messages, they can keep up their data chatter happily without needing extra power. There is a cost in upkeep; batteries and the occasional termite-infested circuit board need to be replaced. But there is no contract to be signed with a third-party provider, no terms of service to be agreed to other than the one that is defined by the forest and the people who live in it.

LoRa works best when there is a clean line of sight between the transmitter and the receiver, so we wanted to get our gateways as high up in the air as possible. In an urban area this would mean putting hardware on top of tall buildings; in the jungle it meant getting up into the trees. The Congo rain forest is home to some very tall hardwoods, mahogany, ebony, iroko, sapele, some exceeding sixty meters (about two hundred feet) in height. We had an extra advantage in the Dja because of the inselbergs, which rise above the forest as high as thirty extra meters, meaning the highest stations might sit some thirty stories above the ground.

Eventually the data collected from our stations will chirp out of the forest, relaying from treetop station to treetop station out to Somalomo. There it will live on a machine in the village, where

permissions might (or might not) be given for it to be shared to the web, to specific researchers, or to the general public. For now, though, the system is smaller, and access to the data relies not on an API key but on knowledge of the forest, on rain gear, and on a tolerance for biting insects. From each LoRa radio station dangles a long gray cable, which terminates in a small box. To gather the data, researchers and the park's conservation agents need to visit the trees, plug into the box with a custom-made data collector, and bring it physically back to camp or out of the park. This is the sneaker-net again (boot-net?), a system made sovereign by its reliance on a necessarily low-tech transfer of data. Its operation is simple, but it fits more closely to the natural patterns of life of the people in the park than any network protocol.

Some two hundred miles northeast of the Dja, in a village called Nditam, a solar-powered community radio station broadcasts to a few hundred people. Founded in 2017 by a persecuted political cartoonist and activist named Issa Nyaphaga, Radio Taboo has an agenda of radical education. Its voices speak of HIV, of women's issues, of gay rights, of the environment. "Power is not only having a lot of money or having a gun in your hand, or that you can sit in any institution designed to marginalize people. That is a very superficial power. Power is to be able to give education and information to people so that they can be empowered."

Compared with North America, community radio is a relatively new arrival in Africa. For much of the twentieth century, radio was mostly state controlled, an instrument for propaganda more than a source for local news and information. Since the turn of the century, this has changed. In Uganda alone there are more than 250 community radio stations on air. In Zambia there are 137; in South Africa more than 200. Many of these stations are, like Radio Taboo, "proximity stations." They are modest affairs, often powered

by the wattage of a car battery. To borrow a phrase from my own Canadian radio childhood: they may not be big, but they're small.

Lynne Muthoni Wanyeki, a Kenyan political scientist, has written extensively on the cultural importance of community radio stations on the other side of the continent from Cameroon. In her book *Up in the Air*, published in 2000, Wanyeki places these stations in a wider category of community media. Community media, she writes, are those "produced, managed and owned by, for, and about the communities they serve." Critically, she draws a distinction between true community media and community-oriented media. The latter, she writes, might encourage community participation, and might have local interests in mind, but they are not owned by the community.

I've come to think of the tree-to-grassland network we helped to start in the Dja as a nascent community data station. It doesn't try to broadcast too widely, and it speaks to the concerns of the Dja and its people. The technology might be mappable to another park or to an ice floe or to an urban neighborhood, but the character of *this network*, the way the stations sit in the crooks of canopy branches, is of *this place*. There is some of the Victoria Free-Net in it, some of St. Silicon's Hospital, some of Radio Taboo. In the network's intimacy, in its moss-covered wires, and also in its outsized, underdog hope.

=

Bouamir Camp burned down a few years ago. It was set alight as protest, a smoky rebuttal to antipoaching efforts that locals thought were challenging their livelihoods. For a while there was only some wet charcoal, melted netting, a crumbling outhouse, the jungle's cacaphony. Two years later the camp was rebuilt, four new

platforms made from hardwood milled on-site, new mesh walls, new roofs. Bathing stalls near the stream, two field toilets, a solar power system. Just last year, satellite internet. With the rebuild came a reenvisioning: a focus on building infrastructure to support Cameroonian scientists, on strengthening local economies, on prioritizing the knowledge and interests of the Baka people. The station would, according to its website, "provide a model for protecting and restoring the Congo Basin forest by providing a hub for conservation research and integrating knowledge and input from indigenous people."

In a 2001 paper, the Cameroonian lawyer and activist Samuel Nguiffo describes an "uneasy coexistence" between the Baka and conservation efforts in the Dja. Uneasy in part because the reserve's restrictions on hunting are directly at odds with the Baka's way of life. "If you go into the reserve," the Baka told Nguiffo, "it is to hunt." Uneasy also because conservation decisions, including the creation of the reserve, have been made without Baka input. The Baka were not consulted when the boundaries of the reserve were created, nor were they consulted on the long-term objectives.

There is an uneasy coexistence at the heart of all of our data lives. It's in the halls of Hunter College High, in our courtrooms and police stations, in our web browsers, on our streets, and, already, in the forests of the Dja. Through ethnographic studies, satellite imagery, and cell phone tracking, the Baka are already living in data. To imagine a form of data citizenship that matches their lives and their worldview is a difficult challenge. It is also a necessary one, as any relief we might prescribe ourselves to remedy data's unease—technological and otherwise—must work equally well for all of data's many residents.

## BUT I DO BELIEVE
## IT'S COMING BACK TO LIFE

MENTIONS OF THE WORD "HOPE"

MENTIONS OF THE WORD "CRISIS"

J. T.        GITHUB.COM/BLPRNT/LID/MEMORIAL

genome of Richard III

Meltz: Glimmer of hope quickly fades

Stocks in Asia rise on hopes for global economy

No hope for children buried in China quake

Questions, and hope, on plans for mortgage giants

He hopes this sends a message

Whatever hopes to clean up with dirty films

> But sometimes a tool may have other uses you don't know.
> Sometimes in doing what you intend, you also do what the
> knife intends, without knowing. Can you see the sharpest
> edge of that knife?
>
> —PHILIP PULLMAN

In a basement room at MIT, a group of researchers have built a custom interface for navigating large sets of data. It has an official name, the Spatial Data Management System (SDMS), but they mostly refer to it by the nickname that one of them came up with over beers: Dataland. At the center of Dataland is a modified Eames recliner, custom fit with small joysticks and track pads at the end of each of its arms. Beside the chair on either side are square data touch-enabled displays, individually configured such that they can show separate content. The chair and the displays are set in front of a huge ten-foot-tall screen, and the room is rigged with eight-channel speakers so that sound can be played both in front of and behind the person who is in control of the system.

One of the researchers sits down in the control chair and takes Dataland for a spin. From the system's main interface, he selects a map, and the Dataland loads four thousand square miles of Landsat satellite imagery, photographs from space of the Eastern Seaboard between Boston and the southern part of Maine. Using

the controls, he zooms in. The Charles River and Logan Airport's triangular runway pattern come into sight, and then with a tap of a button the satellite imagery is replaced by a street map. He zooms in further, and the map centers on Beacon Hill, where the street lines are replaced by a sequence of extraordinarily high-resolution images of the neighborhood. In one of them, there is the figure of a man in a dark gray raincoat walking his dog.

Watching a film of this session with Dataland, I can't help but think of *Star Trek*, of Kirk in the captain's chair, in command of his bridge. Dataland feels like an elaborate cosplay set for the *Enterprise*, the room short a coat of shiny silver paint and the researchers waiting for their costumes to arrive. I keep expecting someone to activate the phasers.

Which makes sense, because it's 1978. The original *Star Trek* series debuted a decade before, but it has by now been widely syndicated, enjoying better ratings than it had ever had in its original run on NBC. It is being shown in sixty countries and holds airtime on stations in more than a hundred American cities, including Boston's WBZ-TV. It's not a stretch to guess that these men working on Dataland might be *Star Trek* fans, that in some way their building of this room serves to satisfy their own desires to boldly go, to bravely explore.

*Star Trek* never tried to hide its design affinity with all things naval, from its chain-of-command terminology, to the boatswain's whistle used to open shipboard communications, to the *Enterprise*'s photon torpedoes. It's an interesting coincidence that Dataland was, likewise, grounded in a history of naval technology and warfare. The SDMS in this film is actually SDMS II, SDMS I having been built two years prior with funding from the Office of Naval Research, an organization that launched the first intelligence and GPS satellites and most recently developed an electromagnetic rail gun, capable of shooting projectiles at forty-

five hundred miles per hour and hitting targets from a hundred miles away. Dataland was sponsored by the Cybernetics Technology Office of the Defense Advanced Research Projects Agency (DARPA), under the wordy title "Augmentation of Human Resources in Command and Control Through Multiple Media Man-Machine Interaction."

It's hard to say how much influence the navy or DARPA might have had in the way Dataland was designed. The system does seem to be built to work in a military fashion, from the idea of the "command chair" itself to the weapons-like triggering systems installed in its arms. What seems certain is that Dataland was built around a core concept of operating on data from a distance. When seated in the chair, its operator can imagine themself orbiting a faraway planet, scanning life-forms from afar, considering the lofty morals of a prime directive.

Dataland neatly captures much of the ethos that would drive the next forty years of data technologies: that the real-world systems that data comes from (that is, the people) are to be acted upon, rather than with. Nicholas Negroponte, one of the creators of Dataland and the founder of MIT's Media Lab, wrote in a summary report that Dataland would "bring computers directly to generals, presidents of companies, and six-year-old children"—we might surmise, in that exact order.

The first two steps were already well under way in 1978. Consumer credit companies were collecting detailed dossiers about their customers, using computers to index and cross-reference, to make list after list for direct-mail campaigns. The military, too, had embraced the promise of data, already scheming to launch more detailed imaging satellites, and building infrastructure to track dissidents, at home and abroad. When data they collected gave answers that seemed incomplete, there was only one solution: more data. Corporate and state pursuits accelerated,

doubled in on each other, Voltron-ing a massive convoluted machine aimed at tracking and targeting, amplifying and excluding, pulling in and pushing away. More data came and is still coming, from our phones and from our web browsers and from cameras in our parks and in the sky. More and more and more and more and more data. To the military, to the corporations, *from* the people.

In the fall of 2018, I was awarded a short writing residency to work on this book, and so I spent some cold weeks in Rensselaerville, New York, tucked in at the ambitiously named Carey Institute for Global Good. It was December when I arrived. Wedding season was some months away, and it was too late in the year for conference planners, so the center was mostly empty, haunted by only the small cadre of fellow nonfiction writers who were part of the residency. With a foot of snow on the ground, most of the other ghosts were content to stay in their rooms, but I'd make the crunch-crunch trek every morning to Huyck House, one of the two austere nineteenth-century buildings on the property, and I'd set up shop in the library.

The main draw the library had as a workplace was its open, drafty fireplace. It was so inefficient as to offer two particular advantages: one, the fire roared and crackled in a satisfying way that made me think of *Masterpiece Theatre*. Two, the flames ate wood so quickly that I'd need to tend the fire every twenty-five minutes, which set up a nice schedule for frequent breaks and healthy blood flow. Often on these fire-stoking breaks I'd take the long way back to the small table I'd set up near the window (which was perhaps four meters from the fireplace), taking some extra minutes to look over the strange mix of books on the shelves.

Since Huyck House had ceased being a private residence in 1963, decades of random works had found their way into the library.

There was a definite bias toward economics and politics—what looked like a full set of *Foreign Affairs*, biographies of Washington and Jefferson, Schweitzer and Khrushchev. *Air Power for Peace*, *Sterling-Dollar Diplomacy*, *A Businessman Looks at Red China*, *A Democrat Looks at His Party*. A battered copy of *The Tower Commission Report*. On one particular trip a paperback caught my eye, the kind of yellow-edged book you might find in a fifty-cent bin at a secondhand store or on a bookshelf in a motel. It was called *The Assault on Privacy*. The title was rendered in bold red letters on the cover, and beneath it there was a blurb from Ralph Nader. *The Assault on Privacy*, Nader wrote, is "a warning of a new form of human slavery," one driven by computers and fueled by personal data.

I sat back down in front of the bay windows and read the book cover to cover as the snow fell and the day grew dark. *The Assault on Privacy* contains passage after passage that might be cut and pasted into a *New York Times* op-ed today. The author, Arthur R. Miller, writes about the dangers of interdata, of the value of personal data to marketers, of remote sensing, of rights and ownership. He writes about data's amplified impact on groups that are already at higher risk, in particular migrants to the United States. Miller talks in detail about the dangers that come when data is digitized and aggregated from disparate sources, in formats that are easily accessible and inexpensively permanent. Writing in 1971, eighteen years before the birth of the web, he neatly presages the internet.

"It seems reasonable to envision," Miller writes, "some form of personal computer 'utility' providing a variety of data processing services to everyone, perhaps through the medium of inexpensive home terminals such as touch-tone telephones or in conjunction with cable television." This new utility, he predicts, "could be used to offer up personal data to any number of interested parties:

credit bureaus, governments, corporations. What's more, these data-consuming parties could put together information from previously disparate sources." He writes, "Relational analysis of an individual's activities is clearly the wave of the future in the surveillance field," giving warning of (or perhaps a road map to) our future of DoubleClick and Facebook, XKeyscore and PRISM.

*The Assault on Privacy* managed to capture three essential pieces of the then nascent data story that has grown to encompass us all. First, Miller sees that benefits of data will always be matched with risks. "The same elective sensors that can warn us of an impending heart attack," he writes, "can be used to locate us, track us, and measure our emotions and thoughts." Second, he argues that the narrative about data systems will be in large part guided by the parties that benefit most by their deployment. Miller predicts that credit bureaus, as an example, would argue that their data collection efforts benefit the average citizen. In doing so, they'd cloak themselves in a convenient "mantle of public service," a strategy written clearly into corporate mottoes like Facebook's: "Give people the power to build community and bring the world closer together." Finally, Miller understood that any effective pushback against the book's titular assault would depend on data issues finding a place in the collective imagination. "The desire of certain members of the community to retain their privacy and express their sense of outrage at having it destroyed," he writes, "will avail them nothing if the majority no longer cares."

This is not to say that *The Assault on Privacy* is entirely timeless. There are numerous facts about "modern" computers, meant to wow the readers of the 1970s. "One of the pioneers in the field of programming predicts," Miller writes, "it soon will be cheaper to store a page of English text in a computer than to preserve it on paper." He is obviously impressed. Miller's warnings about information security likewise sound quaint: there are telephone lines

and terminals and no sign of cryptographic hashes or multifactor authentication. Still, Miller hits the mark so often I found myself wondering if the publication date might have been a misprint.

"There is a risk," Miller writes in what might be his most prescient presaging of our twenty-first-century lives in data, "that enormous quantities of financial and surveillance data from a variety of sources will be made available to anyone who wishes to reconstruct an individual's associations, movements, habits and lifestyle." In perhaps the most distressing example of a sentence that has held truth for fifty years comes a warning about the collection of personal data: "We are only beginning to perceive the intrusive uses to which databases of this type may be put."

There is a sense of urgency running through *The Assault on Privacy.* Miller seems to recognize that at the start of the 1970s there existed a brief window to push legislation and to promote public education around data issues. In the foreword, Senator Sam Ervin (later chair of the Watergate Committee) writes that he hopes the book might "bestir all Americans . . . to demand an end to abuses of computer technology before the light of liberty is extinguished in our land." Toward the end of the book, Miller writes that "it . . . seems imperative to sound the klaxon as a warning that the computer may be precipitating a subtle realignment of power within our society." As I put the book down, I wondered how Miller felt half a century later, if he felt that his warning had been heard, if he could still hear that klaxon sounding.

Back in New York City, I met with Miller in his office, tucked into the corner of the mazelike second floor of NYU's law school. The room is all bookshelves and baseballs, the first a legacy of four decades spend waist-deep in copyright law and civil litigation procedures, the second an artifact of his last twenty years in sports

law. At eighty-five, Miller looks and sounds as if he might be hosting *60 Minutes*. He spent most of our conversation leaned back in a leather chair behind a monumental wooden desk.

"What I wrote back then," he told me, "was a lot of guesswork. I was just starting to get a sense of the power of a new technology." The 1960s were an era of mainframes, he explained. "Handheld computers, whether they be cell phones or laptops, just didn't exist." *The Assault on Privacy* was born out of an eight-page article Miller had written in 1966, on the copyright ability of computer programs, whether you could infringe with machines. Senator Ervin had somehow found the article and thought that Miller would be a good witness to call for an upcoming hearing about a project to build a central database that would hold all federal data about U.S. citizens. "I'm an expert on copyright," Miller told the senator when he called with his request. "I don't know a thing about privacy." There was a brief moment of silence on Ervin's end of the line. "And then he literally bellowed into the phone," Miller recalled with some amusement, "'Well, learn, damn it!'"

*The Assault on Privacy* recommended one specific way to address the burgeoning conflict between data and privacy: legislation. In the closing chapter, Miller calls for "extensive governmental intervention." Such intervention, he continues, "becomes obvious once the computer's ever widening impact on our society and its permeation in our daily affairs becomes obvious." Miller's klaxon was for action at the federal level, and at least in part it was heard. The Fair Credit Reporting Act, the Family Educational Rights and Privacy Act, and the Privacy Act (which covers governmental use of personal information) were all passed by Congress between 1970 and 1974. "It was a remarkable period," Miller told me, "particularly when you look at our Congress today, this inertial beast." With a change of decades, though, came a shift in attitude toward regulation. President Reagan and a Republican-

dominated Congress began listening to corporate claims that such legislation was stifling innovation and the ability to compete in a global market. "The whole issue," Miller says, "sort of went to bed. But I do believe it's coming back to life."

Indeed, there has, in the last years, been a new wave of proposed legislation around data and privacy, combined with a surprisingly bipartisan willingness to commit to governmental regulation of companies involved in the business of personal data. The European Union's General Data Protection Regulation (GDPR) offered a passable model for how governments might act to defend the right to privacy of individual users. In its wake, California's Consumer Privacy Act of 2018 shows what legislation might look like in America, giving citizens control over what data businesses collect about them and imposing penalties on companies that refuse to comply. The proposed Facial Recognition Technology Warrant Act would limit the ways law enforcement agencies can use facial recognition. The Consumer Data Protection Act, the Data Care Act, the American Data Dissemination Act, the Algorithmic Accountability Act—these are all bills that are making their way through Congress at the federal level.

The Algorithmic Accountability Act is particularly promising because it addresses how data technologies are designed and built. Over the last few years, many people have focused attention on how computational recipes might be rewritten to bake in ethics and accountability. Taking arguments for accountability past discussion and into practice, important work is being done in making sure potential for harm is something that is benchmarked alongside web load time and algorithmic performance. In 2018, the AI Now Institute released a framework for what algorithmic impact assessments (AIAs) might look like. A year later, the Canadian government launched a beta program for AIAs, which would be mandated for all government projects, including

work by contractors. The Algorithmic Accountability Act would require companies to conduct similar assessments of all automated systems.

Legislation, though, will take us only so far. As Miller understood in 1971, data practitioners and the corporations that employ them have to commit to change not as a way to duck under the regulators' reach but as a way to become better actors, to make more fair and more equitable data systems. "Self-regulation and self-examination by any company that uses or handles personal information are imperative," Miller writes, "and are certain to play an important role in any serious attempt to safeguard informational policy." Such introspection has hardly been de rigueur in Silicon Valley. As we saw in chapter 5, the companies that dominate our data lives have mostly been content to take shelter behind false statements and marketing-speak. Their strategies in the face of legislation and enforcement have up to now been to absorb any fees that come their way, the mass of their market caps being safe harbor against even historically large penalties. When Facebook was fined a record five billion dollars in 2019, its stock price rose by nearly 2 percent, stockholders apparently comfortable with a fine that was just 10 percent of annual revenue.

Many tech ethics advocates (including myself) have also pointed to the need for companies to diversify their development and management teams as an effective way to see potential harms from data technologies before they get released into the wild. Because women, people of color, the disabled, and other underrepresented groups are often at the biggest risk from these technologies, it makes sense that they would be able to better envision ways where even well-intended data endeavors might go wrong. The big four (Google, Microsoft, Apple, and Amazon) have all made public pledges to do better when it comes to diversity of their staff, but their efforts have not exactly brought about transforma-

tive change. Apple, whose diversity slogan is "different together," speaks publicly of the importance of a workforce that isn't dominated by white men. The company's own numbers, though, paint a different picture. Thirty-two percent of Apple's employees are women, and 9 percent are Black, compared with 50.8 percent and 12.3 percent countrywide. These numbers get worse when restricted to tech jobs (23 percent female, 7 percent Black) or to jobs at the leadership level (29 percent female, 3 percent Black). Here again, companies seem content to speak about change while enacting it at a glacial pace (or not at all).

How might the builders of data systems, these suit makers of our data lives, be held more accountable?

Tracing the roots of the GDPR back in time, we arrive in the West German state of Hesse in 1970, where Der Hessische Beauftragte für Datenschutz und Informationsfreiheit—the Hessian commissioner for data protection and freedom of information—was appointed. This data ombudsperson (today a countrywide role) has broad authority and right of access to data from both private and public institutions. German citizens can, with the help of the Beauftragte, access any information collected about them, whether it be by the state itself or by any corporation operating in Germany. Invested with the right authority, this kind of data public advocate provides an effective opposition to both government and nongovernment bodies that infringe on the data rights of citizens. Miller is a strong advocate of this approach, which he, not surprisingly, links to the baseballs on his desk. "We now have drug testing in sports," he says, "and the drug testing is done on a drop-in basis." Miller believes an ombudsperson granted similar powers to look into data systems and algorithmic design would have a prophylactic effect, if they were also given the authority to impose meaningful fines and to—when necessary—outright stop the use of systems that are in breach. "Teeth are necessary."

=

I left the law school and walked across the street to Washington Square Park. It was early February, and the park was mostly empty, apart from a straggle of tourists, some tightly bundled chess players, and a few chubby resident squirrels. I decided to walk over to the Blind Tiger for a beer, and as I zigzagged my way through Greenwich Village, I thought about someone finding this book on a shelf fifty years from now. Will they lament, as I did in Rensselaerville, how little has changed? Or will they be living data lives that look nothing like ours, citizens of a more habitable, more sustainable data world? That answer lies with you and me.

There is no better or more urgent time to start again. Tech companies are floundering against public opinion and government investigations, their monopolistic armor starting to crack. New ideas and new technologies are giving people ways to collect, store, and share data outside corporate influence. We're facing challenges, urgent life-or-death challenges, that seem intractable to our existing institutions. Government isn't going to fix climate change. Facebook isn't going to solve the collapse of truth. No meeting at Davos is going to remedy income inequality. *If we want to see change in our lives, we have to change things ourselves.*

The word "data," the idea of data, the promise of data, is adrift. It's time to catch it, to write a new story, Negroponte's in reverse. Starting with the public, with the six-year-olds, with ourselves and our neighbors. A story of a future that is more *Sesame Street* than *Star Trek*, set on sidewalks and front steps instead of command centers, in their distant orbits. A story where we see data's imperfections clearly, where we understand that it is a human thing, full of human bias, of hope and promise, error and neglect. A story spoken with new words and in more voices, told in places

closer to home. A story where we feel more like citizens than like subjects.

I told you at the beginning of this book that there would be no straight line to follow. And so I'm not going to end with a neat set of takeaways. No three principles to follow, no seven easy steps. No neat TED-talkable synopsis.

I'll leave you instead where we started, at the side of the river.

There is first of all the problem of the opening, namely, how to get us from where we are, which is, as yet, nowhere, to the far bank. It is a simple bridging problem, a problem of knocking together a bridge. People solve such problems every day. They solve them, and having solved them push on.

Let us assume that, however it may have been done, it is done. Let us take it that the bridge is built and crossed, that we can put it out of our mind. We have left behind the territory in which we were. We are in the far territory, where we want to be.

—J. M. COETZEE, *ELIZABETH COSTELLO*

# Epilogue

Eko followed Manny's bike along the bank, watching the green light on his antenna blink on and off. It was early in the summer, and the air was still cool. In the dark Eko could hear St. Anthony Falls churning, setting the air into a mist that tasted like tree bark and copper. Record rainfall had filled the waterways up north to capacity, and here the river seemed barely constrained by its banks, full of power. Manny had persuaded Eko to sign up for these weekly data runs together, and they'd been doing them for more than a year, even in the deep snow of winter. The sensors mounted on their bikes were measuring air quality a dozen times a second, and every half a mile or so they'd pass a station that connected to a box of instruments in the river. Eko heard a beep from behind her seat as one of the stations synced; it'd sync again to the mesh network when she got home.

At first, the city had removed the stations when it found them, claiming lack of permit. People had gotten better at hiding them, though, and Eko figured the parks people had probably gotten tired of hauling them out. Besides, it was next to impossible for anyone to be charged for anything, because there

was no formal organization behind the sensors. No single person owned more than one or two, and if they did, they were sure not to deploy them in the same place. Slowly, the stations had become a reality of the river, along with the Stone Arch Bridge and the red-winged blackbirds.

Eko was tired. The night before had been Signal Night, and she'd helped some neighbors at Riverside Plaza to raise their beacon. Three years earlier she'd been able to spot only three other beacons from the roof: one downtown, one over in North Loop, and one in Bottineau. Last night there'd been hundreds, thousands maybe, each blinking in synchrony. Air quality, then water quality, then noise levels, then well-being. "Why not just look at a map on a website?" her neighbors had asked before the first time. But they'd all gathered on the roof to watch that night, just the same. There was something about seeing the other beacons, about that feeling of sharing the space and the sky. Public space, and public time. Besides, as Manny always says, no one trusts the internet anymore.

Up ahead, she heard the squeak of Manny's brakes, and she slowed down to pull alongside. They were in the ruins of the old mill, and skeletons of iron and stone traced the edges of the shadows. Eko swatted a mosquito. On a school trip years earlier, Eko had learned the history of this place, how a hundred years ago this part of the river had been the world's biggest producer of hydroelectric power, and how fifty years before that it'd milled half the country's flour. Much later she'd teach herself to say the Anishinaabe name of this place: gichi-gakaabikaa—the great severed rock.

The previous September, a few last sensor stations had come

online in Ohio, and they'd had, all at once, a data view of the entirety of the Mississippi River. Stations reading temperature and depth and flow and dissolved oxygen and heavy metals and boat noise were knit together into a constantly updating assemblage they called the datashed. "Isn't this the kind of thing the government does?" her sister had asked her, when Eko'd excitedly explained it all at the dinner table. *Yes, of course it was.* But there'd been almost a decade when the EPA had ceased to function, and then even when it was "reestablished," it didn't have the budget to do anything at the scale of the datashed. The new agency, folded into FEMA, had access to the datashed, though it had to comply with the protocols for access set out by the indigenous nations and the farmers and everyone else.

Eko waited as Manny clambered down to the river, to replace a heavy metal sensor in one of the stations. Earlier in the year, a farmer down in Arkansas had picked up elevated readings of mercury in an irrigation channel, and for weeks a group on the forums had tried to trace it back to a source. Their model had shown the source as being somewhere near the city. Manny thought maybe it was coming from one of the old hydroelectric tunnels that ran up to the factories on the hill, that some twentieth-century mess was leeching down through the soil. So they'd been putting in some new stations and replacing sensors with newer, higher-fidelity ones. It was quick work; she could already see their flashlight coming back up one of the old stone staircases.

Eko tossed Manny a pair of headphones. She'd finished a new version of the sound piece she'd been working on, which used live readings from the bikes and meshed and merged it with data downstream, as well as records she'd scraped from old websites and even older maps. The piece started here, beside the falls, and

then rushed down through the datashed. By the end it was loud, polyphonic, muddy. All that data, singing aloud all at once. To Eko, it sounded *joyous*.

"Come on," she shouted back to Manny, already pedaling. "Let's take the long way home."

We have less time than we knew, and
that time buoyant and cloven, lucent,
and missile, and wild.

—ANNIE DILLARD

# Notes

## Prologue

The opening vignette about Hal Fisk is largely fictional. While his report, *Geological Investigation of the Alluvial Valley of the Lower Mississippi River*, is extraordinarily comprehensive, there's not much material to go on as to the personal dynamics between Fisk and his team. His memorial in the *Proceedings of the Geological Society of America* contains some details that give a sense of the man: that he completed his BSc, his MSc, and his PhD in four years, that he married Emma Ayrs (also a geologist) during that time, that he was awarded a full professorship just ten years after his doctorate. I suspect the fact that Fisk's name has become most closely associated with a set of colorful maps might have irked him (the adjective I found most used to describe him is "gruff"). First, because the 170-page report that the map plates were included with has managed to become a footnote to the maps, and not the other way around. I suspect Hal would be most uncomfortable with the term "Fisk Maps," because it's almost certain that he didn't draw them. In the report, credit for "illustrations" is given to W. O. Dement, a draftsman for the Mississippi River Commission. Dement's initials are on many of the other plates in the report, but not on the meander maps, plates 22.1 to 22.15. These maps have only Fisk's initials (as does every plate in the report) and R. H. Smith's. There is another striking color meander map in the report, plate 2, which is likewise signed by Fisk and R. H. Smith. From this evidence, it seems likely that Smith is the creator of the famous meander maps and that they might better be referred to as the Fisk/Smith Maps.

Whatever their authorship, the maps are very well worth seeing in person. Original copies of the report are available in a number of academic liberties, including the Library of Congress and (as I found out) the New York Public Library. One thing I've learned through researching this book and spending time at the Library of Congress in Washington, D.C., is that reading rooms (and map collections) are almost always open to the public. I've made it a habit since to visit reading rooms in the places I travel too, where the librarians have always been friendly and helpful, even to someone with my complete lack of academic bona fides.

## 1. Living in Data

The hippo heart-rate data was recorded by an Ambit watch with a remote chest-strap heart monitor. Various expedition members over the years wore similar devices, and they give a pretty interesting look into the energetic and interpersonal dynamics of fieldwork. The more intrepid of you might be interested in digging into these (and many, many more data points) at the mostly undocumented and yet somehow not yet defunct project API: http:// data.intotheokavango.org/api.

The 2014 Okavango expedition, led by Dr. Steve Boyes, was the second of nine annual transects primarily aimed at counting wetland birds, with the goal of monitoring ecosystem health over time. The hippo counts, though inconsequential to the central goal of the project, also provided a time-based record of population. In a recent paper, Boyes and his team used these data to show that hippo populations seem to be retreating farther and farther away from heavily touristed areas of the delta. This sets up a cycle in which guides travel farther to get to the animals, disrupting areas that were otherwise largely "pristine." I am indebted to the Ba'Yei members of the expedition team, without whose expertise and skills we would have gotten nowhere. I'd like to specifically remember my friend Leilamang Kgetho, whom I spent time with in Angola and Botswana in 2015 and 2016. Leilamang died in 2020 (he was twenty-seven).

The hippo data sonification, the color economy project, the *New York Times* word-frequency visualizations, and many of the graphics in this book were made with Processing, an open-source tool kit for creative coding originated by Ben Fry and Casey Reas. Now two decades old, Processing has far exceeded its original goals of providing a medium for people to "sketch" easily with code. I'm not sure there's a project of mine in this book that didn't use Processing in some fashion, and I owe much to the project and all of the people

who have built and supported it. I'm also wildly in love with Processing's newest iteration, p5.js, which you can dig into online at http://p5js.org.

At *The New York Times*, I made up my title of data artist in residence. The paper had had two futurists in residence in the past and offered me that title, but it seemed a bit too . . . well, a bit too futurist-y. The *Times*'s R&D Lab lasted from 2005 until 2016. It was an unlikely space, mostly free from corporate whims, and I was lucky to have been able to settle there on the fourteenth floor for a couple of years. Another, perhaps even more unlikely space is ITP— the Interactive Telecommunications Program—where I teach to this day. Red Burns, who started the program in 1979 and who roped me in in 2010, used to give a talk to all of the first-year students, which mainly consisted of short provocations. A very many of these still rattle around my brain. *In any creative endeavor you will be discomfited, and that is part of learning. Poetry drives you, not hardware. Technology doesn't make a community.* You can read a version of Red's famous ITP introduction here: https://creativeleadershipblog.files .wordpress.com/2013/08/reds_2010_ver3.pdf.

The New England Complex Systems Institute is an independent research institution in Cambridge, Massachusetts. On August 20, 2013, it released a paper titled "Sentiment in New York City: A High Resolution Spatial and Temporal View" from which Hunter College High's "saddest school in NYC" label was derived. You can still read the paper online on the institute's website (https://necsi.edu/sentiment-in-new-york-city), where there is no mention of erroneous methodology (or a faulty premise). Reading the press release, you get a sense of the authors' excitement for this approach of geographic sentiment mining. "This is the first time we are able to easily and precisely map people's mood to their time and location," says the paper's lead author. "The possible uses of this tool are endless." Reading through NECSI's publications is like walking through a data-utilitarian theme park. There are papers that analyze social fragmentation and racial segregation in the United States (using geo-located tweets), studies that "use physics to explain democratic elections," and a proposal to "fix science using a new science of science." The NECSI's list of thirty faculty and co-faculty on Wikipedia includes exactly two women and exactly one Black person.

Ursula Franklin's 1989 Massey Lectures are essential. You can listen to them online (www.cbc.ca/radio/ideas/the-1989-cbc-massey-lectures-the-real -world-of-technology-1.2946845) or read them in a collected edition (https:// houseofanansi.com/products/the-real-world-of-technology-digital). Franklin's writings on feminism ("an alternative way of ordering the social space") and pacifism have also been very useful to me as I've put together this book.

**Notes**

A fair amount has been written about J. L. Moreno's sociograms, much less about Helen Hall Jennings's role in their creation. It seems clear (at least to me) that Jennings brought with her ideas of how social systems might be mapped and quantified and that these ideas were then collaboratively stitched into Moreno's well-developed philosophies on sociometry. Moreno's son, Jonathan, told me in conversation that Jennings most likely did much of the research work (data collection from the students), and I think it's possible that she drew the first sociograms as well. Distilling out truth from J. L. Moreno's life is a difficult task. He appeared on national television to defend Woodrow Wilson from a psychoanalysis performed by Freud. He ran couples counseling for Joan Crawford and Franchot Tone. He was an on-screen boxing analyst, though he knew almost nothing of the sport. He wrote a fairly earnest book about being God, and his autobiography was titled *Autobiography of a Genius*. He was, in Jonathan's words, "absolutely a theater guy," and all of his work is as much performance as it is science. The sociogram work does seem to me to be a real collaboration, and as with the Fisk/Smith Maps these diagrams should be referred to as Moreno/Jennings creations.

My conversation with Jonathan Moreno was very useful for this chapter, as was his biography of his father, *Impromptu Man*. Jonathan Fox's *Essential Moreno* (1987) is a succinct collection of J. L.'s writing, and René F. Marineau's 1989 biography filled in some of the narrative of Moreno's early years.

## 2. I Data You, You Data Me (We All Data Together)

The text analysis for this chapter was cobbled together using Node.js, the *New York Times* API, and word2vec. I downloaded every article containing the word "data" in the *Times* from 1981 to 2018 and assembled large corpora for each year containing the full body of every article. From each of these I created a set of multidimensional coordinates for the top ten thousand words using word2vec. From this I could find out which words were moving closer to "data" and which were moving farther away. It's worth saying again that this is not an analysis of common usage of these words, but rather of their usage in the very specific editorial context of the *Times*. The same code, run with text from other publications, or with chat transcripts or tweets or books or academic papers, would present different results. I chose the *Times* mostly because of my own experience using its data over the last decade. Jonathan Furner's work excavating early usages of the word "data" was hugely helpful in tracing the word's path from 1587 to its center point in my linguistic maps.

I spoke with Matthew Kenney in 2019 about his investigations of word-2vec. The original post on word2vec can be found at www.mattkenney.me /google-word2vec-biases/. Since this was written, Kenney has been digging deep into generative text models—machine learning systems built not to analyze text but to create it. The phrase "Russian botnet" encompasses much of the potential risk of these systems, and Matt's dive into how generative text might be used to pull people into alt-right communities is really worth reading: www.mattkenney.me/gpt-2-345/.

A fair number of people featured in this book I met at Eyeo Festival in Minneapolis, an event that I've co-curated for ten years. Right from the beginning, we posted video of the talks for free, so if you Google "Eyeo" and names you read in these pages, you're more likely than not to get results. Meredith Whittaker's talk came shortly after she co-founded the AI Now Institute with Kate Crawford, where I spent a fair amount of my time writing this book as writer in residence. The AI Now reports, published annually, are available on its website (https://ainowinstitute.org/reports.html) and are very comprehensive snapshots of critical data studies from 2016 to 2020.

I wish I'd made up the whole Jared + lacrosse thing, but I didn't (https://qz .com/1427621/companies-are-on-the-hook-if-their-hiring-algorithms-are -biased/). While bias in machine learning HR systems is well-known, adoption of these technologies is greatly increasing. As of 2019, somewhere around 60 percent of companies were using applicant screening software, and right now during the COVID-19 epidemic there is at least anecdotal evidence that the practice is becoming even more prevalent (https://venturebeat.com/2020 /03/13/ai-weekly-coronavirus-spurs-adoption-of-ai-powered-candidate -recruitment-and-screening-tools/). In what seems to me to be a fairly audacious PR move, a lot of these ML/HR companies are promoting their products as tools for reducing biases in hiring processes rather than amplifying them. Knockri, a product that "has merged Industrial Organizational Psychology with Machine Learning" by analyzing applicant videos, boasts on its website that its system creates "24% more diverse shortlists." It does not tell us how many of these diverse short listees end up with job offers.

Johanna Drucker's 2011 essay is here: www.digitalhumanities.org/dhq /vol/5/1/000091/000091.html. The idea of capta was actually first put forward by Christopher Chippindale in *American Antiquity* 65, no. 4 (2000). An archaeologist, Chippindale persuades his colleagues to keep data separate from "the archaeological affair they were hoped to represent." In what could perhaps serve as a much shorter and less ornamented version of these particular chapters of my book, he offers this sentence: "I do wish all those papers

that routinely refer to 'data' did show awareness of the difference between the data and the capta, between what we have grasped and what we hope to study, and will take every notice when that difference is sufficiently material to affect the pattern of the data."

Maans Booysen, peerless photographer of birds on the wing, would no doubt be disappointed if I didn't include a link to his son's metal band, Octainium: www.facebook.com/octainium.

## 3. Data's Dark Matter

You can find a detailed post about the names placement algorithm I wrote for the 9/11 memorial on my (dusty, neglected) blog: http://blog.blprnt.com/blog /blprnt/all-the-names.

The work I did for the memorial was as a contractor for Local Projects, and the strange email that kicked it all off came from Jake Barton. Though my solved layout was the first to be generated, it's not the exact one that is inscribed into the memorial. The final one used my layout as a base and swapped names and groups of names to match the architects' aesthetic concerns, and was the work of Michael Arad's team using the software tool I developed.

Mohammad Salman Hamdani's name can be found on panel S-66. As of this writing, he has not been officially recognized as a first responder to the World Trade Center.

I spoke with Mimi Onuoha shortly after I started writing this book in 2018. Since then her work has continued to focus on absence, omission, erasure, and their associated harms. You can read more about *The Library of Missing Datasets* and keep up with what she is doing on http://mimionuoha.com/.

The figures on the Māori undercount in the New Zealand census come from Te Mana Raraunga (www.temanararaunga.maori.nz/). The U.S. numbers are from the National Congress of American Indians (www.ncai.org/policy -issues/economic-development-commerce/census#:~:text=In%20the%20 2010%20Census%2C%20the,the%20next%20closest%20population%20group). The York/St. Michael's study was published in *BMJ Open* in 2017 (https:// bmjopen.bmj.com/content/bmjopen/7/12/e018936.full.pdf).

Information on the NPMSRP came from David Packman's *Guardian* post (www.theguardian.com/profile/david-packman) as well as archived pages from the blog on the Internet Archive. Killed by Police (https://killedbypolice .net/) is run by an anonymous person whom I was unable to get in contact with. The site carries this bizarre disclaimer: "We may earn a small part of the sale from links to any products or services on this site. You do not pay any-

thing extra and your purchase helps support my work in bringing you more awesome gun and gear articles." Fatal Encounters has a website with details about the project (https://fatalencounters.org/), but it is mostly a front end to this Google spreadsheet that is maintained by volunteers: https://docs .google.com/spreadsheets/d/1dKmaV_JiWcG8XBoRgP8b4e9Eopkpgt7FL7ny spvzAsE/edit#gid=0.

Sam Sinyangwe spoke at Eyeo Festival in 2015 (https://vimeo.com /133608602) and 2017 (https://vimeo.com/232656871). Some of what is written in this chapter comes from personal conversations during these times. Campaign Zero came under intense criticism in the spring of 2020 for exaggerating some of its claims about effectiveness of police policy changes and for not showing strong enough support for defunding and/or abolishing police forces. You can read a good summary of these criticisms here: www.colorlines .com/articles/what-went-wrong-8cantwait-police-reform-initiative.

## 4. By Canoe and Caravan

The expedition to Angola was organized by the Wild Bird Trust and led by Steve and Chris Boyes. We were accompanied by a *National Geographic* crew who later wrote a feature article for the magazine (www.nationalgeographic .com/magazine/2017/11/africa-expedition-conservation-okavango-delta -cuito/) and produced a film that was released in 2018 (http://intotheokavango .org). Although the film carries the same name as the open data platform we built for the expeditions, I had no direct involvement in the film (though I do provide some comic relief).

In my conversations with Tim Gargan, he often expressed frustration at the difficulty of raising funds for a project with as long of a time span as demining in Angola. *Didn't I already contribute to this? Why aren't those mines gone already?* There is still a lot of work to do, and if you want to throw some support toward the efforts of people like Tim you can do so at www.halotrust .org/.

The *Guardian* article about the expedition is here: www.theguardian .com/environment/radical-conservation/2015/may/28/expedition-source -okavango-delta. Nancy Jacobs's *Birders of Africa* is a deep historical investigation of a network of ornithologists and the largely forgotten guides, hunters, and taxidermists who supported their work. It's a measured look at colonialism and science, and the human stories Jacobs tells will stay with me for a long time.

I've quoted Lauret Savoy's *Trace* (2015) many times, and its ideas and spirit

are threaded through this book in many other ways. I dog-ear the corners of the books I read while researching (sorry) to mark passages and quotations I want to come back to, and *Trace* is folded up on almost every page.

I stumbled onto J. C. B. Statham's travelogues during my time at the Library of Congress and was immediately taken by the ridiculous title of his book. The book is perhaps worth reading for the natural history records; the back of it holds several tables listing the species he observed. But you could throw a rock at an archive of writing about Africa in the early twentieth century and find a dozen books like it, equally self-aggrandizing, equally racist. Though the maps of Angola from this era likewise carry the stink of colonialism, I found more joy looking at them. On many of the maps I found names for rivers that we'd passed on our expedition. Some were indigenous names that we never learned or that have been forgotten. Some were colonial names, Portuguese and German, scent markings of explorers like Statham that didn't quite stick.

The James Scott quotation is from *Seeing Like a State* (1998). Kate Crawford's salient point about the planetary network of AI is from the essay she wrote to accompany "Anatomy of an AI System," a collaboration with Vladan Joler. The project (which is now in the permanent collection of MoMA) is "an anatomical map of human labor, data and planetary resources" that extend from a single query to Amazon Echo (https://anatomyof.ai/).

Brian House (https://brianhouse.net/) is a frequent collaborator whose work I recommend to students, friends, and strangers on the street every week. You can find remnants of our Into the Okavango platform at http://data .intotheokavango.org. Steve Boyes's 2013 talk at the *National Geographic* headquarters isn't online, but this one covers some of the same territory: www .youtube.com/watch?v=vAiP1iOv23M.

David Birmingham's *Short History of Modern Angola* (2015) was a useful reference for the short paragraph on Angola's civil wars.

Risks of GPS info in photo EXIF was reported on by Adam Pasick in 2014 (https://qz.com/206069/geotagged-safari-photos-could-lead-poachers-right -to-endangered-rhinos/). Sean Martin McDonald's "Ebola: A Big Data Disaster" is a detailed case study of the data grab during the humanitarian response to the 2014 Ebola outbreak.

Julietta Singh's *Unthinking Mastery* (2018) was the first book that I read when I set out to write *Living in Data*, and its themes of confronting the drive toward mastery and decolonial thinking influenced much of what you'll find in these pages.

Nathaniel Raymond spoke at Eyeo Festival in 2018 (https://vimeo.com /287094217), and many details about the Satellite Sentinel Project and Sudan

came from an interview in the spring of 2020. You can find the initial human security alert here: www.satsentinel.org/sites/default/files/SSP%2024%20 Siege%20012512%20FINAL.pdf.

## 5. Drunk on Zima

Floodwatch is no longer operational, but you can find some documentation of it on Ian Ardouin-Fumat's website (Ian was the lead designer and front-end developer for the project): https://ian.earth/projects/floodwatch/. Ashkan Soltani's work with *The Washington Post* is here: https://ashkansoltani.org /work/washpost/. Julia Irwin's Cookie Jar project is no longer documented, but you can view her recent work at www.juliai.com/. When I originally wrote about my experiments with Floodwatch data and Mechanical Turk (MT), I didn't do enough to credit Julia, so I'll be very clear here that the idea to send ad histories to MT workers and have them write biographies for people was Julia's and Julia's alone.

Very little remains of my own BBS history, but digging through the BBS archive at textfiles.com/bbs/ is a delightful experience for anyone who remembers the sound of a dial-up modem. The first version of nytimes.com is archived on the Internet Archive and is viewable on its Wayback Machine. The time line of ad placement that I write here is based on research we did at the OCR for a project called Behind the Banner: http://o-c-r.org/behindthebanner/. While the Vickrey auction is not as common as it used to be, it's still an oft-used approach to decide who wins an ad bid: "The Lovely but Lonely Vickrey Auction," Lawrence M. Ausbel and Paul Milgrom, *Combinatorial Auctions* (2005).

The first banner ad is archived for posterity at http://thefirstbannerad .com/. The Zima story comes from Ross Benes's oral history of the creation of this ad: https://digiday.com/media/history-of-the-banner-ad/. Latanya Sweeney's paper on Google AdSense is worth reading in full: "Discrimination in Online Ad Delivery," *Communications of the ACM* 56, no. 5 (May 2013): 44–54. ProPublica's articles on Facebook's ad placement discrimination (www .propublica.org/article/facebook-lets-advertisers-exclude-users-by-race, www .propublica.org/article/facebook-advertising-discrimination-housing-race -sex-national-origin, and www.propublica.org/article/facebook-ads-can-still -discriminate-against-women-and-older-workers-despite-a-civil-rights -settlement) were authored by Julia Angwin, Terry Parris, Jr., Ariana Tobin, Madeleine Varner, and Ava Kofman. The Cornell paper was authored by Muhammad Ali, Piotr Sapiezynski, Miranda Bogen, Aleksandra Korolova, Alan

Mislove, and Aaron Rieke and can be found at https://arxiv.org/abs/1904 .02095.

Don Levy's 2010 Thinking Digital talk is here: https://vimeo.com/13998027. A transcript of Clive Humby's 2006 talk is still online at https://ana.blogs .com/maestros/2006/11/data_is_the_new.html. If you're in the mood to watch a somewhat hagiographic history of the Tesco Clubcard, queue up this video: www.mycustomer.com/experience/loyalty/edwina-dunn-and-clive-humby -how-we-revolutionised-customer-loyalty. A comprehensive history of the Air Miles program can be found on Wikipedia: https://en.wikipedia.org/wiki/Air _Miles.

"Big data disaster response" is a phrase that can be read more than one way, but there is at least one start-up that is trying to use census data to help cities make plans: www.nytimes.com/2019/08/09/us/emergency-response -disaster-technology.html.

Joy Buolamwini's "Gender Shades" report has its own website (http:// gendershades.org/), and you should read it. You should also watch her performance about how Black women are misgendered by computer vision, *AI, Ain't I a Woman?* (www.youtube.com/watch?v=QxuyfWoVV98), and learn more about the Algorithmic Justice League (www.ajl.org/).

The University of Minnesota study is authored by Veronica Marotta, Vibhanshu Abhishek, and Alessandro Acquisti (https://weis2019.econinfosec .org/wp-content/uploads/sites/6/2019/05/WEIS_2019_paper_38.pdf). The Arthur R. Miller quotation is from *The Assault on Privacy* (1971). You can read the bizarre story of the Pikinis app here: www.bloomberg.com/news/articles /2019-10-01/zuckerberg-can-t-escape-lawsuit-over-bikini-photo-finder-app.

## 6. Number of Grown Sheep That Were Sheared

The graphic for this chapter was made with Processing.js, and the data was processed from the Library of Congress's publicly available (though perennially out of date) MARC records (www.loc.gov/cds/products/marcDist.php). The items in red were selected more or less at random.

*America's Greatest Library: An Illustrated History of the Library of Congress* (2017) by John Y. Cole is a comprehensive history of the institution, albeit a fairly uncritical one (Cole is a longtime LOC employee and its official historian). The numbers that I've listed for the LOC holdings are estimates from its annual report. If there's one thing I learned while I was at the LOC, it's that you'll find no good way to get a real count of the holdings, because they are constantly being added to and because any determination of what

is or isn't an object is a very subjective one. Consider a folder in the Manuscript Division holding that contains seven envelopes of receipts. Is this one object? Or seven? Or several hundred? Similar questions can be asked about collected journals, bound volumes, photo books, software CDs, and so on.

I was invited to the library under the auspices of the LC Labs, an amazing group of people doing an amazing range of things. You can find some of my work alongside all kinds of useful resources on its website, https://labs.loc.gov/. You can listen to the podcast that I made while I was at the library on pretty much any podcast app or at https://artistinthearchive.podbean.com/. The Neo-Aramaic translation of the Emancipation Proclamation can be viewed in high resolution here: www.loc.gov/item/mal3217600/. Julie Miller wrote an excellent essay about the Sheep Census: https://guides.loc.gov/manuscript-resources-for-teachers/how-to-use-manuscripts/sheep-census. I interviewed Miller for my podcast in 2018. You can see the original document in her essay, or here: www.loc.gov/rr/mss/images/Sheep_01.jpg, www.loc.gov/rr/mss/images/Sheep_02.jpg.

I've assigned Jacob Harris's original essay on the Guantánamo database to every class I've taught since it was published in 2015. Read it here: https://source.opennews.org/articles/consider-boolean/. I interviewed Jacob for this book in the fall of 2019. "The Guantánamo Docket," powered by the database in question, is sadly still being updated at www.nytimes.com/interactive/projects/guantanamo.

## 7. do/until

The definitive text on algorithmic bias is Safiya Noble's *Algorithms of Oppression* (2018). Ruha Benjamin's *Race After Technology: Abolitionist Tools for the New Jim Code* (2019) also examines algorithms as part of a broader critique of tech as a supportive structure for white supremacy. David Berlinski's *Advent of the Algorithm: The Idea That Rules the World* (2000) is a good historical look at the concept and the development of algorithms.

The five-thousand-kilowatt-hour BigGAN experiment was run by Meltem Atay, then an intern at Google (www.fastcompany.com/90244767/see-the-shockingly-realistic-images-made-by-googles-new-ai/). A description of neural networks can be found in pretty much any coding textbook, but I like this one from Daniel Shiffman's *Nature of Code*: https://natureofcode.com/book/chapter-10-neural-networks/.

*The Washington Post*'s police shooting database is here: www.washingtonpost.com/graphics/investigations/police-shootings-database/.

Birds have been on my mind as I've been writing this book; after a decade or so of avoiding it, I've finally accepted that I'm a bird watcher. Despite my distrust of setting machine learning applications on human data, I'm a frequent user and big fan of a few applications focused on biodiversity. iNaturalist (www.inaturalist.org) uses a massive neural net—which costs a hundred thousand dollars to train—to identify user-submitted photos of pretty much any living thing. Merlin (https://merlin.allaboutbirds.org) does the same thing for birds, and BirdNET (https://birdnet.cornell.edu) will give you a pretty good guess at what bird you're hearing out your window right now.

### Interlude

Cindy Lee Van Dover's *Deep-Ocean Journeys: Discovering New Life at the Bottom of the Sea* (1996) is an excellent collection of stories. William Broad's *Universe Below: Discovering the Secrets of the Deep Sea* (1997) does a good (if by now somewhat dated) job of describing deep-sea ecosystems and the ways we have come to explore them.

### 8. A Lossy Kind of Alchemy

I first heard the story about the *Mariner 4* map from Dan Goods. You can see a high-resolution version on NASA's website (https://photojournal.jpl.nasa.gov /catalog/PIA14033). More detail about the map and how it was drawn can be found in this 2015 Gizmodo post by Mika McKinnon: https://gizmodo.com /this-paint-by-numbers-drawing-was-the-very-first-image-1687904838.

A few of my favorite talks about the iterative nature of data visualization are by Moritz Stefaner (https://vimeo.com/28443920), Amanda Cox (https:// vimeo.com/29391942), and Nadieh Bremer (https://vimeo.com/354276689).

Process images (and the final product) of my *PopSci* collaboration with Mark Hansen are on Flickr, and I wrote a blog post about it: http://blog.blprnt .com/blog/blprnt/138-years-of-popular-science. Much of the documentation for Cascade has been lost to time and obstinate legal departments, but there are images on Flickr and a little bit of video scattered around the internet (https://vimeo.com/54858819). I also talk about it in some detail in this TED-Ed talk: https://ed.ted.com/lessons/mapping-the-world-with-twitter-jer -thorp. The first working version of Cascade was a collaboration with Jake Porway, and subsequent versions were made by a team that included Nik Hanselmann and Deep Kapadia.

I use Alberto Cairo's *Truthful Art* (2016) as somewhat of a negative example here, but it's a very good book.

## 9. The Rice Show

Statistics about the number of people in the air are from *Now Boarding*, an artwork made with Ben Rubin and Mark Hansen for an exhibition about the past and future of airport design at the Denver Art Museum in 2012. You can watch a section of the global air traffic visualization here: https://vimeo .com/91515815. I wrote about the process for the U.K. National DNA database on my blog in 2009: http://blog.blprnt.com/blog/blprnt/wired-uk-july-09 -visualizing-a-nations-dna. Scroll through the whole visualization of the Hong Kong street protest here: www.nytimes.com/interactive/2019/06/20 /world/asia/hong-kong-protest-size.html.

I interviewed James Yarker in 2019. This short chapter is not enough to capture the absurd variety of Stan's Cafe's work, so I recommend you spend some time at www.stanscafe.co.uk/. Here's Amanda Cox on the "kooky comparison": https://datatherapy.org/2013/07/11/the-power-of-the-explanatory -comparison/.

## 10. Paradox Walnuts

*Rose of Jericho* was made in 2008; there is more information on it along with photo documentation at www.martinluge.de/work/roseofjericho/. Trehalose is found in shrimp, grasshoppers, locusts, butterflies, bees, and many plants and mushrooms. I've had an *Anastatica* on my desk the whole time I've been writing this book, and I've lost count of how many times I've been convinced I'd killed it.

I learned a lot about the natural history of the Bow Glacier region from Dale Leckie's *Rocks, Ridges, and Rivers* (2017) and from Chief John Snow's *These Mountains Are Our Sacred Places* (1977). Carole Harmon's *Byron Harmon, Mountain Photographer* (1992) was the source of much of the story of her grandfather's trek through the Wapta with Lewis Freeman.

Our work at the glacier and in Calgary was commissioned by Brookfield Place, and the project was a collaboration between myself and Ben Rubin. The sensor equipment was built by Shah Selbe and Jacob Lewallen, and we managed to survive the storm thanks mostly to Jeff Kavanaugh.

George Vaux's photo and his grandson's are in the collection of the Whyte Museum of the Canadian Rockies and can be viewed online.

Natalie Jeremijenko's original website for the OneTrees project went dark while I was writing this but is still viewable on the Internet Archive. Ellyn Shea's 2014 blog post on searching for the remaining trees (www.deeproot .com/blog/blog-entries/onetrees-the-forgotten-tree-art-project) was very useful for me as I conducted my own tree hunt. This interview by Zahid

Sardar in 2004 was likewise helpful in understanding some of Jeremijenko's intent: https://www.sfgate.com/bayarea/article/Society-s-signposts-Natalie-Jeremijenko-s-trees-2641315.php.

## 11. St. Silicon's Hospital and the Map Room

The opening graphic was made with Processing and data from *The New York Times*.

A concise history of the Cleveland Free-Net, "rescued from the Administration section," can be found here: www.atarimax.com/freenet/common/html/about_freenet.php. Other artifacts, including the last screen shown to users, photos from meetups, and an obituary for Tom Grundner, are at http://cfn.tangledhelix.com/main.html. Gareth (www.victoria.tc.ca/gareth_shearman_obituary.html) and Mae Shearman's (www.victoria.tc.ca/mae_shearman_obituary.html) memorials go some small way toward telling of their generosity and their legacy.

Data.gov was launched in 2009 by Vivek Kundra, the United States' first federal chief information officer. Kundra is now the CEO of Sprinklr, a company that uses AI to advertise to users on social media. Federal agencies are required, as of January 2019, to make their data open, though not specifically to post it to data.gov. While the site continues to grow, some parts of data.gov are actually shrinking. In 2018, the Environmental Data and Governance Initiative found that the number of climate-related documents searchable on the site had fallen from 762 to 677.

In the full quotation, Dickens describes D.C. as the "City of Magnificent Intentions . . . Spacious avenues, that begin in nothing, and lead nowhere; streets, mile-long, that only want houses, roads and inhabitants; public buildings that need but a public to be complete; and ornaments of great thoroughfares, which only lack great thoroughfares to ornament." This quotation comes from *The Complete Works of Charles Dickens* (2017).

The Open Knowledge Foundation definition of open data is online at https://opendefinition.org/.

The Elephant Atlas project is no longer online, but you can find documentation at https://ian.earth/projects/elephant-atlas/. Information about the elephant census itself can be found at www.greatelephantcensus.com/, and the final report from the count can be found at https://peerj.com/articles/2354/.

Danielle Poole's ideas about teledemography (https://bmcpublichealth.biomedcentral.com/articles/10.1186/s12889-018-5822-x) are relevant here: that in order to make tech effective, we need to first understand existing models

and methods of the information needs. Put more simply, we need to deeply understand a particular community's relationship to a particular technology (how they use it differently, what the barriers are, how it connects to local cultures) before we set out to build any kind of tool or platform that is meant to serve that community.

The Ellen Ullman quotation is from *Life in Code: A Personal History of Technology* (2017). Halberstam's is from *The Queer Art of Failure* (2011), which should be on literally everyone's bookshelf.

Data for the two Michael Brown illustrations was collected from the Google Places API with assistance from Talia Kauffman.

Twenty-seven of the maps that were made in the gymnasium in St. Louis can be found at www.cocastl.org/stlmaproom/. Some of the maps were not put online because they contained information that was private or sensitive.

Much has been written about redlining in the last few years. Richard Rothstein's *Color of Law* (2017) is an exceedingly comprehensive look at the conditions that led to redlining, the ways in which it was enacted in various cities, and the lasting effect it's had on the American social landscape.

Colin Gordon's *Mapping Decline: St. Louis and the Fate of the American City* (2008) was indispensable to me as I was working on the Map Room. Just recently, I began reading Walter Johnson's *Broken Heart of America* (2020), which comprehensively analyzes how racism and colonialism defined the map of St. Louis, and continue to do so today.

One of the two drawing robots in the Map Room was named Camille after Camille Dry. In 1876, Dry spent weeks aloft in a balloon drawing a topographical survey of St. Louis. The 115 illustrations are viewable on Jared Nielsen's site: http://jarednielsen.com/pictorial-st-louis/.

Shannon Mattern's essay is here: https://publicknowledge.sfmoma.org /local-codes-forms-of-spatial-knowledge/. Dickson Beall's article is here: www.timesnewspapers.com/westendword/arts_and_entertainment/harlem -renaissance-contemporary-response-at-coca/article_a4a15658-e960-52da -ada8-b08d936a33db.html.

Yanni Loukissas's book *All Data Are Local* (2019) is a careful, case-study-rich argument that data cannot be understood outside the geographic, historical, and political context in which they were created. It's very much worth the read.

## 12. Te Mana Raraunga

The Te Mana Raraunga website is rich with resources about the Māori data sovereignty movement: www.temanararaunga.maori.nz/. Tahu Kukutai and

John Taylor's *Indigenous Data Sovereignty: Toward an Agenda* (2016) is an in-depth look at indigenous data sovereignty that includes contributions from indigenous thinkers around the world. Claudia Orange's *Illustrated History of the Treaty of Waitangi* (1990) and Malcolm Mulholland and Veronica Tawhai's *Weeping Waters: The Treaty of Waitangi and Constitutional Change* (2010) were helpful in understanding the treaty and its larger context within New Zealand history.

The original Waitangi Tribunal text of the radio frequency claim can be found on the Internet Archive (https://web.archive.org/web/20010715203845 /http://www.knowledge-basket.co.nz/waitangi/reports/wai26.html). The 1992 Te Roroa report involving spiritual places is here: https://forms.justice .govt.nz/search/Documents/WT/wt_DOC_68462675/Te%20Roroa%201992 .compressed.pdf. David V. Williams's 1997 report *Matauranga Maori and Taonga* covers the Waitangi Tribunal's hearings on traditional knowledge of flora and fauna.

I met with Tahu Kukutai and Maui Hudson in the fall of 2018 in Hamilton, New Zealand. The section about whakapapa comes from Maui Hudson et al., "Whakapapa—a Foundation for Genetic Research?," *Journal of Bioethical Inquiry* 4, no. 1 (April 2007): 43–49. Kukutai talks about her whakapapa project in this lecture: www.youtube.com/watch?v=qfxC6HXY968.

I first learned the Henriette Avram story from Kate Zwaard's Collections as Data talk in 2017: www.loc.gov/item/webcast-8168/. Jesse Walter Fewkes's exhaustive report of his work with the Passamaquoddy is on Project Gutenberg (www.gutenberg.org/files/17997/17997-h/17997-h.htm), as are the results from his expedition in Arizona (www.gutenberg.org/files/23691/23691-h/23691-h .htm). An example of an LOC page with Traditional Knowledge Labels is this one for the Passamaquoddy "Song of Salutation": www.loc.gov/item/2015655561.

My interview with Donald Soctomah, along with more detail about the cylinders and their cataloging at the LOC, can be found in episode 8 of Artist in the Archive (https://artistinthearchive.podbean.com/e/episode-8-thirty-one-cylinders/). I interviewed Jane Anderson for the same episode in December 2018.

The paper on reimagining the DIKW pyramid is "Mātauranga Māori and the Data–Information–Knowledge–Wisdom Hierarchy: A Conversation on Interfacing Knowledge Systems," *MAI Journal* 1, no. 2 (2012).

## 13. An Internet of What

The Dja Faunal Reserve is in southeastern Cameroon. The research camp is built and maintained by the Congo Basin Institute (www.cbi.ucla.edu/). I visited in December 2019. Our work there would have been impossible without

the support of Romeo Kamta, Aziem Jean, Obam Mael, Megwadom Dieudonné, Abem Anne Marie, and Jean de Dieu. I still can't stop saying the word "inselberg," which has the same root as "iceberg" and means island mountain. An inselberg is also known as a monadnock or a koppie, and the French speakers in the Dja called them rochées.

Matt Zumwalt's quotation comes from his 2016 essay "The Internet Has Been Stolen from You. Take It Back, Nonviolently" (https://medium.com/@flying zumwalt/the-internet-has-been-stolen-from-you-take-it-back-nonviolently -248f8d445b87). You can try hashing stuff using SHA-256 at https://emn178 .github.io/online-tools/sha256.html. The story about the IPFS Turkish Wikipedia distribution is here: https://blog.ipfs.io/24-uncensorable-wikipedia/. The Dat project's home page is https://dat.foundation/, and you can get your own piece of the distributed web up and running with the Beaker Browser (https:// beakerbrowser.com/).

You should definitely take a few minutes (right now?) to read about Alexander Stepanovich Popov and his lightning detector: http://www.saint -petersburg.com/famous-people/alexander-popov/. Russia still celebrates Radio Day on May 7, the anniversary of Popov's first lightning detector experiments. You can read a little more about the LoRa network we deployed in the Dja on the *FieldKit* blog: www.fieldkit.org/blog/fieldkit-goes-arboreal-in -cameroons-dja-reserve/.

Radio Taboo's Facebook page is at www.facebook.com/radiotaboofilm/. The quotation from Issa Nyaphaga is from this 2015 interview with Caitlyn Christensen of Sampsonia Way: www.sampsoniaway.org/interviews/2015/06/02/a -voice-can-travel-anywhere-an-interview-with-issa-nyaphaga-of-radio-taboo/.

## 14. Here in Dataland

The Hope/Crisis illustration was made with Processing and the *New York Times* Article Search API. It was originally made in 2009 and updated for this book. The Philip Pullman quotation is from *The Subtle Knife* (1997).

I first learned about Dataland from this 2012 Verge article by Thomas Houston: www.theverge.com/2012/5/24/3040959/dataland-mits-70s-media -room-concept-that-influenced-the-mac. Richard Bolt's report on Dataland, *Spatial Data-Management*, was published in 1979 by MIT. The cover is really amazing. *The Averaged American* (2007) by Sarah E. Igo is an excellent history of the ways in which government and corporations in the United States have worked to index people.

The Logan Nonfiction fellowship at the Carey Institute gave me four weeks to work on this book without interruption in 2018, and I will be forever grateful.

The particular copy of *The Assault on Privacy* (1971) I found/stole from Huyck House is the Signet paperback from the New American Library. I interviewed Arthur R. Miller in January 2019.

The AI Now Institute's report on AIAs is here: https://ainowinstitute.org /aiareport2018.pdf. You can read about the Government of Canada's AIA efforts and see the beta version of its questionnaire here: www.canada.ca/en /government/system/digital-government/modern-emerging-technologies /responsible-use-ai/algorithmic-impact-assessment.html. Facebook's stock really did rise after its FTC fine: www.businessinsider.com/facebook-stock -rose-news-5-billion-ftc-settlement-why-critics-2019-7.

The figures about Apple's internal diversity are from its 2018 report, which is at the time of writing still the most recently released report at www.apple .com/diversity/.

Those with German-language skills can check out *Der Hessische Beauftragte für Datenschutz und Informationsfreiheit*'s website at https:// datenschutz.hessen.de/.

# Acknowledgments

I wrote the initial proposal for *Living in Data* in 2012. It spent five years being shuffled into various digital desk drawers before an existential fear of the Trump administration and a tenacious string of emails from a literary agent combined to revive it. I'll be forever thankful for one of these things. Jeff Shreve saw many sides of this book that I didn't, and through his patience and reassurance over the long process of getting this thing done, he's saved me many future fortunes in therapy bills.

Everyone I talked with for this book was gracious with their time and kind in their tolerance of my somewhat improvisational interview style. Thank you to Mimi Onuoha, Matthew Kenney, Jacob Harris, James Yarker, Maui Hudson, Tahu Kukutai, Jane Anderson, Julie Miller, Jonathan Moreno, Arthur Miller, Ashkan Soltani, and Nathaniel Raymond. I promise to buy you each a drink of your choice the next time we meet.

I had the great honor to work alongside a legendary group of creative and talented and downright good humans at the Office for Creative Research. The studio closed before this book began, but I see *Living in Data* very much as an OCR project, and I hope everyone from that team can see some of themselves in these pages. Ben Rubin, Ian

Ardouin-Fumat, Noa Younse, Zarah Cabañas, Genevieve Hoffman, Kate Rath, A'yen Tran, Chris Anderson, Jane Friedhoff, Eric Buth, Gabriel Gianordoli, Erik Hinton, Mahir Yavuz, Ellery Royston, Ashley Taylor, and Sarah Hughes, thank you. All of you also get drinks.

This book starts and ends on the banks of the Mississippi, and that river's cities have played an outsized role in shaping my work and my ideas. In St. Louis, Kelly Pollack and Jennifer Stoffel supported the Map Room, which looked almost nothing like the work I'd done before, but which has affected everything after. The project was a gamble for COCA, and I'm grateful they felt it was worth the risk. In Minneapolis, I've spent a decade helping to put together Eyeo Festival, a strange gathering for computational artists and an ever-expanding range of like minds and likely collaborators. Dave Schroeder planted the seed for Eyeo beside the river, and he, Caitlin Rae Hargarten, and Wes Grubbs have watered and tended to it so that it blooms every summer with brilliant colors. I'm forever grateful to them and to the hundreds of people who've stepped onto the Eyeo stage or walked down the halls at the Walker Center, who, I regret to say, won't get drinks.

There are other rivers, too. Steve Boyes took the leap of faith to bring me, a city kid with all the wilderness skills of a boiled egg, along on his transect of the Okavango Delta in 2014, and John Hilton managed the not-insignificant logistics of keeping me alive on that and several other expeditions. I'll never forget sitting on a log beside James Kydd, watching a bull elephant ten yards away use its trunk to toss berries into its mouth like popcorn. In my mind, James's name is synonymous with wilderness, and I hope he can read some of his grace and respect for nature in these pages. Our work in the Okavango depended on the deep knowledge and tremendous skill of the Ba'Yei—thank you in particular to Gobonamang Kgetho, Tumeletso Setlabosha, and Leilamang Kgetho.

Shah Selbe was my boatmate on that first trip, and we're still adventuring together, in both literal and figurative senses. Shah leads the FieldKit team, whom I get the pleasure to work with most

Acknowledgments

days: Jacob Lewallan, Bradley Gawthrop, Susan Allen, Lauren McElroy, and Ally Fabale. Jeff Kavanaugh imparted his deep glacial wisdom on all of us during our Bow Glacier work. Peter Houlihan, tree climber extraordinaire, was essential to our work beside the Dja River in Cameroon, and we couldn't have done any of it without Romeo Kamta, Aziem Jean, Obam Mael, Megwadom Diedonné, Jean De Dieu, and Abem Anne Marie.

I had the great fortune to spend four weeks working on *Living in Data* at the Carey Institute, as part of its Logan Nonfiction fellowship. Though I spent most of my time walking, on damp leaves and then on crunchy snow, I wrote some words up there, too, and met a cadre of truly remarkable writers. Sara Hendren deserves particular thanks, for recommending me for the residency and for accompanying me on more than one of those snowy walks.

For a long stretch in the middle of writing this book, I had a desk at the AI Now Institute, where I'd hunker down for an hour or two when I found myself in the city. The desk was nice, but the conversations and commiserations with Kate Crawford were invaluable. Kate gave me the courage to excise grand swaths of this book, to rewrite and reconsider and revise, to strike so many things that so dearly needed to be struck. Thank you, Kate, for your wisdom and your advice and particularly for that one glass of Japanese whiskey that came exactly when I needed it.

Sean McDonald's succinct advice on how to make this book better made this book better. His decision to take a chance on me and on this strange project has made my life better.

Thank you to Brian House, Jake Porway, Mark Hansen, Yanni Loukissas, David Lavin, Bob Thiele, Claudia Madrazo, Betty Hudson, Cindy Lee Van Dover, Dan Shiffman, Lillian Schwartz, Craig and Amy and Sabine Wilkinson, Jennifer Gardy, Mathieu and Jeanne Maftei, Luke Manson, Jason Schultz, Sandy Hall, John Underkoffler, Ian and Jenn Neville, Tim and Timberly Ambler, Jon and Maria Foan, Chuck and Sharon Hallett, Mark and Andrea Busse, JVS, Erin and Olivia and Thomas and Henry Thorp, Sarah and Hossannah

and Zazie Asuncion-Lidgus, Kathie and Mike Lidgus, and all of the friends and family who've tolerated me and loved me and supported me for years and decades.

In the basement of my childhood house there were two floor looms, a little Mac Plus with a 2400 baud modem, a closet full of sheep's fleece, a 108-gallon aquarium, and a box of 1970s-era IBM punch cards. Much of the path of my life is written in these items. Dad, Mom, and Matt, thank you for growing up with me.

My partner, Nora, believed in this project from the very beginning, and somehow maintained that belief in the face of my best efforts to convince her it was doomed to be an unsuccessful proposal, and then an unfinished manuscript, and then an unread book. Like most every other part of my life, *Living in Data* would be nothing without her. My son, Pilot, has also been a vocal booster of my efforts, and just last week told me that he'd like to be a writer when he grows up (between the superhero-ing and the mobile crane driving). Pi, this might well be the best advice I ever give you: don't wait until you grow up.

Every word on every page of this book rests on top of the work done by decades of researchers and scholars and artists and activists—largely women of color—who saw the mess we were making with data, and to whom we mostly didn't listen. If there's going to be any kind of decent life in data for any of us, we need to start listening and keep listening. So thank you at last to all who, in the face of closed doors and all-male panels and all-white tenure committees, didn't give up. Thank you. Thank you. Thank you.

# A Note About the Author

Jer Thorp is an artist, a writer, and a teacher. He was the first data artist in residence at *The New York Times*, is a *National Geographic Explorer*, and served as the innovator in residence at the Library of Congress in 2017 and 2018. He lives under the Manhattan Bridge with his family and his awesome dog, Trapper John, MD. *Living in Data* is his first book.